WOOD CARVINGS

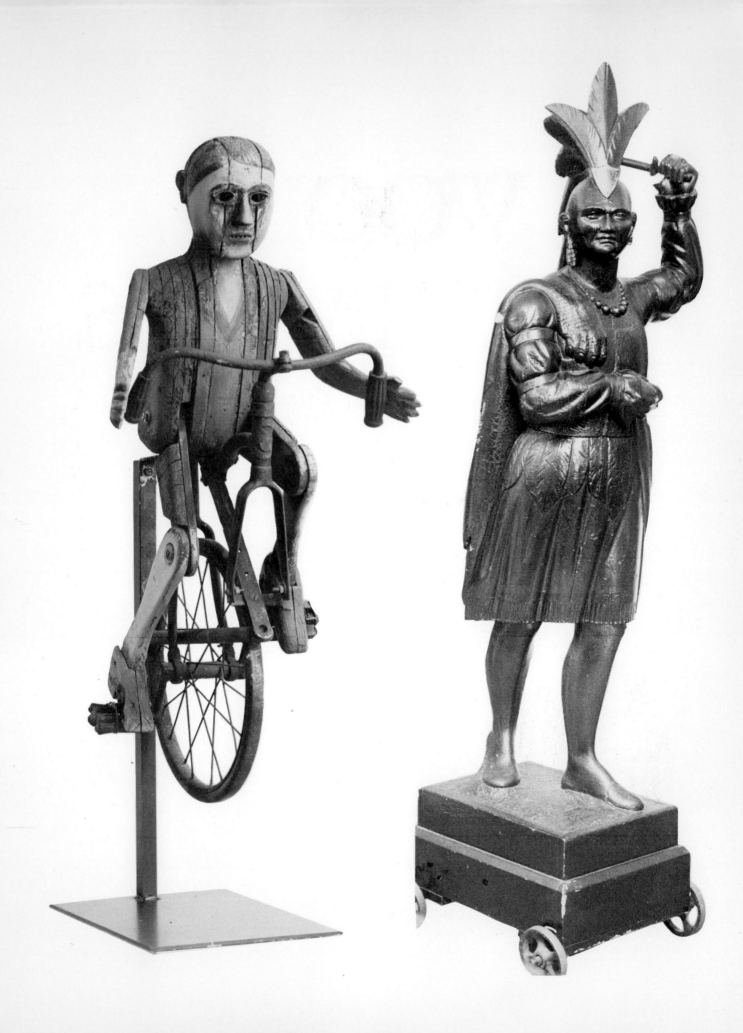

WOOD CARVINGS

North American Folk Sculptures

Marian Klamkin and Charles Klamkin

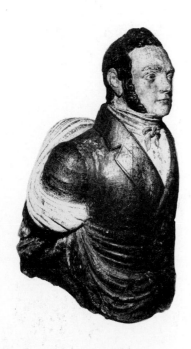

HAWTHORN BOOKS, INC.
PUBLISHERS/*New York*

This book is dedicated to
James Oliver Brown

Library of Congress Catalog Card Number: 73-21309
ISBN: 0-8015-8816-2

1 2 3 4 5 6 7 8 9 10

Contents

Acknowledgments

In the process of researching information and securing photographs for this book, we were fortunate to have access to several important collections of American folk art. Among those dealers and collectors who were especially helpful and enthusiastic in this project were Mr. Alan Cober, Mr. and Mrs. Harold Corbin, Mr. Norman Flayderman, Mr. and Mrs. Richard N. Fried, Dr. William Greenspon, Mr. Kenneth Homes, Mr. Harvey Kahn, Mr. James Kronen, Mr. George Schoellkopf, and Mr. Bernard Zipkin.

We would also like to thank Mr. Richard Ahlborn, of the Smithsonian Institution's Department of Cultural History, who furnished us with certain key data concerning contemporary folk carvers. We should also note the hospitality and cooperation of the members of the New England chapter of the National Woodcarvers Association at their meeting in Lexington, Massachusetts.

WOOD CARVINGS

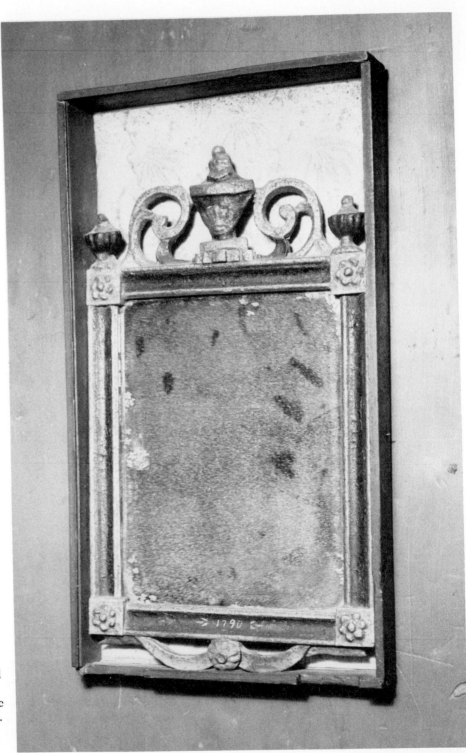

Courting mirror in travel box. Dated 1790. Frame hand-carved in neoclassic style, painted and gilded. (*Collection of Harvey Kahn*)

1 Wood Carving as an American Heritage

Within the past few years, academic and collector interest in all aspects of American folk art has expanded markedly. Museums and private galleries have held major exhibitions, and the number of dealers specializing in this area has multiplied greatly. Formerly neglected everday items from our country's past, such as quilts and coverlets, children's samplers, old tools and hardware, woven baskets, kitchen utensils, toys, and textiles, are now fetching record prices in dealers' shops and auction salesrooms.

Among the most noteworthy achievements of America's folk art has been the boundless vigor and creativity of its wood-carvers. From the earliest days in this country's history, wood has been the key to our growth and expansion. Wood in great quantity and variety was available for building homes, barns, fences, ships, wagons, furniture, tools, and utensils. It was easily worked, and consequently, there were more artisans familiar with its fabrication into useful products than there were blacksmiths and stonemasons.

It is natural, then, that a large proportion of America's artistic talent should have chosen to express itself in this accessible and familiar medium. With a minimum amount of training and the simplest of tools, the casual whittler shaped both useful and decorative objects. His imagination transformed a fragment of board into a bold rooster weather vane or enlivened a mold for pressing butter by carving the image of a cow on its surface.

Children were amused by watching the carver rough out simple, yet evocative, toys such as dolls, small animals, and soldiers. With a little more time, a rocking horse, still among the most satisfying of playthings, could be made.

During long whaling or trading voyages, sailors passed the hours carving intricate mementos for those at home with their jackknives. They used whatever scrap pieces of wood were aboard or picked up more exotic woods in the far corners of the world.

The sailing ships themselves carried supreme examples of the carver's art, from the distinctive figureheads at the bow to elaborately carved stern boards. More affluent American merchants would commission the carving of gang boards and mast sheaths as additional ornamentation for their vessels.

The commercial history of the country is reflected in carved wood trade signs advertising the shopkeeper's wares, the physician's or dentist's profession, or the hospitality offered by a tavern's landlord. This fascinating branch of American wood carving encompasses trade figures such as the cigar store Indian, and these life-size and larger-than-life-size figures represent a huge body of meritorious work.

The patriotic fervor of the nineteenth century is preserved in the carvings of eagles, symbols of the Goddess of Liberty, and portraits of American political and military heroes. Carvings done by our soldiers, particularly during the Civil War, are extremely important. In addition to exhibiting great technical competence, they are a graphic record of the suffering and boredom of prisoners of war on both sides of the struggle and a historical account of the war as it was fought battle by battle.

Especially indigenous to American folk carving are the decoys made to facilitate the hunting of wild fowl and shorebirds. These were very common and usually prosaic, but some of the carvers had the ability to transform their precise observations of nature into wooden forms. When hunter or hobbyist carved and painted his block of cedar or pine with the proper fidelity to species, attitude, and conformation, and saw to it that the finished bird was durable and seaworthy as well, the decoy became a true work of art.

There are contemporary carvers who are perhaps even more skilled than the early decoy-makers in producing exact replicas of birds. Their work is so meticulous and the coloring so delicate and precise that their birds never see the water. They are sought as prized ornamental pieces; while beautiful, they do not have the vigor of the rugged working decoy.

One group of folk carvings was not made to serve a useful purpose, but rather just for fun. This would include wind toys, such as the whirligigs, and the whimsies and oddities that were made merely to show off a carver's skill or patience. The whirligig is a construction with parts that are driven by the wind. The most typical is a figure with rotating arms, and the more elaborate have vanes powering a wide variety of other activities. The whimsies include such tributes to the carver's perseverance as chains carved with separate interconnecting links, a ball in a cage, and other complicated objects, some of which are produced from single pieces of wood.

The field of American folk carving is vast, and enough examples of merit or interest from the eighteenth century and certainly the nineteenth century have been preserved to reward the serious collector or student. However, a distinction should be made between what was done by the casual, unschooled whittlers and the truly accomplished artists whose work conforms to the highest standards of craftsmanship and design.

In the latter group, we have in the late eighteenth and early nineteenth centuries the Skillin brothers of Boston, Samuel McIntire of Salem, Massachusetts, and William Rush of Philadelphia. Among the greatest of the late-nineteenth-century carvers was John Bellamy of Kittery, Maine.

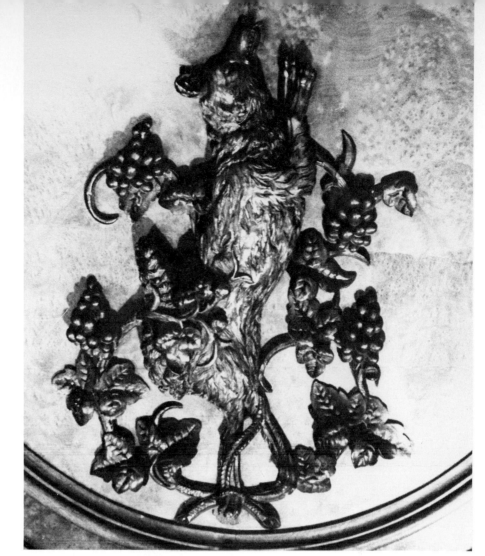

Furniture detail, "Fox and Grapes" motif (*The Mabel Brady Garvan Collection, Yale University Art Gallery*)

Figures of Peace, Plenty, and Virtue on pediment of chest-on-chest. Carved by John and Simeon Skillin. Late eighteenth century. (*The Mabel Brady Garvan Collection, Yale University Art Gallery*)

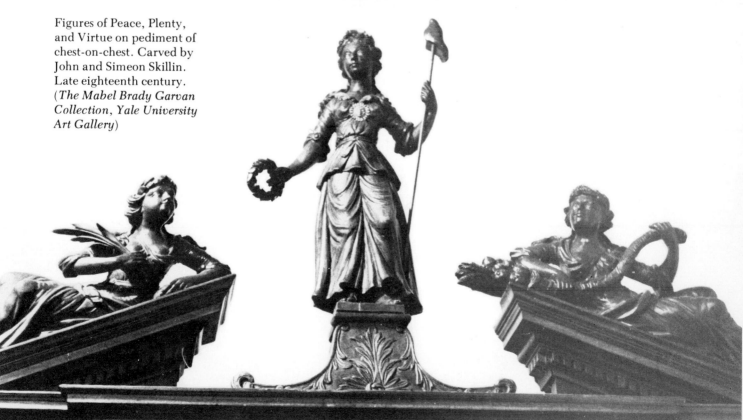

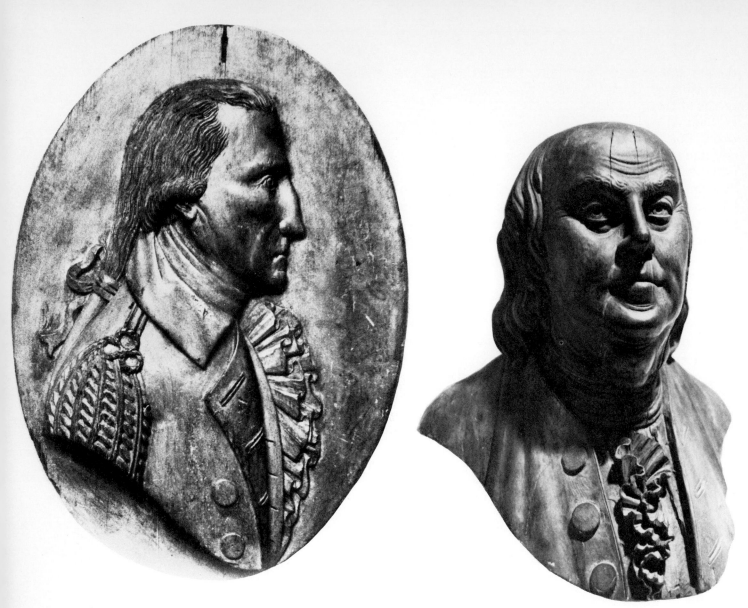

Portrait plaque of George Washington, attributed to Samuel McIntire of Salem, Massachusetts. Eighteenth century. Height: 22 inches. (*Old Sturbridge Village*)

Bust of Benjamin Franklin attributed to William Rush of Philadelphia. *Circa 1800.* (*Yale University Art Gallery*)

All of these men were originally ship-carvers, but their enormous talent directed them into carvings of a more academic nature.

Besides their outstanding ship figureheads, John and Simeon Skillin created a series of classical figures for public buildings in Boston and Worcester, Massachusetts. The Skillins also devoted some of their time to the carving of intricate furniture ornamentation. Atop a huge chest-on-chest in the Garvan collection of the Yale University Art Gallery is a group of three female figures representing Peace, Plenty, and Virtue. This work was contracted to the Skillins by a Dorchester cabinet-maker, and the brothers' bills for it are part of the provenance obtaining to the piece. The

themes and styles of execution of these figures were carried over into the Skillins' larger sculptures and have aided scholars in attributing several pieces to them.

Samuel McIntire is best known as a carver of architectural details, and many fine doorways on important buildings in his native Salem are credited to him. As a skilled and meticulous carver, he was able to execute portrait busts and plaques in relief, as well as the ship carvings that were his principal occupation. The portrait plaque of George Washington in the Old Sturbridge Village collection is one of a series that McIntire did from a sketch he made of Washington on his visit to Salem in 1789. The carving is precise and is no doubt an excellent likeness of the first president.

During the period bridging the late eighteenth and early nineteenth centuries, William Rush, who was working in Philadelphia, was considered to be this country's finest wood sculptor. His father was a ship's carpenter, but young Rush aspired to a more challenging profession. He was apprenticed to a ship-carver, and very soon the student surpassed his master by carving figureheads that embodied a feeling of movement, a radical and distinct departure from the stilted figures in vogue at that time. By 1794, Rush's reputation as a ship-carver was secure and he was commissioned to design six figureheads for warships of the new United States Navy. Four of these were executed by him. While ship carving occupied most of his time, Rush is also noted for his carving of traditional statuary with classical themes, busts, and life-size representations of popular American heroes.

John Bellamy, who died in 1914, was one of the last of our country's great ship-carvers. Bellamy was a native of Maine and for a number of years was employed in the United States naval shipyard in Portsmouth, New Hampshire, just across the mouth of the Piscataqua River from his home in Kittery. His most notable ship carving was of an eagle with an 18-foot wingspread, which he made for the naval vessel U.S.S. *Lancaster* when it was reconditioned at the Portsmouth Navy Yard in 1880. Bellamy's present reputation as an important American wood-carver is based mainly on the countless number of small eagles that he made in his later years. These are described more fully in Chapter 3.

All of these men, the Skillins, McIntire, Rush, and Bellamy, were masters of the art of wood carving. Their work and the apprentices whom they trained influenced generations of American craftsmen. The men who worked in wood as professionals and whose training was in the shipping industry of the East helped to establish an American tradition of wood carving. Amateur craftsmen continued this tradition as the country expanded, and immigrant groups added their own national traditions. From all of these diverse groups grew a strong and bold style of carving that can be termed national in spirit—an expression of an entire people rather than just a few carefully trained artists. Many of the wood carvings we classify as "folk art" were made for practical purposes, as advertising art, as children's playthings, as wind directionals, and as part of the illusion necessary to the entertainment industry. Others are one-of-a-kind personal expressions of unschooled carvers. Many have historical associations that place them within a certain time frame, while some are so strongly regional in style and spirit that we can identify where they were made if not by whom.

Detail from carved bible box. Seventeenth century. (*The Mabel Brady Garvan Collection, Yale University Art Gallery*)

Wood carving as a folk art in America is very much an ongoing tradition, and examples of twentieth-century carvings should be included in any exhibit or publication on the subject. It is not a craft, as are many in this country today, that was once abandoned and then recently rediscovered. There have always been American carvers who derived satisfaction from the work they could turn out with a knife and a block of wood. The spirit and history of America can be seen in the folk sculpture illustrated on the following pages. Through a study of our folk crafts, we can learn more about our past than we can through the reading of history books. All of the feelings experienced by the carvers, their patriotism as well as their prejudices, are evident in the work that they fashioned with their hands.

2 Figureheads, Ship Carvings, and Sailors' Carvings

The use of figureheads on ships has its origins in superstition and legend and goes back many centuries. In primitive times, the oculus or "evil eye" was painted or carved onto the prow of a boat to guide the vessel safely through the many dangers of the unknown seas. Other symbols of guardian spirits were also used from early times. The British lion was the earliest figurehead to adorn ships that sailed from American ports, but after 1726 the shipbuilder and carver were allowed to choose their subjects freely. Following the American Revolution, a wide variety of patriotic symbols and devices was used to identify the ships of the new nation.

The figurehead announced to all the identity of a ship, and the early patriotic symbols, especially, let it be known that the United States sailing fleet believed in free trade and sailors' rights. The figure of Liberty, as well as carved busts and full figures of America's early patriots, were used in some quantity. The bold American eagle often led its ship into port. The same motif was used on stern board carvings and as decoration on mast boards.

As the American shipbuilding industry grew during the first half of the nineteenth century, ship carving became a separate industry, employing many master carvers in the East Coast ports. The industry lasted until the end of the century, by which time sailing ships had become obsolete and carved figureheads and other ship decorations were no longer used.

At the beginning of the nineteenth century and for many years thereafter, the owner of a new ship would commission carvers to decorate his ship with a figure of his wife or daughter or, frequently, himself. Often the carved figures were clothed in the neoclassic style. Figureheads of military persons were dressed in contemporary uniforms.

Most ships were named for the figurehead that adorned them, although it is not known whether name or figure came first. Thus, the

David Crockett figurehead, with buckskin jacket and gun in hand, came from the ship named for it that was launched in 1853. This famous figurehead is now in the San Francisco Maritime Museum. The whaler *Thomas Jefferson* had a carved figurehead bust of the famous patriot.

Because shipbuilding in the nineteenth century was concentrated in the ports along the East Coast, the best American professional woodcarvers clustered there during the heyday of American shipbuilding. Besides ship carving, their talents were put to use in carving shop signs and trade figures and in repairing and restoring ship carvings, which quickly deteriorated after being exposed to the ravages of salt water and sun.

The figurehead of a ship was important to the sailors of the nineteenth century. Many were illiterate and could identify the name and national origin of a ship in port only by the brightly painted figure on its prow. Some figureheads were associated with tough ship's masters, and a sailor looking for a berth knew enough to avoid applying for a job on a particular ship no matter how beautiful and innocent the lady at the prow might appear.

Through the nineteenth century, the configuration of the carvings changed as the designs of ships developed. Late-eighteenth-century figureheads were almost perpendicular in their placement. As the great sleek clipper ships were built more for speed than for storage capacity, the figureheads were placed in almost horizontal positions and the carvers necessarily adapted their designs to the ships' lines. When figureheads in museums or private collections are displayed in the approximate position they were originally carved to maintain, they have a movement and thrust that is lost in improper mounting.

While figureheads were mostly carved in the human form, either full-figure or bust, there were also many birds, animals, and motifs from mythology, some of which have been preserved. The Shelburne Museum in Shelburne, Vermont, has a huge carved robin figurehead that came from the ship *Robin.* However, the identity of many of the noble-appearing human figures that once adorned American ships has been lost to us.

Figurehead from whaler
*Thomas Jefferson (Sag
Harbor Whaling Museum)*

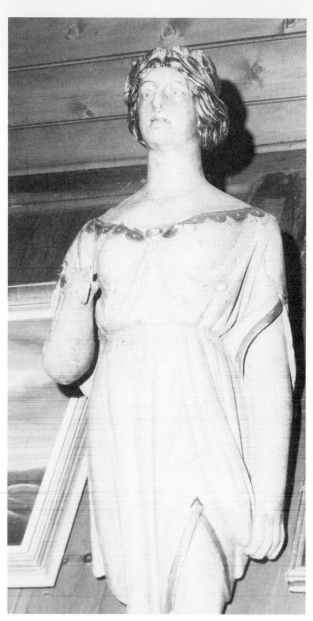

Although the baroque style of decorating almost every available part of the exterior of a sailing ship was past when the American shipping industry had its period of greatest activity, carvers did decorate other parts of ships besides the prow. The trail boards and gangway boards of American ships were consigned to the wood-carver, and there exist today fine examples of billet heads, stern pieces, and cat heads that exhibit the commercial ship-carver's art at its best. Stern board carvings in relief can still be seen in museums, although few are found by collectors today. The wingspread eagle motif in half-round or relief was exceptionally adaptable to placement on the stern of a ship. Sometimes the wood-carver or ship owner developed other ideas for stern board relief carving, but the eagle was extremely popular after 1850 and is usually found with a variety of other patriotic devices, such as flags, stars, or shields. The spread eagle, perched on a globe or rock, may or may not be surrounded by a sunburst, which is so adaptable to the semicircular shape of a stern board. This decoration

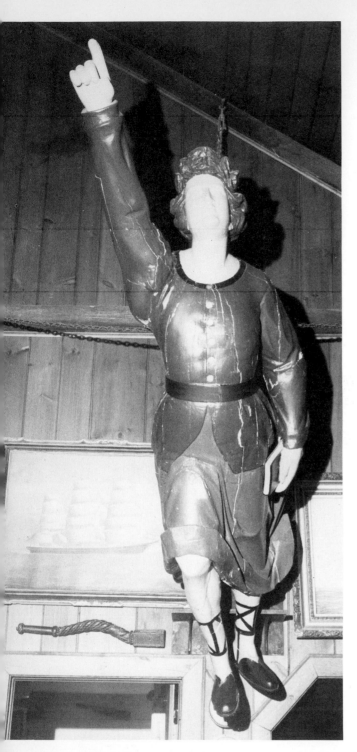

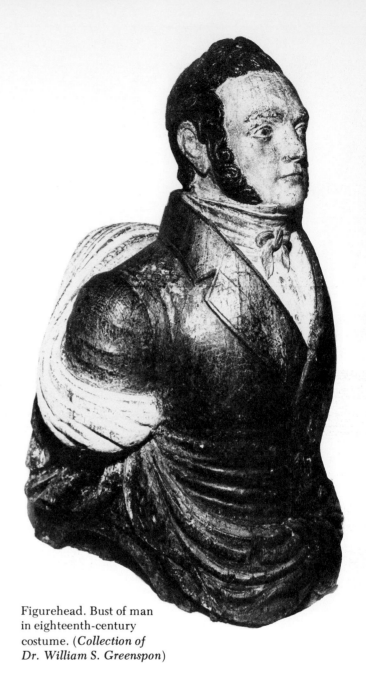

Figurehead. Bust of man
in eighteenth-century
costume. (*Collection of
Dr. William S. Greenspon*)

Figurehead (*Collection of
Norman Flayderman*)

suited the space allotted it, and perhaps this was the most compelling
reason for its popularity.

With the advent of steam, carvings were used less and less as external
ship decoration. Paddle wheel covers, used to keep the deck of a ship from
getting splashed with every rotation of the wheel, were sometimes carved.
But frequently the painted name of the ship was their only decoration.

The names of the men who carved individual figureheads for sailing
ships are, for the most part, lost to us. While hundreds of names of carvers
who specialized in this form of art can be found in nineteenth-century
business directories and other records of seacoast towns, there are few

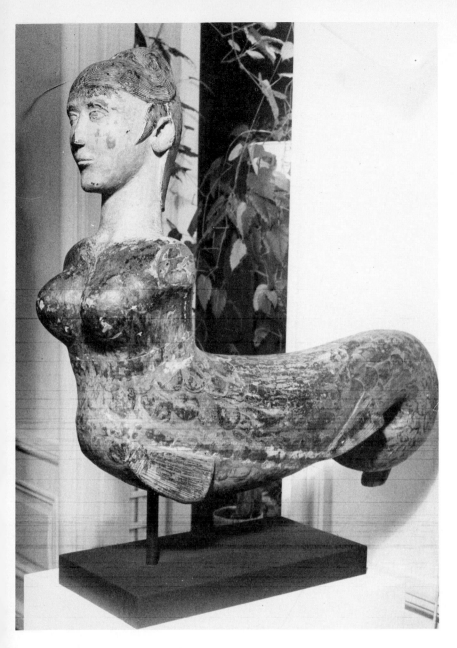

Mermaid. Body painted in simulated scale pattern in blue and green. (*Collection of Dr. William S. Greenspon*)

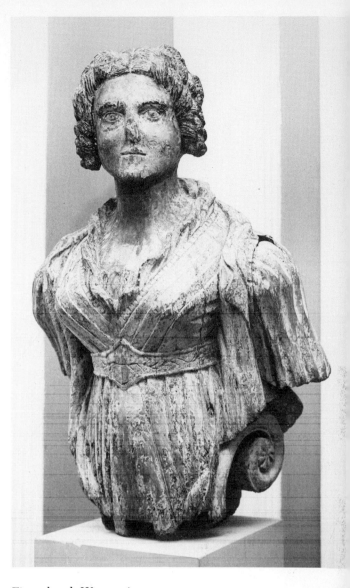

Figurehead. Woman in eighteenth-century costume. (*Collection of Dr. William S. Greenspon*)

Cat head, attributed to John Bellamy. Appeared on end of boom at the bow of sailing ships and was used as a derrick to raise the anchor. Nineteenth century. Height: 14 inches. (*Old Sturbridge Village*)

Billet head. Type of elaborate ship carving used on early sailing vessels. (*Eleanor and Mabel Van Alstyne Collection, Smithsonian Institution*)

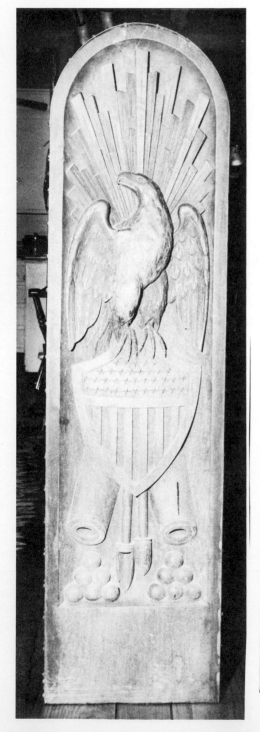

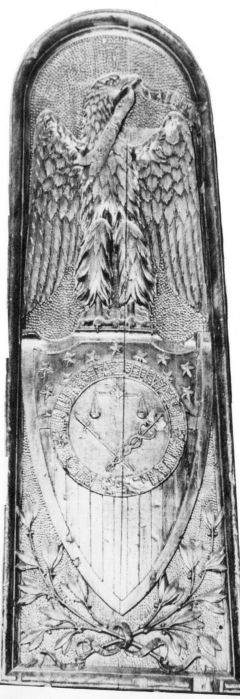

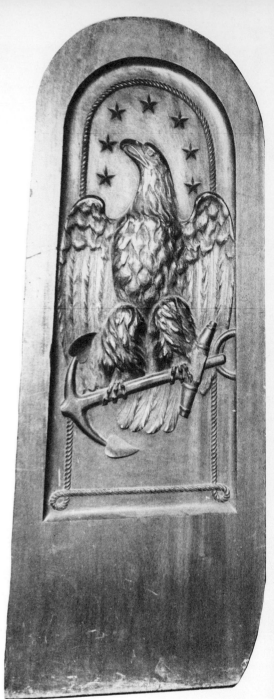

Gangway board, eagle on anchor, rope border with seven stars over eagle's head (*Collection of Norman Flayderman*)

Left:
Gangway board, eagle over shield with sunburst in background and cannon and cannon balls (*Collection of Norman Flayderman*)

Right:
Gangway board, eagle over shield (*Collection of Norman Flayderman*)

Stern board carving of man (in center) surrounded by books, maps, a globe, and scrolls (*Shelburne Museum*)

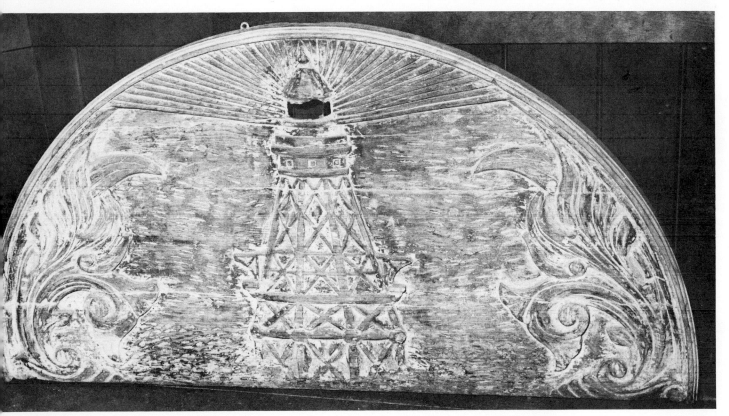

Carved paddle wheel cover with lighthouse, rays, and scrolling (*Collection of Norman Flayderman*)

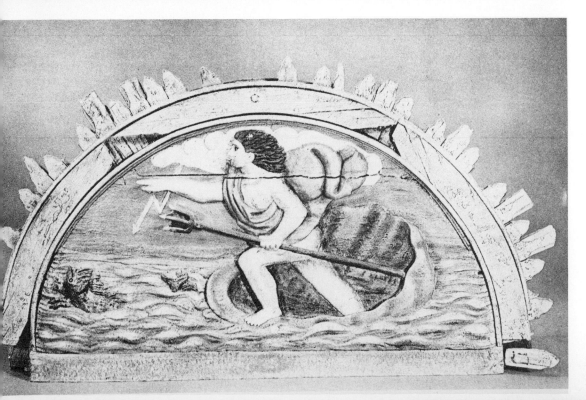

Carved and painted paddle wheel cover. Subject is Neptune. Last half of nineteenth century. Height: 40 inches. (*The Eleanor and Mabel Van Alstyne Collection, Smithsonian Institution*)

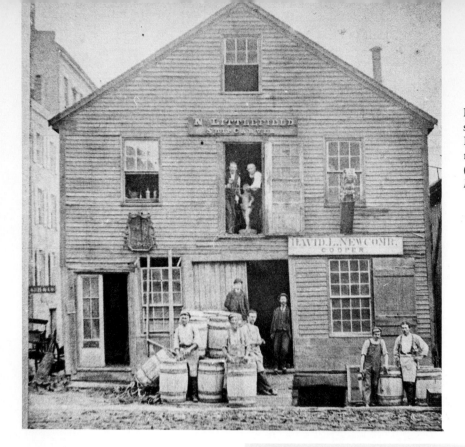

Photograph of East Coast ship-carver's shop, N. Littlefield. Late nineteenth century. (*Collection of Norman Flayderman*)

Handbill advertising Boston ship-carvers. 1862. (*Collection of Norman Flayderman*)

Maker of Ventillators

To Ship Owners and Builders.

The Undersigned successors to N. STODDARD, lately deceased, would respectfully inform his patrons that we are prepared to attend to all orders with promptness and to follow the example our esteemed friend has left us, by furnishing a SUPERIOR Style of Work, that cannot fail of giving satisfaction, either as respects QUALITY or PRICE.

Particular attention paid to FIGURES.

McINTYRE & GLEASON,

SHIP CARVERS,

JAMES McINTYRE,
HERBERT GLEASON,

No. 21 Commercial St.

Boston, Sept. 1st, 1862.

remaining documents to attest to what each master carver did. The early photograph shown here of the ship-carver shop of N. Littlefield, might have been taken in any one of many New England towns, where Littlefield is a rather common name. More satisfying documentation can be found in the illustrated broadside, advertising the firm of McIntyre and Gleason, successors to the Boston firm of N. Stoddard.

Few figureheads of nineteenth-century American ships are available to today's collector. When an authenticated American ship figurehead does come up for sale, the collector has to compete with the many maritime museums. Since these figureheads are often in need of expert and expensive restoration, it is perhaps just as well that so many of the most representative examples end up in museums that have the facilities to preserve them properly. There are still a few talented restorers who understand the meticulous methods necessary to preserve wood that has been severely damaged by the elements. Poor restoration, especially bad repainting, will devalue an early figurehead considerably.

Collectors of American folk art should be warned that a few recently carved figureheads have appeared on the market. Some of these are carved from old wooden beams and have been painted and suitably "aged" to make them appear authentic. One can only repeat what has been said many times about the purchase of antiques that require a major investment on the part of the collector—buy only from a reputable dealer who specializes in the category of antique being purchased. When buying at auction, seek expert advice before bidding on such an important piece as an early carved figurehead. There are a few dealers of maritime antiques who value their reputations far above any profit, and these are the experts one must go to for safe investment in ship carvings.

Although devotees of American folk art have given a great deal of attention recently to the whalebone carvings of the eighteenth and nineteenth centuries, there has been much less focus on the wood carvings done by these same talented men. Therefore, there are still many excellent examples of whalers' carved wood objects that can be purchased for far less than the now prized whale's teeth and bone carvings. The two forms of the whaler's art have, however, a lot in common.

A tradition of spending their leisure hours in carving developed early among the men who went to sea in search of the lucrative whale. During the height of the whaling industry, the ships were often at sea for several years at a time. As they traveled farther and farther from their home ports, the whalers had endless hours to fill between catches. Their knives were their most precious possessions, and an enormous amount of carving was done aboard American whaling vessels.

They had to work with the materials and tools at hand. Wood was the popular medium before the first whales were caught. It was brought aboard ships and utilized for repairs and in coopers' shops, where casks to hold whale oil were made while the ship was on its voyage. Scraps were often available, and these were used by many whalers to carve small objects for their families. Once whales had been taken, the teeth and bones were divided among the crew for carving and fashioning hundreds of objects. However, sailors who preferred working with wood rather than whalebone saved their share of the precious bone until their ships pulled into port at one of the South Sea Islands, where they then traded it for choice pieces of mahogany or other exotic woods.

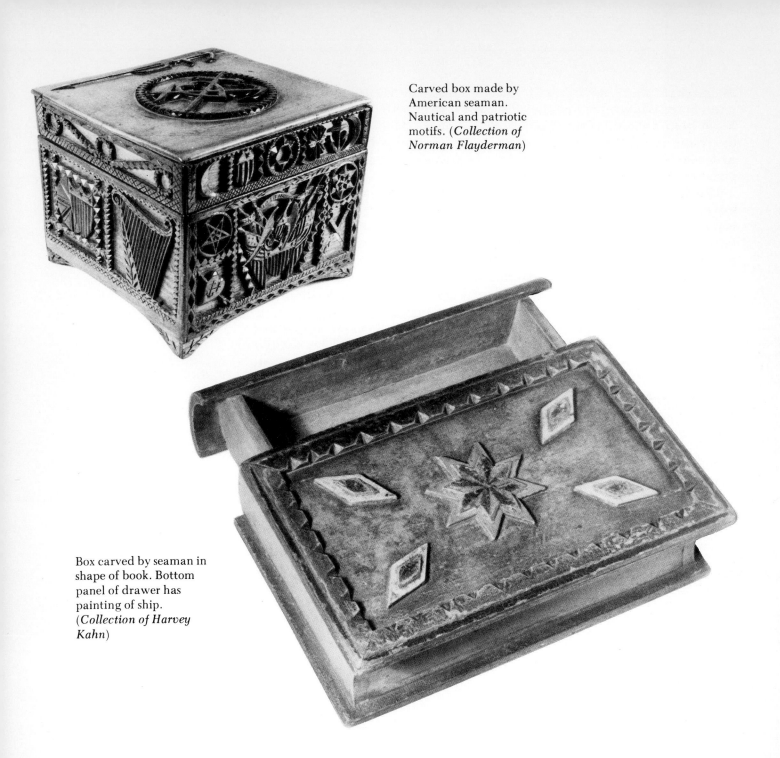

Carved box made by American seaman. Nautical and patriotic motifs. (*Collection of Norman Flayderman*)

Box carved by seaman in shape of book. Bottom panel of drawer has painting of ship. (*Collection of Harvey Kahn*)

Since the wood thus procured was valuable, the sailor usually made small objects such as boxes, cane heads, watch holders, or rolling pins where the wood was used in combination with pieces of whalebone or, less frequently, seashells. Wood was easier to use for making boxes, since the whale's skeleton contained few pieces flat enough to be utilized for this purpose. Decorations were usually carved into the surfaces of wood boxes. The motifs were nautical or patriotic. Ships, anchors, and rope designs were carved in conjunction with contemporary folk motifs, such as stars, hearts, birds, and stylized flower or foliage patterns.

Two interesting boxes made by sailors are illustrated in this chapter. One is a heavily incised box with rope, anchor, star, and other motifs. On

its front is an American eagle over a shield with crossed flags. This well-carved trinket box was made by a sailor with better than average skill in carving. The other box with definite connections to the sea is made in the shape of a book; the "cover" has painted diamond and star-shaped patterns. Not shown in the illustration is a painting of a ship on the bottom panel of the drawer.

Frequently, the whaling man used inlaid whalebone decoration on the surface of wood boxes and other objects. When this was done, the wood had to be carefully carved so that the ivory inlay fit the incised design perfectly. The whaling man who did this kind of work had to understand his materials perfectly to allow for variations in shrinkage, and it is probable that many of the wood-carved relics that remain from the whaling days in America were made by the coopers and ships' carpenters, who preferred working with a material with which they were most familiar.

An area of wood carving that is of interest to today's carvers but which can only be touched upon here is model shipbuilding. This dates back to the earliest days of sailing, and the most ancient models were made as votive offerings in the maritime countries of Europe and Asia. American seafarers have always made models of their ships and used whatever materials were at hand. Often the models were made in a combination of whalebone and wood. Ship models also have always appealed to carvers who lived along the seacoasts. In addition, ship designers made scale models of the ships that they hoped to build, and these are, perhaps, the most desirable of all models for collectors.

Building an authentically scaled ship model requires more than just the infinite patience of the wood-carver. Skill in rigging and making sails and

Ship model-carving and -building is specialized area of American wood carving which presently has a large following. (*Seamen's Bank for Savings*)

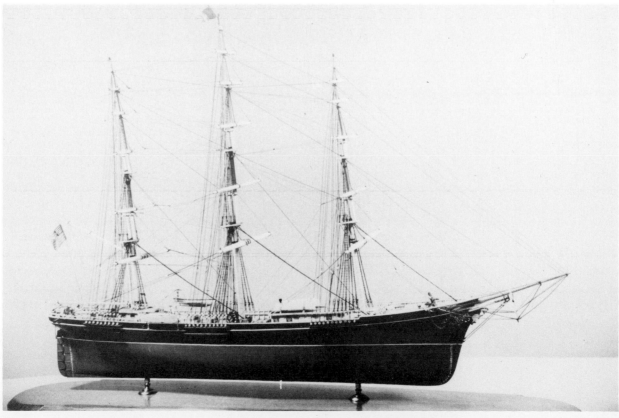

Architectural detail,
possibly window grille,
with nautical motifs

a knowledge of ship parts are required. Though this is an extremely specialized form of working with wood, it is a hobby that enjoys a rather large following today.

The history of America as a seafaring nation is bound up with the professional skills of the men who built the ships and those who carved the decorations that identified them. Of those carvings connected with ships and the sea that still exist, the work done by individual sailors and seacoast inhabitants is the true folk art. However, the wood-carvers who were carefully trained and skilled in turning out figureheads and other carvings were also active in making trade figures, circus carvings, and other forms of wooden objects. Ship-carvers were the single most important influence on American folk art in wood, and this influence lasted well into the twentieth century.

3 Patriotic Symbols and Parade Carvings

Throughout the nineteenth century, the American bald eagle was a popular subject for both professional and amateur wood-carvers. Eagles adorned ships, furniture, and the interior and exterior of buildings. The bird was used as a regal figure by itself or in combination with sunbursts, crossed flags, banners, shields, or ribbons. It was carved in relief, quarter- or half-round or full-bodied, depending upon where it was going to be used. Models for eagles could easily be found on coins of the nineteenth century. The eagle motif was usually adapted by the wood-carver from the great seal of the United States and was frequently used with the motto *E Pluribus Unum*.

Perhaps the most common use of the carved and gilded eagle was as decoration for stern pieces on boats and ships. Ships' pilothouses and United States Customs houses also used carved eagles over doors as decoration. Commercial wood-carvers, who had a large trade in eagles, kept many on hand in different sizes and poses for this purpose. The magnificent carved and gilded eagle with the large snake in its talons is said to have come from the Boston Customs House. It is truly a superb carving and illustrates the artist's ability to achieve fluid lines and detailed patterns. There is strength portrayed in the two adversaries, the eagle and the snake. The carving is attributed to the Skillin brothers.

As architectural and furniture detail, carved eagles were used over mantels, as pediments on furniture, and on mirror and picture frames. The eagle was portrayed as a fierce and warlike bird throughout the nineteenth century, and where the great seal was used as a model, its head is turned in the direction of the arrows held in one talon rather than toward the olive branches in the other. It wasn't until the administration of President Harry Truman that the eagle was standardized to turn permanently toward the olive branches that symbolize peace.

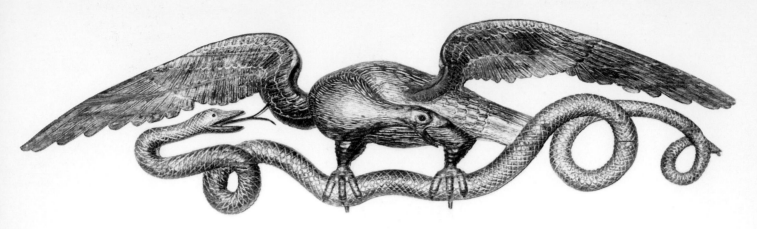

Magnificently carved eagle
and snake, gilded.
Attributed to Skillin
brothers. Possibly from
Boston Customs House.
(*Collection of Dr. William
S. Greenspon*)

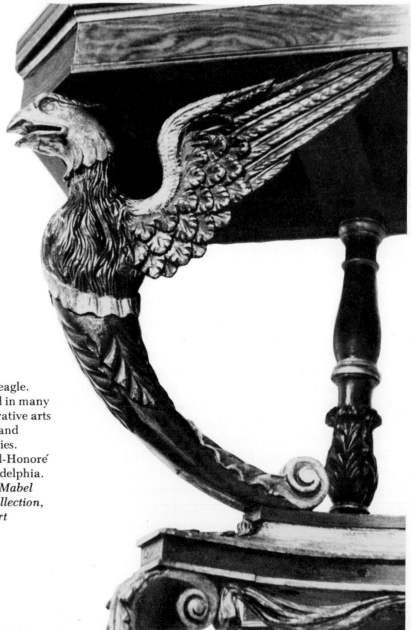

Furniture detail, eagle.
The bird was used in many
forms of the decorative arts
in the eighteenth and
nineteenth centuries.
Attributed to Paul-Honoré
Launnier of Philadelphia.
Circa 1810. (*The Mabel
Brady Garvan Collection,
Yale University Art
Gallery*)

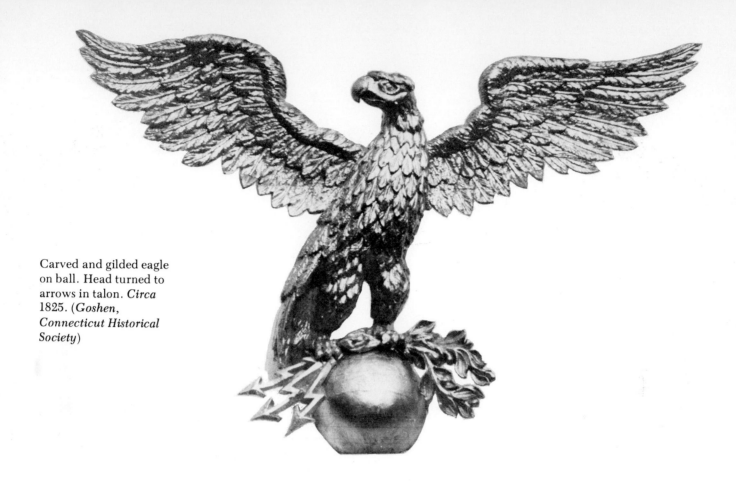

Carved and gilded eagle on ball. Head turned to arrows in talon. *Circa* 1825. (*Goshen, Connecticut Historical Society*)

Depending upon the carver's whim and skill, the feathers of the eagle were either suggested by simple incised lines or were fully carved in a most realistic manner. Eagle carvings were usually gilded and painted with the additional devices, such as the shield, banner, or ribbon, painted in red, white, and blue. The eagle illustrated on the opposite page holds only arrows joined by a shield and a flag with twenty-five stars flying above him.

Wilhelm Schimmel, the itinerant Pennsylvania carver who is discussed in another chapter, carved eagles to trade for whiskey in taverns in the vicinity of Carlisle, Pennsylvania. Schimmel eagles are highly prized by collectors. The eagles were his largest pieces, and some of them measured 3 feet from wing tip to wing tip. The feathering on the body of Schimmel eagles was indicated by a diamond-shaped pattern that is not seen in his other birds. The beaks on his eagles are far from accurate—in fact, his eagles are frequently compared to parrots.

A New England carver noted especially for the great variety of his eagles was John Bellamy of Kittery, Maine. As already noted, Bellamy was primarily a ship-carver, but as the demand for this work declined in the latter half of the nineteenth century, he turned to making decorative eagles. Carved as wall plaques with unfinished flat backs, Bellamy's eagles have fully spread wings, with the head projecting forward and turned most typically to the left. Two Bellamy eagles illustrated here are almost identical except that one has an additional ribbon above it with the painted motto "Don't Give Up The Ship."

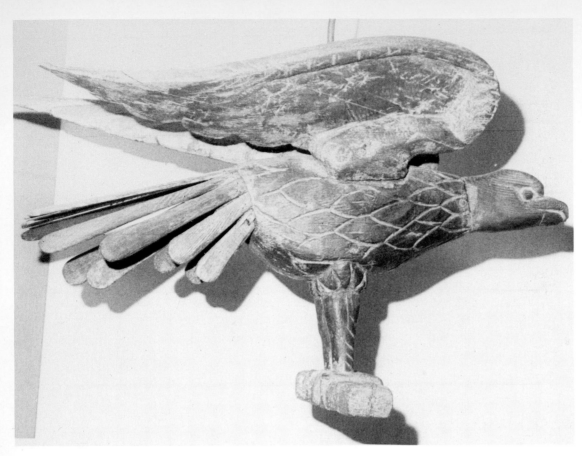

Folk carving of eagle with unusual treatment of tail feathers (*Collection of Harvey Kahn*)

Eagle with flag, shield, and arrows, gilded and painted. Length: 36 inches. (*Old Sturbridge Village*)

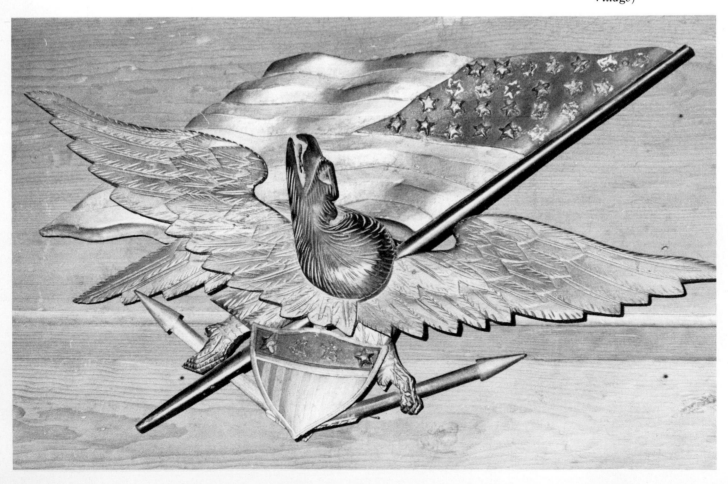

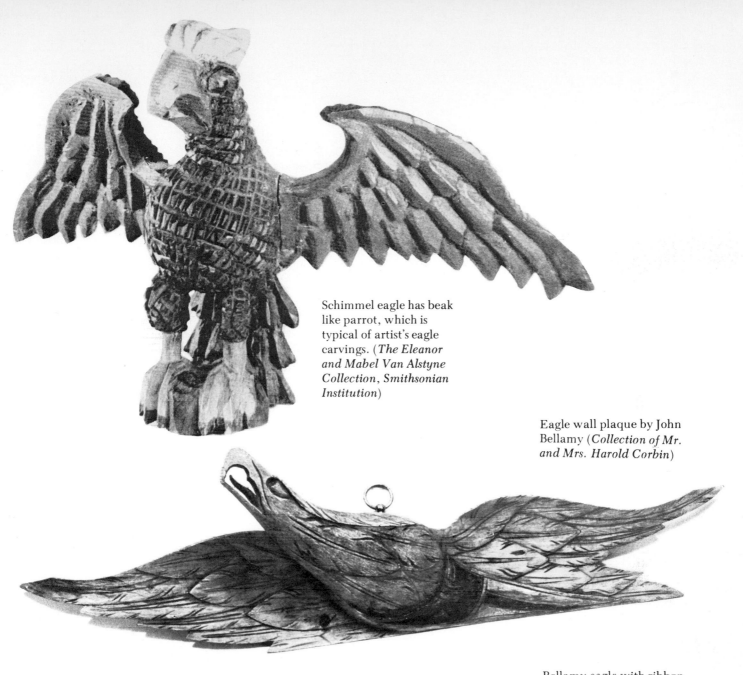

Schimmel eagle has beak like parrot, which is typical of artist's eagle carvings. (*The Eleanor and Mabel Van Alstyne Collection, Smithsonian Institution*)

Eagle wall plaque by John Bellamy (*Collection of Mr. and Mrs. Harold Corbin*)

Bellamy eagle with ribbon and painted motto "Don't Give Up The Ship." Length: 24½ inches. (*George Schoellkopf Gallery*)

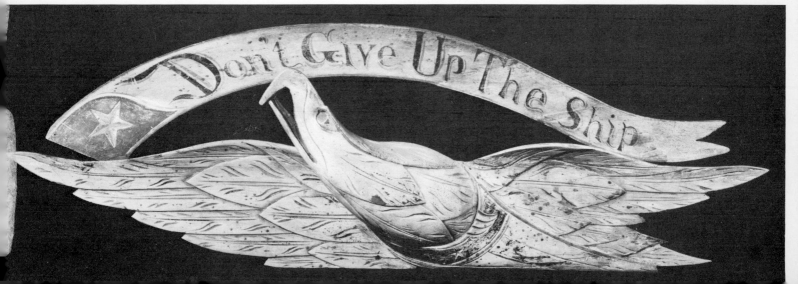

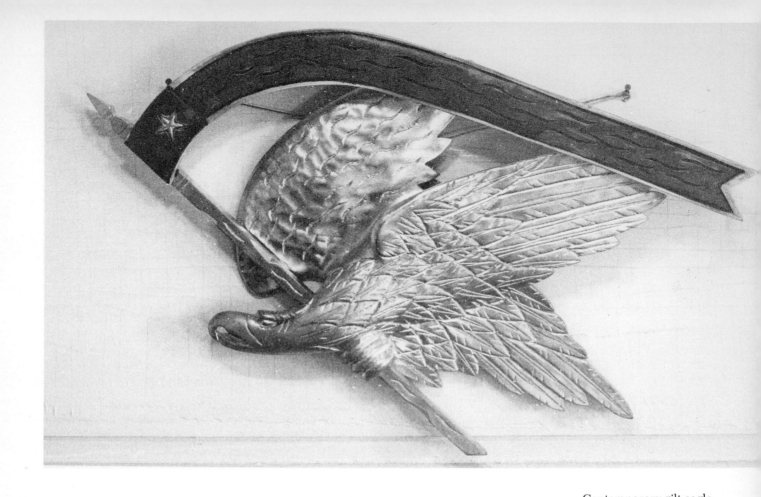

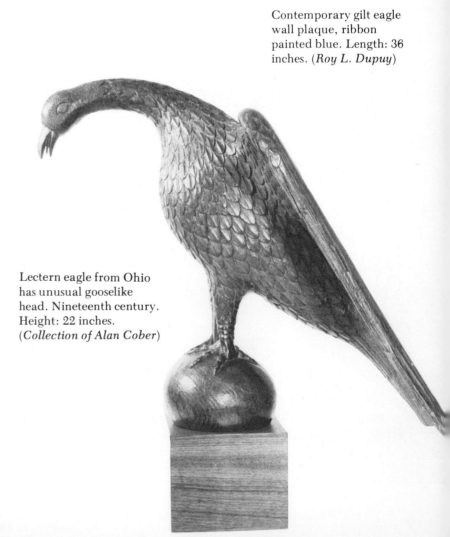

Contemporary gilt eagle
wall plaque, ribbon
painted blue. Length: 36
inches. (*Roy L. Dupuy*)

Carved head of eagle
(*Shelburne Museum*)

Lectern eagle from Ohio
has unusual gooselike
head. Nineteenth century.
Height: 22 inches.
(*Collection of Alan Cober*)

Bellamy's eagles were generally not more than 3 feet wide and were either painted off-white or were gilded. Patriotic symbols, such as flags, shields, or a pennant with a motto, were usually incorporated into the design and painted in red, white, and blue.

Although the American bald eagle has become an endangered species in our time, he is very much alive in the numerous eagle carvings that have survived. Modern wood-carvers, such as Henry Winter of Long Island, New York, still find the eagle an exciting subject. Winter's full-figure stylized eagle, illustrated here, although unmistakably modern in feeling, has some of the vigor of the early folk carvings.

Although the eagle is the most common patriotic symbol in American wood carving, many other patriotic subjects were frequently used by nineteenth-century carvers. The liberty cap was a parade and street decoration during General Lafayette's famous tour of the United States in 1824-1825. Carved and polychromed caps were placed on poles and carried in the parades held in every city and many towns of the twenty-four states that were host to the aged Revolutionary War general. A particularly fine example of a liberty cap is shown here. In the illustration, one can see the hole at the bottom of the carving where a pole was inserted so that the red, white, blue, and gold cap could be held high.

Other patriotic symbols have inspired American wood-carvers for 200 years. The figure of the Goddess of Liberty has been carved in a variety of

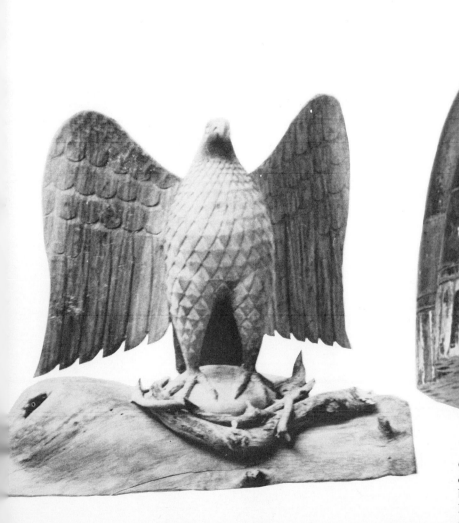

Liberty cap, carved wood polychromed in red, white, blue, and gold. Hole in bottom was used to insert pole for parade use. Probably made in 1824-1825 for reception for General Lafayette. Height: 10 inches. (*Collection of Norman Flayderman*)

Contemporary carving of eagle on driftwood base is by Henry Winter of Long Island, New York. (*Joseph and Ellen Wetherell*)

25

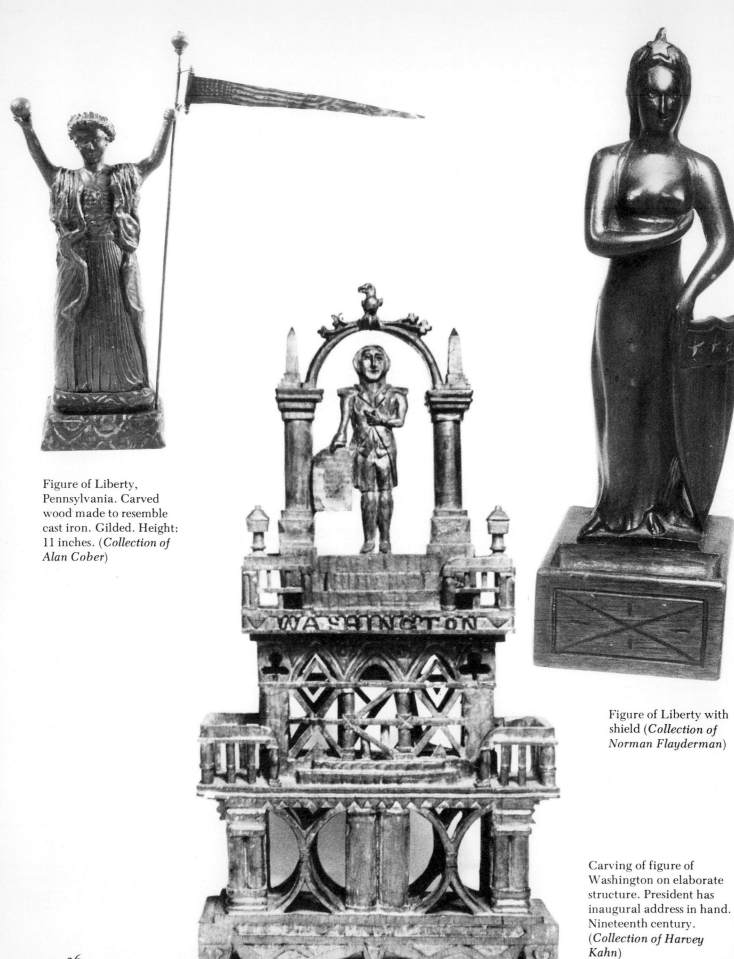

Figure of Liberty, Pennsylvania. Carved wood made to resemble cast iron. Gilded. Height: 11 inches. (*Collection of Alan Cober*)

Figure of Liberty with shield (*Collection of Norman Flayderman*)

Carving of figure of Washington on elaborate structure. President has inaugural address in hand. Nineteenth century. (*Collection of Harvey Kahn*)

26

woods, styles, and poses throughout two centuries. Flags and shields can also be found, although not as often as the eagle.

Portraits of American patriots have also been carved from wood. Busts and full-figures of early patriots and presidents appeared as figureheads on nineteenth-century ships. Frequently, the portraits were carved in relief as wall plaques. One especially fine example of a portrait of George Washington that is attributed to the carver Samuel McIntire of Salem, Massachusetts, is discussed and illustrated in Chapter 1. Another carving of Washington shows him with his inaugural address in hand.

Abraham Lincoln has been the subject of many wood carvings, and anniversaries of his birth, presidency, and death have inspired carvers to create their own impressions of his likeness, with varying degrees of success. When one compares the bust carved by Melchior Klaus Peterson in 1906 with the folk carving of a replica of the Lincoln Memorial done by an unknown artist around 1922, it must be said that the latter, though primitive and executed by someone of obviously lesser talents than Peterson, is a stronger portrait.

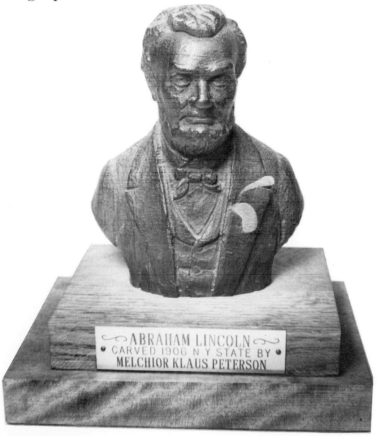

Carved bust of Abraham Lincoln by Melchior Klaus Peterson (*Collection of Norman Flayderman*)

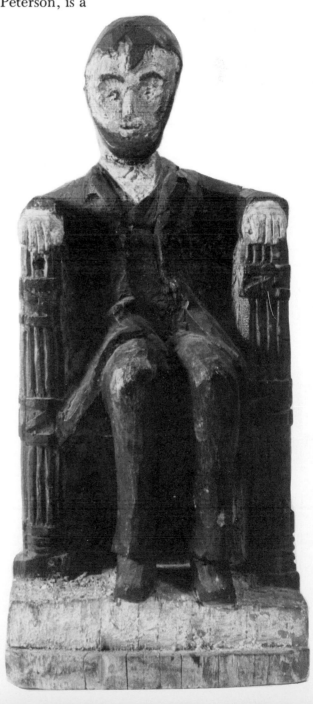

Carving of Lincoln Memorial. Chair painted red; figure black, flesh color, and white. Height: 13½ inches. (*Private Collection*)

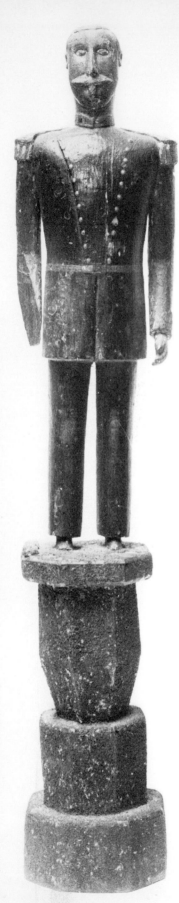

Historical figures and patriotic symbols and devices are still favorite subjects of the American wood-carver. Portraits of Lincoln, Franklin, Washington, and Jefferson are now copied from earlier works or adapted from paintings and prints, but each carver brings to his work his personal interpretation of what these men actually looked like.

One especially interesting and curious form of wood carving that should be more familiar to collectors and Americana are the parade axes that were used in the late nineteenth and early twentieth centuries by fraternal and benevolent societies to identify individual lodges and orders. These axes, about 4 feet in length, were hand-carved in a variety of styles and painted with symbols and lettering. Probably one of the reasons they came into use is that they were easier to read than flags and were convenient to carry.

The parade axes are simple in form, although a great variety of shapes exists, ranging from medieval battle-axes to simple hatchets. The axes are painted with the names and chapters of the various groups for which they were made, with Masonic symbols appearing on many of them. A bonus for the collector is that many of the axes are easy to identify as to place of origin. The name of the town from which an ax came is often part of the painted decoration. These oversize symbolic axes with their brightly

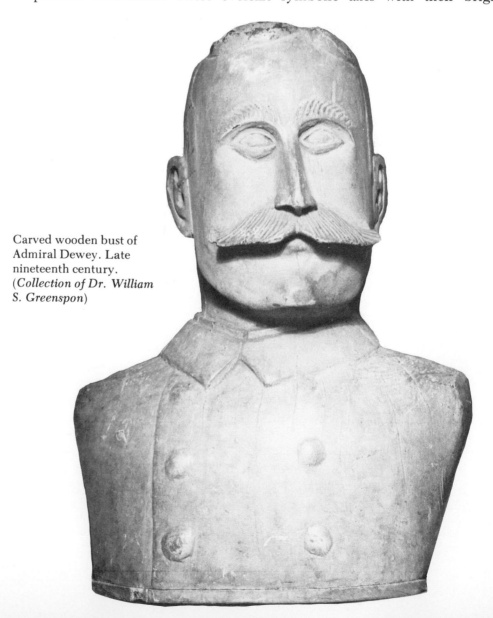

Carved wooden bust of Admiral Dewey. Late nineteenth century. (*Collection of Dr. William S. Greenspon*)

Carving of figure of Admiral Dewey in uniform. Late nineteenth century. (*Collection of Harvey Kahn*)

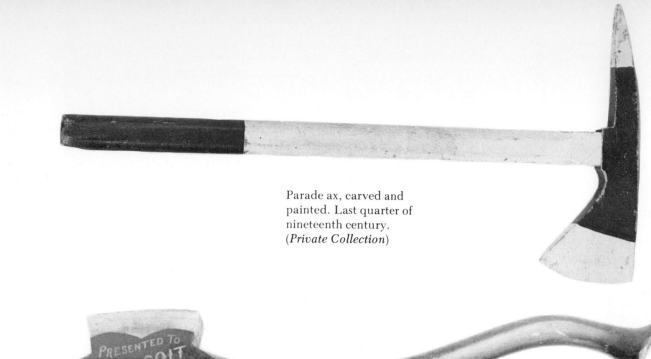

Parade ax, carved and
painted. Last quarter of
nineteenth century.
(*Private Collection*)

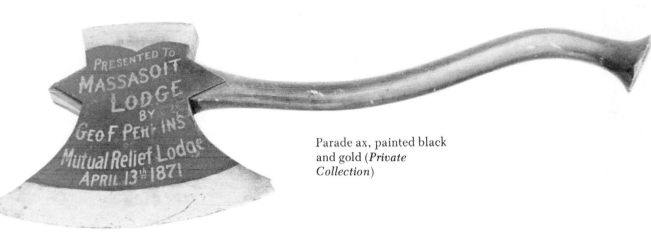

Parade ax, painted black
and gold (*Private
Collection*)

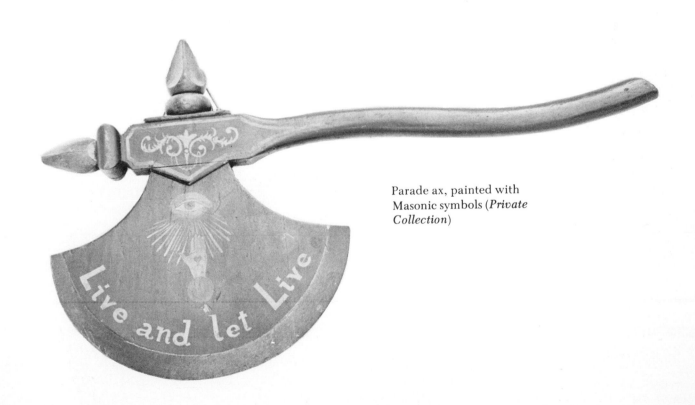

Parade ax, painted with
Masonic symbols (*Private
Collection*)

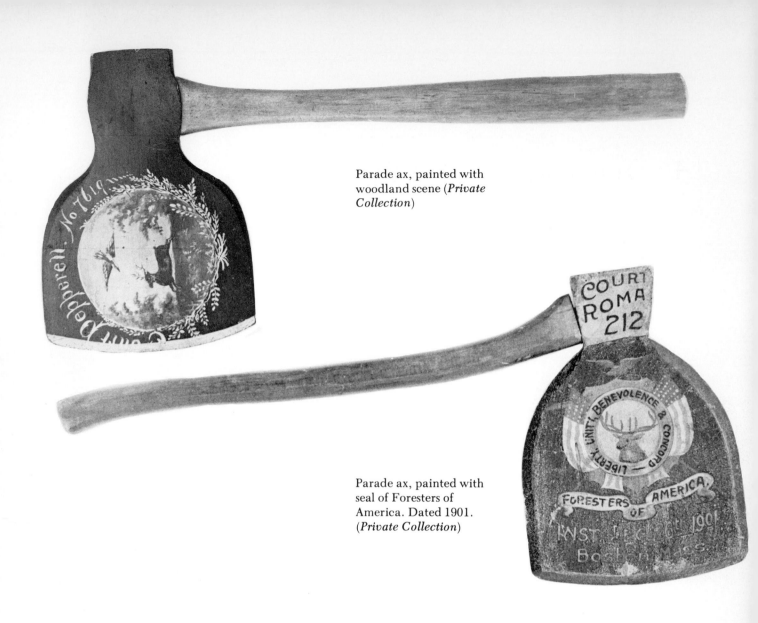

Parade ax, painted with woodland scene (*Private Collection*)

Parade ax, painted with seal of Foresters of America. Dated 1901. (*Private Collection*)

painted decorations must have added color and excitement to holiday parades.

Some of the axes appear to be presentation pieces from the maker to an organization of which he was a member. One such ax has the legend "Presented to Massasoit Lodge by Geo F Perkins Mutual Relief Lodge April 13th 1871." The fact that some of the axes are dated adds much to their value as collectors' items. One especially fine parade ax, which from its painted symbols can be identified as representing a Masonic lodge, has the motto "Live and Let Live." Another has a Victorian painting of a woodland scene with a running deer and a bird.

These parade axes are part of nineteenth-century Americana that has been overlooked by those interested in the history of fraternal organizations and wood carving and decoration as an American folk art. The great diversity of shapes and decoration is of interest and they represent a colorful segment of our history.

4 Trade Signs and Shop Figures

The use of symbols to represent or identify a place of commerce is a very old custom. For centuries the type of business of English and European shops and the names of taverns and inns were made known by a sign or figure. A traveler seeking an inn of good reputation would recognize the establishment by the shingle with three roosters painted or carved on it swinging over the door. If that was the place which had been described to him, he would not confuse it with another nearby hostel displaying a mounted warrior on its sign.

Shops engaged in various trades resorted to carved signs or figures that were indicative of their business. It is recorded that figures of American Indians were used by tobacco shops in England in the early seventeenth century, because tobacco was associated with the New World and with the red man who cultivated and introduced it to sixteenth-century British explorers and adventurers. So it would seem that the most widely used and recognized American trade figure, the cigar store Indian, actually had its origin on the other side of the Atlantic.

American colonists brought with them the tradition of making wooden trade signs and shop figures, and the few that have been preserved have long since found their way to museums or distinguished private collections. However, nineteenth-century tobacconists' figures, especially Indians, were once so numerous and widely distributed that many still survive. Though there was no real appreciation of their artistic merit when they were made (many were carelessly destroyed or left to decay in damp cellars and dusty storerooms), we are fortunate that a few enthusiasts as long as fifty years ago cared enough to gather and preserve a large number of these valuable artifacts in their private collections. These collections have been largely dispersed by auctions of the estates of the original collectors, and the individual pieces are now in museums or in the possession of other individuals.

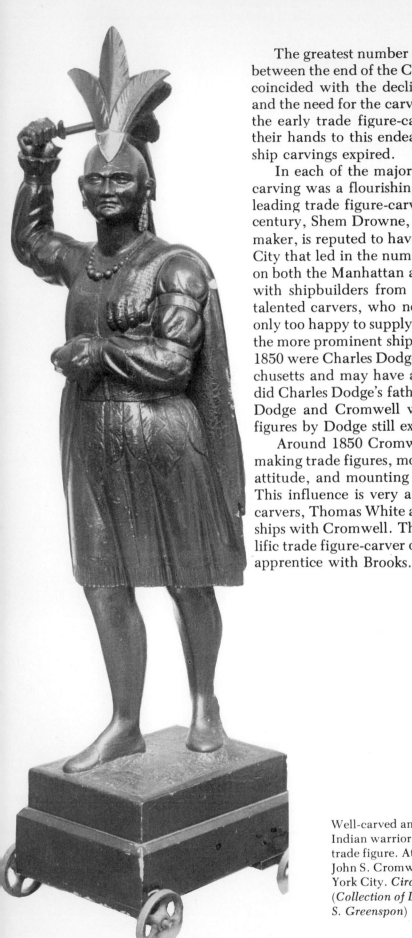

The greatest number of American trade figures was made in the period between the end of the Civil War and the turn of the century. The activity coincided with the decline in the construction of wooden sailing vessels and the need for the carvings with which they were decorated. Therefore, the early trade figure-carvers were craftsmen who were forced to turn their hands to this endeavor when the market for figureheads and other ship carvings expired.

In each of the major shipbuilding centers along the East Coast, ship carving was a flourishing business, and it was in these seaports that the leading trade figure-carvers were found. As early as the mid-eighteenth century, Shem Drowne, the famous Boston ship-carver and weather vane maker, is reputed to have carved some trade figures. But it was New York City that led in the number of great trade figure-carvers. The waterfront on both the Manhattan and Brooklyn sides of the East River was crowded with shipbuilders from the early 1800s until after the Civil War. The talented carvers, who no longer could find work decorating ships, were only too happy to supply carved figures for New York's merchants. Among the more prominent ship-carvers who began to make trade figures around 1850 were Charles Dodge and John Cromwell. Cromwell was from Massachusetts and may have apprenticed with the Skillin family of Boston, as did Charles Dodge's father before both families moved to New York. Both Dodge and Cromwell were gifted carvers, but very few authenticated figures by Dodge still exist.

Around 1850 Cromwell turned a large part of his busy shop over to making trade figures, mostly Indians, and the styles he developed in dress, attitude, and mounting influenced the succeeding generation of carvers. This influence is very apparent since two other important trade figure-carvers, Thomas White and Thomas Brooks, both served their apprenticeships with Cromwell. This tradition was carried forward by the most prolific trade figure-carver of all, Samuel A. Robb, who began his career as an apprentice with Brooks.

Well-carved and vigorous Indian warrior cigar store trade figure. Attributed to John S. Cromwell, New York City. *Circa* 1850. (*Collection of Dr. William S. Greenspon*)

Robb spent five years with Brooks, and in 1869 went to work as a carver for William Demuth, who also made trade figures. During this period with Demuth, Robb was encouraged to study drawing for several years at some of the best art schools in the city. This classical training in drawing from life and from casts no doubt contributed to his ability to expand his subject matter beyond the ordinary cigar store Indian.

In 1876, Robb opened his first shop on Canal Street in New York, and from that time until about 1910 his output was unique in terms of quality, variety, and sheer quantity. Aside from producing hundreds of Indian warriors and squaws in a wide assortment of sizes and styles, he made Turkish sultans, baseball players, soldiers, and animals. No type of wood carving was untried by him. He did ship carvings for steamboats and private yachts, religious figures for churches, trade signs for dentists, chiropodists, saloons, and livery stables. He even carved prosthetic devices for people who had lost a hand or leg. He also carved an oversized "Inexhaustable Cow" from which milk was dispensed and sold at Coney Island.

Among Robb's greatest achievements were the carvings he executed for the circus wagons of the Barnum and Bailey Circus. In 1902, James Bailey contracted with the Sebastian Wagon Company of New York for a group of thirteen new circus chariots, bandwagons, and tableaux cars. Each of the wagons would be ornamented with the most elaborate scroll work and the most ambitious assortment of carved figures that had ever been seen in this country. Sebastian subcontracted the wood carving to Robb and allowed him to use a portion of his wagon factory on East Forty-third Street. The job was finished in early 1903, after Robb and the best carvers he could hire had worked frantically to complete the largest circus wagon order ever undertaken.

Around 1910, Robb's business in making and refurbishing trade and show figures had dwindled to the point where he no longer maintained a shop, though he continued to do smaller carvings that he could handle out of his home. This work consisted of carved lettering for signs, trade signs, wooden casting molds, ventriloquists' dummies, and eagles. The decline in Robb's fortunes coincided with the advent of electric signs and the enactment of city ordinances restricting the use of trade figures on sidewalks. Robb continued to subsist on whatever odd jobs came his way until about 1925, when he became bedridden much of the time until his death in 1928. It is ironic that less than fifty years after Robb died a poor man, any piece of his work is among the most highly valued items in American folk carving.

The late-nineteenth-century wood-carvers who worked along the Atlantic coast seem to have been influenced by the Yankee ship-carvers. In the Middle West, especially in Detroit, carvers trained in the European tradition appear to have been the most successful. Around 1850, Detroit was the center of a large population of German immigrants who had left their homeland after the repression of the Revolution of 1848.

In 1852, a twenty-three-year-old Prussian-born artist named Julius Theodore Melchers arrived in Detroit, having fled Germany three years before. In the intervening years, Melchers had spent time studying art in Paris, and in 1851 moved to England where he found employment in connection with the Crystal Palace Exhibition. After that project was finished, he came to the United States, worked in New York for a time, and then

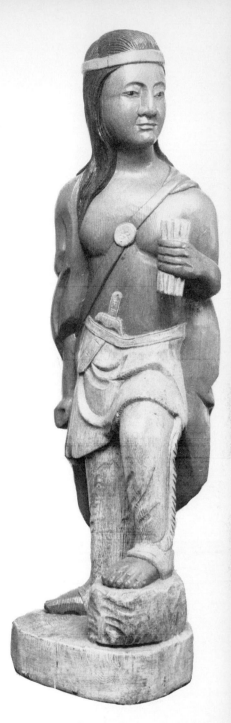

Tobacco store figure of Indian brave attributed to John S. Cromwell. *Circa* 1850. Height: 60 inches. (*Collection of C. Dinsmore Tuttle*)

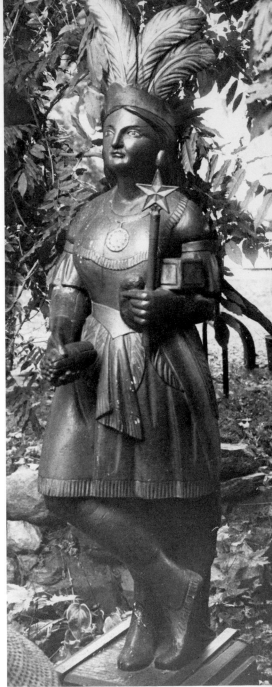

Cigar store trade figure of
Indian princess holding
baton with star and cigars
in other hand

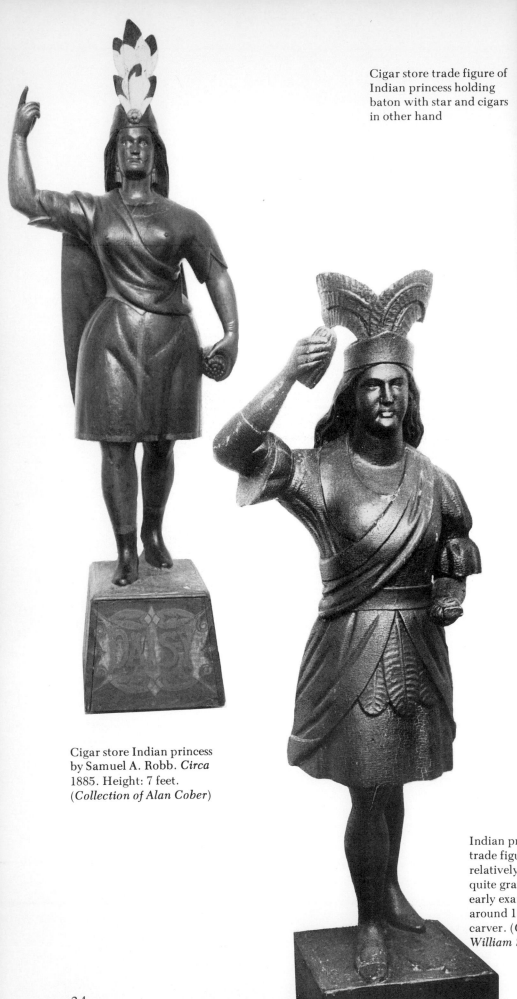

Cigar store Indian princess
by Samuel A. Robb. *Circa*
1885. Height: 7 feet.
(*Collection of Alan Cober*)

Indian princess cigar store
trade figure, which is
relatively unadorned but
quite graceful. This is an
early example, made
around 1845 by unknown
carver. (*Collection of Dr.
William S. Greenspon*)

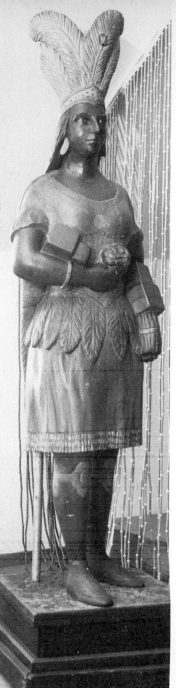

Indian princess, cigar store trade figure, found in Idaho. *Circa* 1880. Height with base: 84 inches. (*Mahopac Country Museum*)

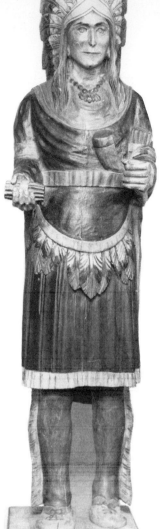

Finely carved tobacco store figure of Indian chief by unknown maker. Carver added stability by not carving out wood between the legs. *Circa* 1880. Height with base: 71 inches. (*Collection of C. Dinsmore Tuttle*)

Cigar store Indian princess trade figure. Height: 44 inches. (*James Kronen Gallery*)

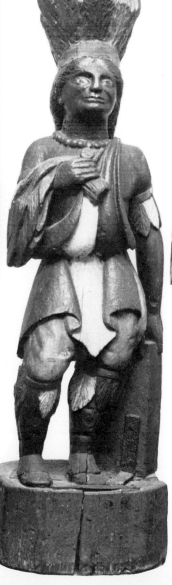

Tobacco store Indian. Figures requiring additional support were called "leaners." Late nineteenth century. Height: 44½ inches. (*Collection of C. Dinsmore Tuttle*)

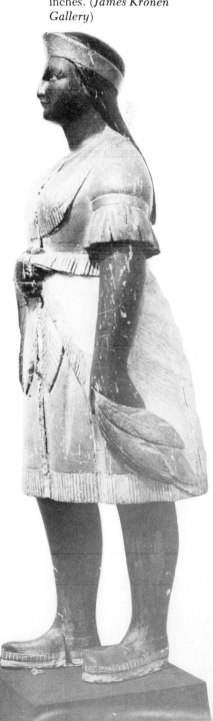

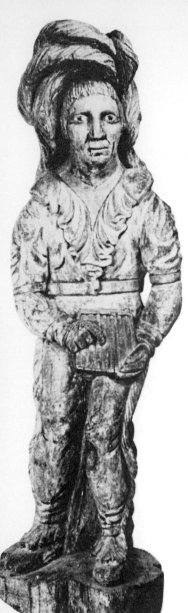

moved to Detroit, attracted by the community of his fellow German expatriates.

Melchers produced every type of modeling and sculpture, including eight monumental sandstone figures for the Detroit City Hall executed between 1870 and 1884. For more than fifty years, he was considered to be Detroit's foremost artist, and in addition to operating his business he conducted classes in drawing and carving. He also took in a number of apprentices and put them through a rigorous four-year training program.

Whatever Melchers' artistic achievements, he is best known today for his tobacco shop trade figures of the Great Plains Indians. These figures are carved in meticulous detail. The handling of a garment's drape and the unstilted stances reflect a thorough knowledge of classical sculpture. The few remaining documented examples of Melchers' trade figures are among the finest ever made and are now among the most treasured holdings of American folk art museums and private collections.

The carvers so far mentioned are perhaps the best known and most widely appreciated, but there have been dozens of other fine carvers about

Cigar store trade figure of Indian. Height: 75¼ inches. (*The Eleanor and Mabel Van Alstyne Collection, Smithsonian Institution*)

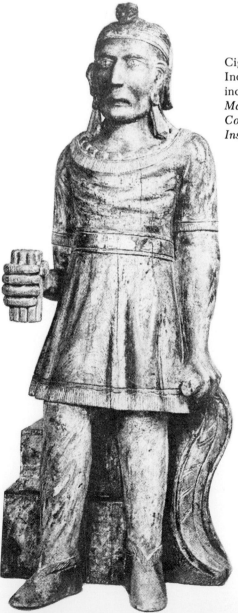

Cigar store trade figure of Indian. Last half of nineteenth century. Height with base: 35¼ inches. (*The Eleanor and Mabel Van Alstyne Collection, Smithsonian Institution*)

Indian, cigar store trade figure (*The Eleanor and Mabel Van Alstyne Collection, Smithsonian Institution*)

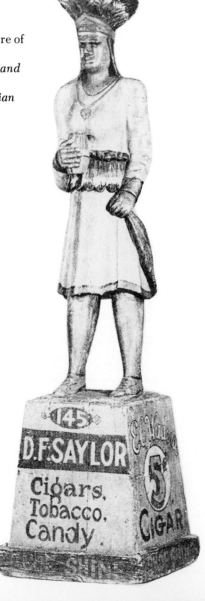

whom less is known or whose work defies identification. This is to be expected in an area in which so many figures were made of a similar theme and where almost any full-size figure required a high degree of technical competence. Today, dealers, collectors, and museum personnel are pleased to own any of these once-neglected relics, the bulk of which are just now reaching one hundred years of age.

Because more Indians were made than any other trade figure, they are still the most frequently found. For this reason many collectors prefer the more unusual figures. Acquiring a rare sultan or sulatna, a baseball player, historical personality, sailor, or black man is certainly a prudent investment. But none of these figures combines dignity and vigor with a sense of history as well as the great American cigar store Indian.

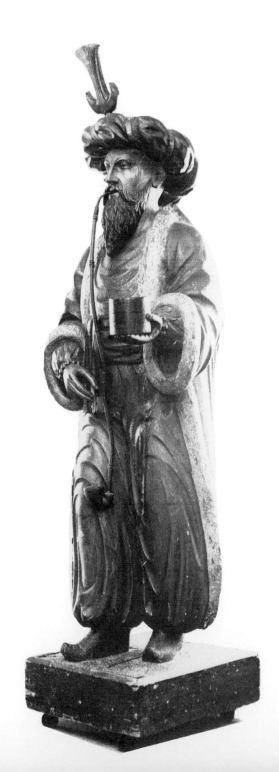

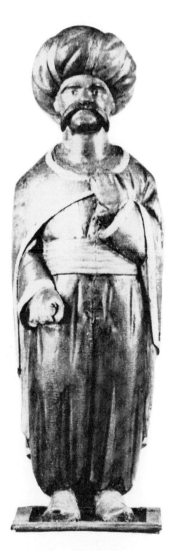

Cigar store figure of Turk. Last quarter of nineteenth century. Height with base: 56 inches. (*The Eleanor and Mabel Van Alstyne Collection, Smithsonian Institution*)

Cigar store Indian trade figure. Indian is pictured as lean and fierce warrior. Last half of nineteenth century. Height with base: 84¾ inches. (*The Eleanor and Mabel Van Alstyne Collection, Smithsonian Institution*)

Turkish sultan cigar store trade figure smoking pipe with improbably long stem. Attributed to William Demuth. *Circa* 1870. Height with base: 70 inches. (*Mahopac Country Museum*)

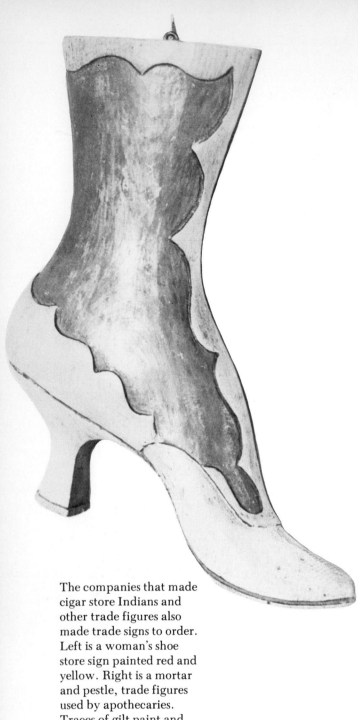

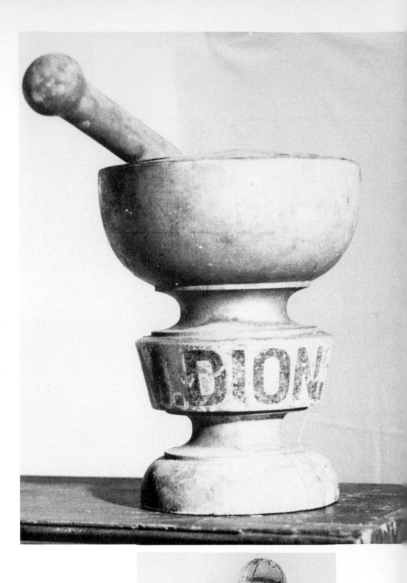

The companies that made cigar store Indians and other trade figures also made trade signs to order. Left is a woman's shoe store sign painted red and yellow. Right is a mortar and pestle, trade figures used by apothecaries. Traces of gilt paint and "Dr. E. M. Dionne" painted in black on mortar. (Left, *John and Jacqueline Sideli*; Right, *Wayne Pratt*)

Rare small baseball player trade figure. Right hand originally held baseball bat. *Circa* 1890. Height with base: 60 inches. (*Collection of Dr. William S. Greenspon*)

38

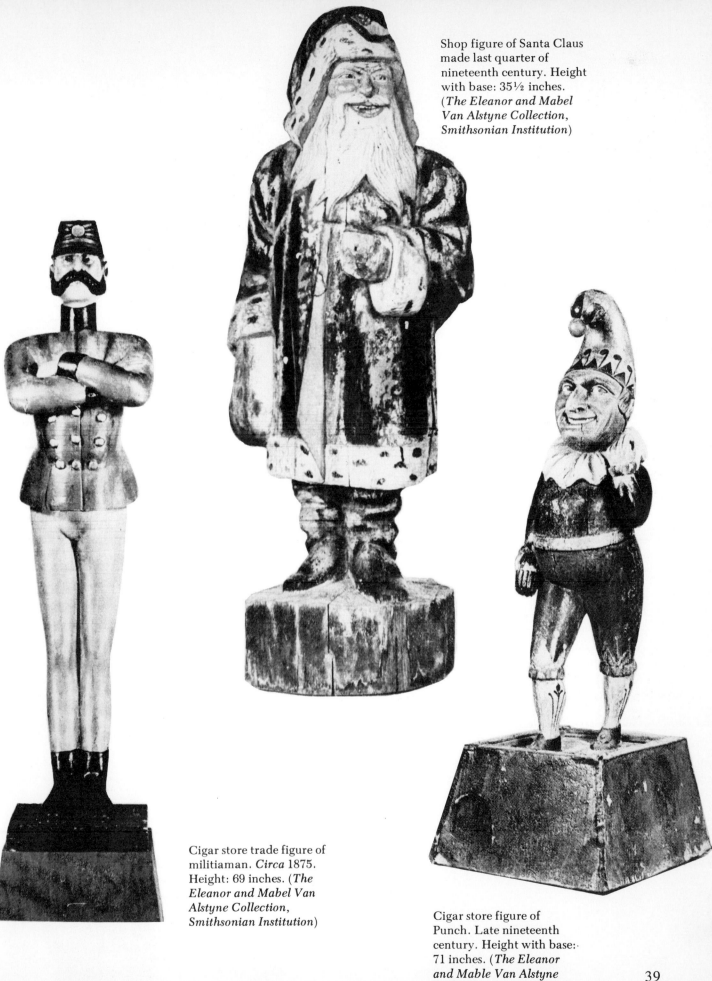

Shop figure of Santa Claus made last quarter of nineteenth century. Height with base: 35½ inches. (*The Eleanor and Mabel Van Alstyne Collection, Smithsonian Institution*)

Cigar store trade figure of militiaman. *Circa* 1875. Height: 69 inches. (*The Eleanor and Mabel Van Alstyne Collection, Smithsonian Institution*)

Cigar store figure of Punch. Late nineteenth century. Height with base: 71 inches. (*The Eleanor and Mable Van Alstyne Collection, Smithsonian Institution*)

39

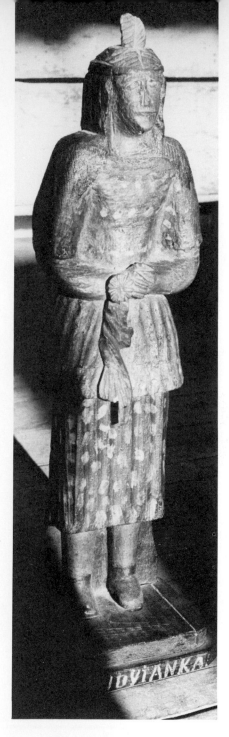

Trade figure used on
counters of cigar stores.
Man wearing liberty cap.
Nineteenth century.
Height: 22 inches.
(*Collection of Norman
Flayderman*)

Indian maiden countertop
trade figure with name
"Idyianka" painted on
base. Late nineteenth
century. Height: 22 inches.
(*Robert S. Walin*)

Carved and gilded
bootmaker's trade sign.
Nineteenth century.
(*Collection of Dr. William
S. Greenspon*)

Trade sign for palmist.
Late nineteenth century.
Height: 64 inches.
(*Lovelady Powell
Antiques*)

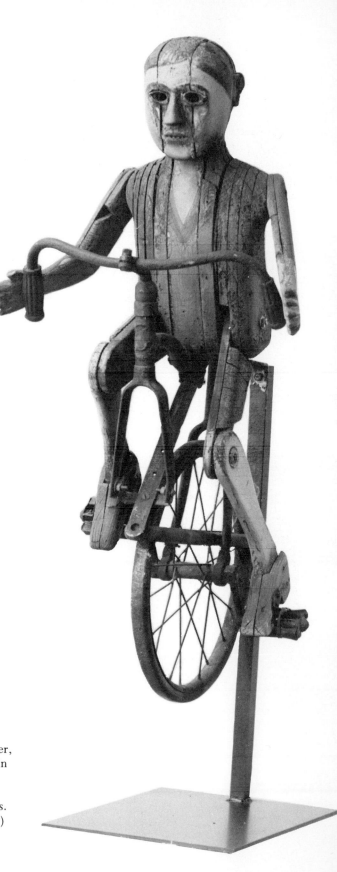

Trade sign, bicycle rider,
made for bicycle shop in
Greenpoint section of
Brooklyn, New York.
1922. Height: 40 inches.
(*James Kronen Gallery*)

41

5 Indian Carvings

The white carvers of Indian trade figures saw the American Indian as a noble and heroic figure. Most of those who worked in eastern seaports had never seen an Indian, and their figures were carved from imagination rather than life. It is possible that a few of the more conscientious carvers took the trouble to attend one of the traveling circuses which sometimes featured Indians as part of the show, or looked through the Catlin lithographs of Indians for realistic representations. Some may have seen drawings of Indians in magazines or books. For the most part, however, the images that the carvers used for models of their chiefs, braves, and Indian women were only figments of their own imaginations. Unfortunately, since a wooden Indian stood in front of almost every tobacco shop in the latter half of the nineteenth century, these romanticized Indians became for many Americans the accepted version of what an Indian really looked like.

Until rather recently, more attention has been paid to these commercial versions than to the relatively few extant examples of figures carved by the Indians themselves. Though most of the Indian-carved figures that can still be found are rather late, some of them were made at the same time as the popular trade figures. One has only to look at the few examples of Indian carvings illustrated here to see that the Indian's self-image is very different from the white carver's version of him. The cigar store Indian is a stereotype and his costume overromanticized and Victorian.

In contrast, the Indian's own version of himself, as seen in the carved dolls and figures of the latter half of the nineteenth century, gives us an entirely different image. The faces are strong and sad and the figures lean. The clothing, when it has survived intact, is certainly more typical than the brightly painted knee-length garments of the cigar store guardians. Whether made originally as playthings to be sold to tourists or simply as

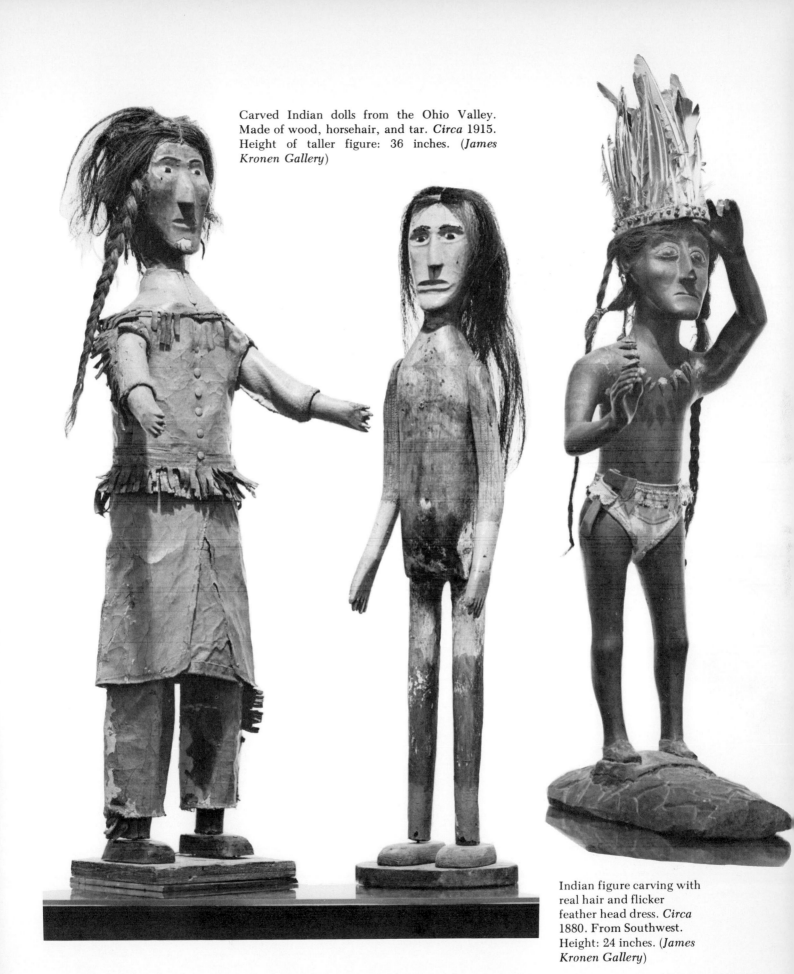

Carved Indian dolls from the Ohio Valley.
Made of wood, horsehair, and tar. *Circa* 1915.
Height of taller figure: 36 inches. (*James
Kronen Gallery*)

Indian figure carving with
real hair and flicker
feather head dress. *Circa*
1880. From Southwest.
Height: 24 inches. (*James
Kronen Gallery*)

43

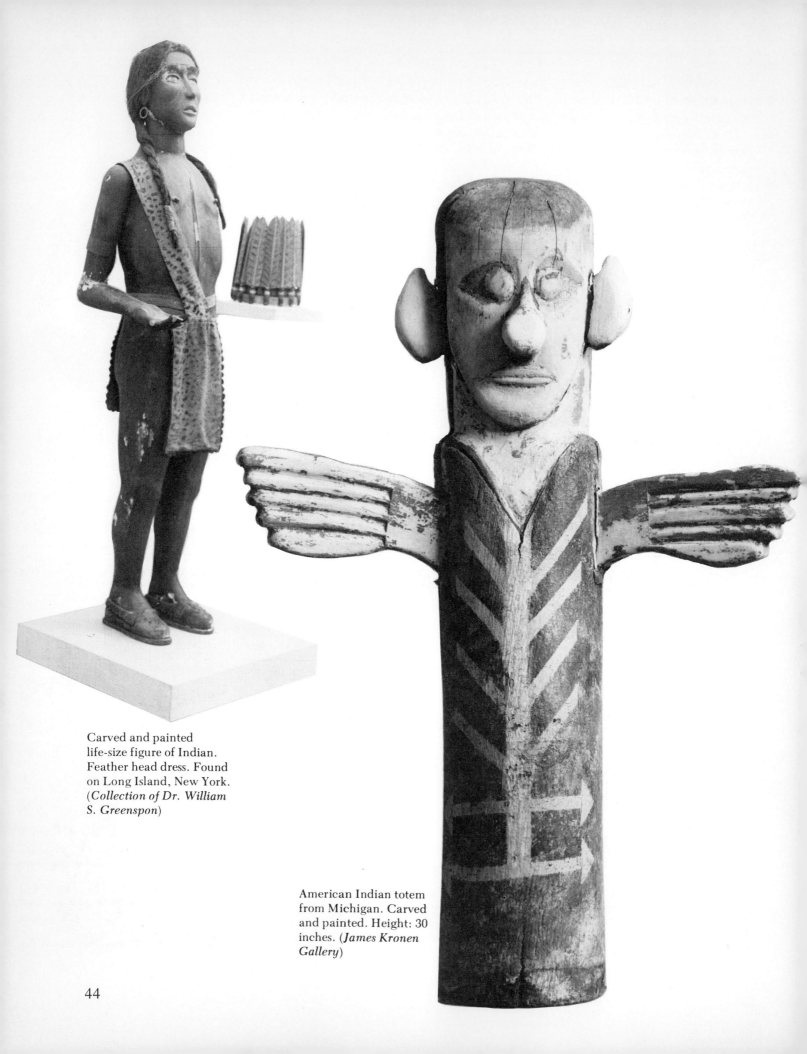

Carved and painted
life-size figure of Indian.
Feather head dress. Found
on Long Island, New York.
(*Collection of Dr. William
S. Greenspon*)

American Indian totem
from Michigan. Carved
and painted. Height: 30
inches. (*James Kronen
Gallery*)

self-expressive art, the Indian figures illustrated here can be categorized as true American folk sculpture. The faces are superbly carved and the addition of real hair gives them a truly human quality.

Although some attention has been given in recent years to the American Indian's skill in making basketry, pottery, and textiles, Indian wood carving, an art at which many Indians were obviously proficient, has been largely ignored. We know generally of the carved and painted totems, but very little of the origins of some of the figures and animals that were carved on them. Examples of some of these objects appear from time to

Iroquois Indian papoose board with unusual decoration of American flags, bears, birds, deer, and flowers (*Collection of Norman Flayderman*)

Iroquois Indian carved and painted papoose board. Flowers and foliage with birds. (*Collection of Norman Flayderman*)

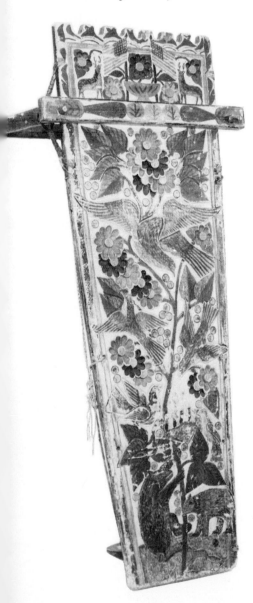

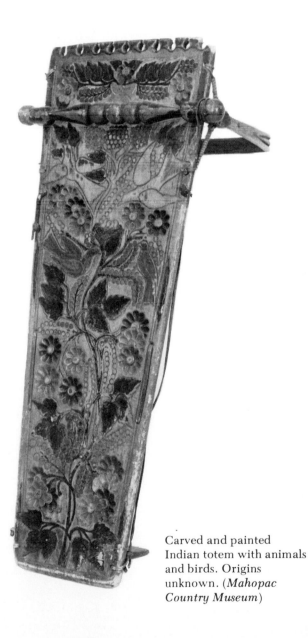

Carved and painted Indian totem with animals and birds. Origins unknown. (*Mahopac Country Museum*)

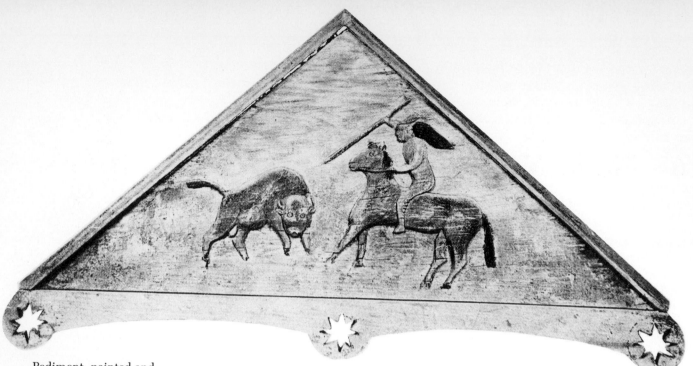

Pediment, painted and carved. Mounted Indian hunting buffalo. Late nineteenth century. Length: 38 inches. (*The Eleanor and Mabel Van Alstyne Collection, Smithsonian Institution*)

time in exhibits of American Indian crafts, but they are seldom included in general collections of American wood carving. Knowledgeable collectors have been quietly adding the scarce Indian wood carvings to their other choice pieces, and it can be predicted that Indian carvings will continue to increase enormously in value as more is learned about them.

Certainly, a carved Indian doll or a carved and painted papoose board has an important place in the total story of American folk art. The papoose board illustrated here is an example of the white man's influence of Indian art. The board, made by a member of the Iroquois tribe, is decorated with American flags and an eagle. These motifs are intertwined with the more typical designs of flowers and animals. The brightly painted carved board is a masterpiece of balance and humor.

6 Weather Vanes and Whirligigs

Weather vanes carved of wood are probably one of the oldest applications of the craft in this country. The vanes were necessary to our ancestors as one of the very few means at their disposal for predicting the turn of the weather. A vane could help determine when to plant or harvest a crop or when it was safe to embark on a sailing voyage.

Quite satisfactory vanes could be made from a simple board, and it is likely that the earliest wooden examples emphasized the practical rather than ornamental aspects of their construction. From the surviving examples it would appear that it was not until the late eighteenth or early nineteenth century that time was spent in fashioning any but the most rudimentary weather vanes.

When the carvers turned their attention to making more decorative vanes, they usually adapted such traditional motifs as roosters, arrows, pennants, or bannerets. Later, representations were made of familiar subjects close at hand or those associated with the geographical area in which the carver lived and worked. In the former category would be vanes representing horses, cattle, and other barnyard livestock; Indians, birds, and dogs. Along the eastern seacoast, the latter category is represented in fish vanes in shapes of local species and sailing vessels.

Because they were usually highly visible, weather vanes often served as effective trade signs. A vane carved in the shape of an anvil told where the local blacksmith was located, while other vanes representing a butcher's knife, boot, telescope, or mortar and pestle identified the premises of the local butcher, shoemaker, ship's chandler, or pharmacist. Since a large part of the population was illiterate, these trade sign weather vanes served two very practical purposes.

A particularly interesting group of carved wood weather vanes was done by imaginative carvers who produced ingenious religious or mythological themes. The angel Gabriel is the most frequently found religious

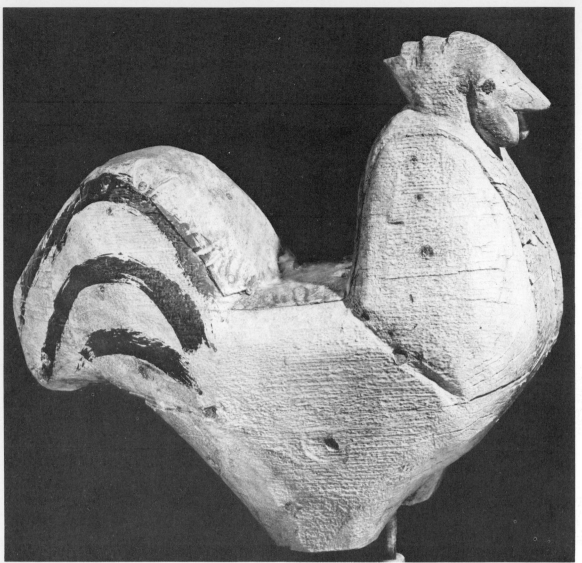

Rooster weather vane,
laminated body with
traces of paint. Nineteenth
century. Height: 16 inches.
(*George Schoellkopf
Gallery*)

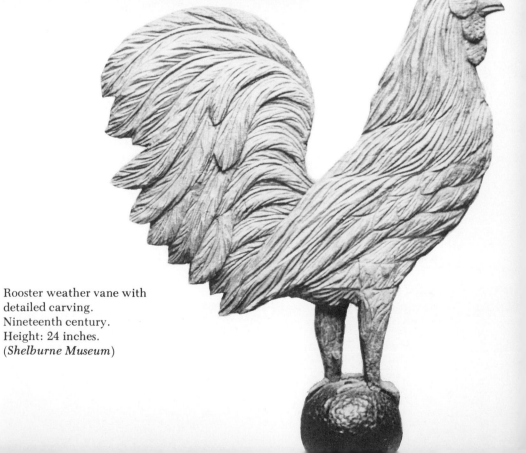

Rooster weather vane with
detailed carving.
Nineteenth century.
Height: 24 inches.
(*Shelburne Museum*)

48

Well-sculpted horse weather vane with traces of original paint. Nineteenth century. Length: 20 inches. (*Collection of Harvey Kahn*)

Horse weather vane carved as exact duplicate of popular late-nineteenth-century hollow-bodied copper manufactured model. Length: 32 inches. (*James Kronen Gallery, Luigi Pelletieri Photograph*)

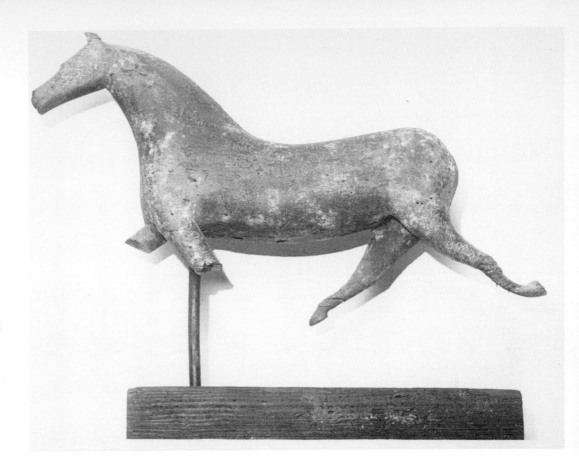

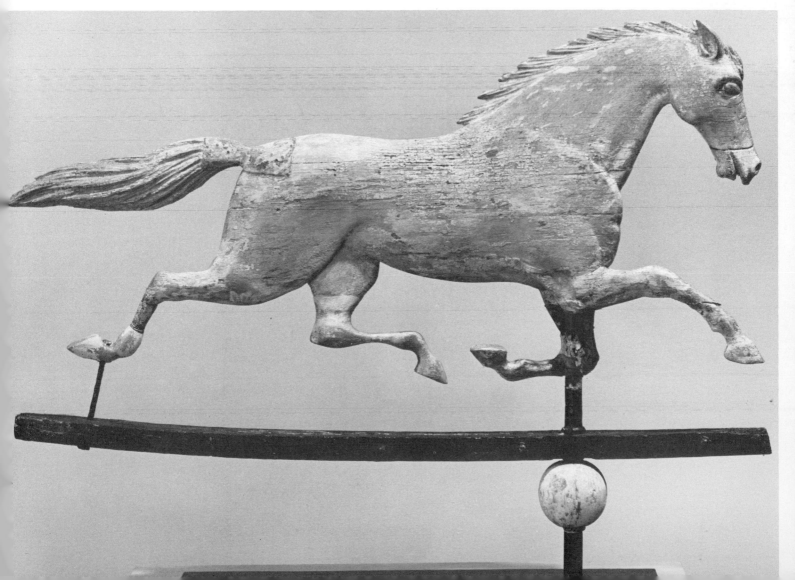

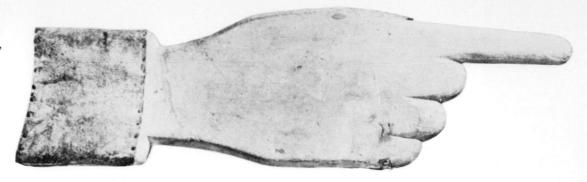

Wooden weather vane, painted. Nineteenth century. Length: 25¼ inches. (*George Schoellkopf Gallery*)

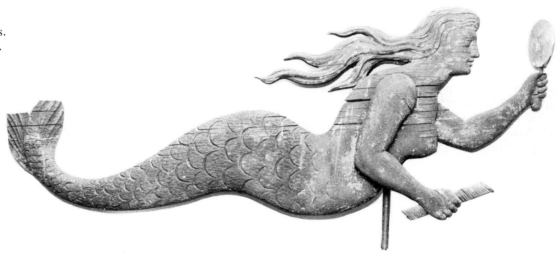

Mermaid, attributed to Warren Gould Rody of Wayland, Massachusetts. Mid-nineteenth century. Length: 52½ inches. (*Shelburne Museum*)

motif. The "hand of God" was another symbol used to lend a pious element to vanes of many types.

Since wood is far less durable than iron or copper, very few authentic early carved vanes are still in existence. Most of those that have survived are in museums, private collections, or in the possession of dealers who specialize in American folk art. One of the largest and most varied collections of early carved wood weather vanes is at the Shelburne Museum in Shelburne, Vermont.

The Shelburne collection contains examples of many of the subjects that were typical of the early carved vanes. On display are several wooden fish and sailing vessel vanes found along the New England seacoast, as well as angels, Indians, and realistically carved horses and roosters. Some vanes are carved with such great fidelity to detail that the delineation of each scale on a fish or the texture of a rooster's plumage is evident. Others are much more stylized, and although they could be considered rather crude, they do exhibit the originality, freedom, and naïveté of good American folk art.

Very few carved wood weather vanes can be attributed with any precision to individual craftsmen. Most were done as spare-time amusement for the carver and were meant for his personal use or as offhand gifts for friends. A rare exception to the anonymous weather-vane carver was

James Lombard, who was active in his native state of Maine in the latter half of the nineteenth century. Lombard specialized in hens and roosters cut or carved from pine planks; one of the marks of attribution is his elaborate treatment of the tail feathers. Although cut from a flat board, the figures were given character by the cutouts and the flowing arrangement of the tail. Simple wooden legs were attached to the figure of the fowl, and the whole body was usually painted yellow to simulate the gold leaf used on the factory-made copper vanes then coming into vogue.

Today, discovering a Lombard vane of unquestioned provenance outside a museum collection would be a rare occurrence. Occasionally, a properly documented example will come into the hands of a dealer who is known to handle the better and more esoteric items of American folk art. The only basis upon which the collector could entertain the purchase of such a rarity would be the integrity and reputation of the dealer, plus, perhaps, authentication by a recognized curator in American folk art.

An equally important weather-oriented item of American wood carving is the whirligig, or wind toy. A whirligig is made so that at least one of its parts is actuated by the wind. The most typical form is a figure whose arms are carved as an air foil and which rotate frantically in the breeze. Soldiers with painted uniforms were a common subject for early whirligigs and are the most frequently found today. It is sometimes possible to date individual whirligigs by reference to the military uniform on the figure. There are examples of Hessian costumes from the Revolutionary War, uniforms from the War of 1812, Civil War uniforms of both the North and the South, and Rough Riders' outfits from the Spanish-American War.

More imaginative carvers applied the principle of wind-activated parts to construct more complicated or sophisticated whirligigs. Employing a propellor or pinwheel, whirligig-makers have been able to

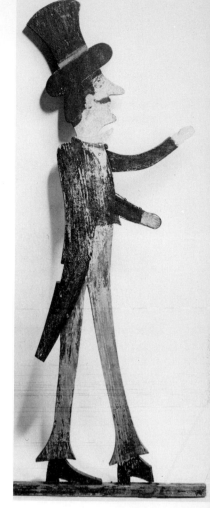

Weather vane of a circus ringmaster. Painted wood. Late nineteenth century. Height: 48 inches. (*George Schoellkopf Gallery*)

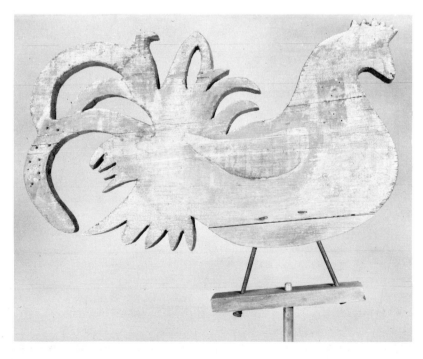

Rooster attributed to James Lombard of Maine. Second half of nineteenth century. Length: 20 inches. (*Shelburne Museum*)

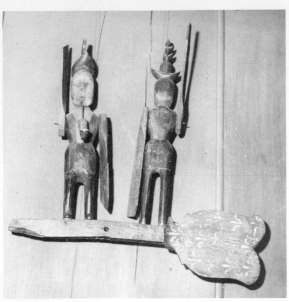

Weather vane with two whirligig figures representing Spanish Conquistadors. Found in Florida. Mid-nineteenth century. Height: 18 inches. (*Collection of Harvey Kahn*)

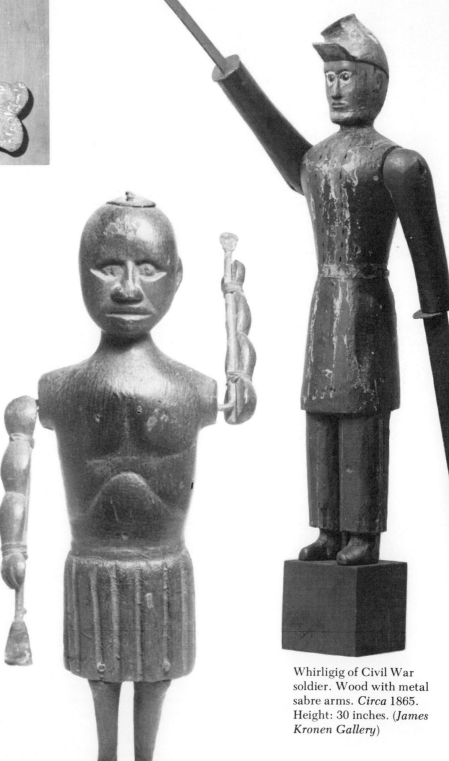

Whirligig of Indian figure that originally had rare pewter paddles and head dress. Height: 9 inches. (*Collection of Harvey Kahn*)

Whirligig of Civil War soldier. Wood with metal sabre arms. *Circa* 1865. Height: 30 inches. (*James Kronen Gallery*)

Whirligig with unusual
stance. Nineteenth
century. Height of figure:
10½ inches. (*Collection of
Harvey Kahn*)

Bareback rider whirligig.
Carved wood with horse
covered with leather and
both horse and rider
coated with plaster and
painted. Height: 28 inches.
(*George Schoellkopf
Gallery*)

Kilted hussar with busby.
Possibly from Canada.
Nineteenth century.
Height: 18 inches. (*Joseph
and Ellen Wetherell*)

53

impart movement to a figure of a woman scrubbing clothes over her wash-tub, a cyclist peddling his bicycle, an Indian paddling his canoe, or even a miniature Ferris wheel that turns perpetually.

Aside from whirligigs that depend upon simple rotating parts, there are numerous examples of birds whose wings are carved and joined to the body to make them appear to be flapping in flight. An interesting example of this type of movement is seen in the small whirligig of a U.S. Navy sailor whose semaphore or signaling flags are activated in this manner.

In the late nineteenth and early twentieth centuries, whirligigs were manufactured extensively for sale as toys or as amusing artifacts for a householder's barn, garage, rural mailbox, or lawn. These commercial wind toys evidence very little hand carving but are mainly constructed from flat pieces of wood cut out on a band saw. In general, it can be observed that the better collectible examples exhibit careful carving done in the full-round with proper regard as to how well the parts will continue to rotate after they have worn.

The demand by collectors for good early whirligigs has caused their value to appreciate enormously and may well encourage their reproduction. At the very least, upon close examination, some pieces now being offered for sale show considerable effort at restoration in terms of repaired or replaced arms and other appendages or in some quite obvious repainting and varnishing. However, it is desirable that these charming and often amusing and complicated forms of American folk art be saved from further weathering. They are examples of the wood-carver's art, often coupled with the mechanic's genius, and their only purpose was to entertain.

Whirligig of two Indians in a canoe. Wooden ball at top is rare. Length: 12 inches. (*Collection of Harvey Kahn*)

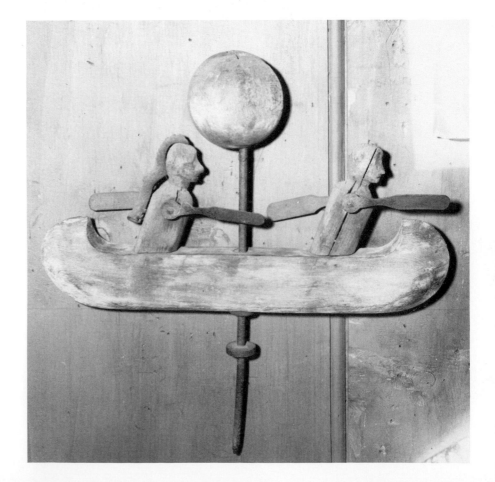

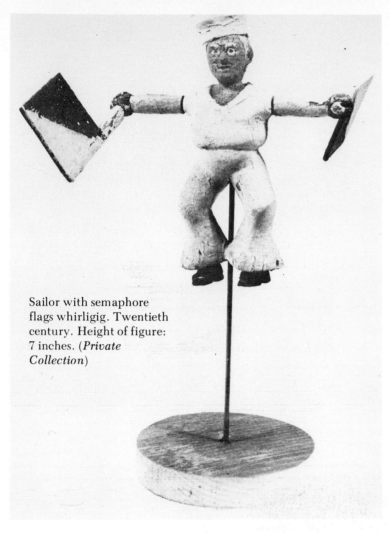

Sailor with semaphore flags whirligig. Twentieth century. Height of figure: 7 inches. (*Private Collection*)

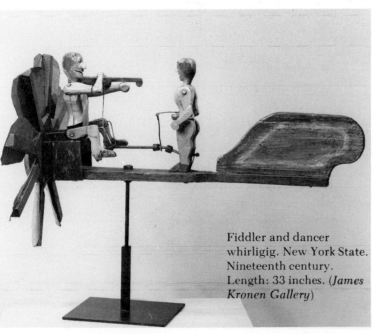

Fiddler and dancer whirligig. New York State. Nineteenth century. Length: 33 inches. (*James Kronen Gallery*)

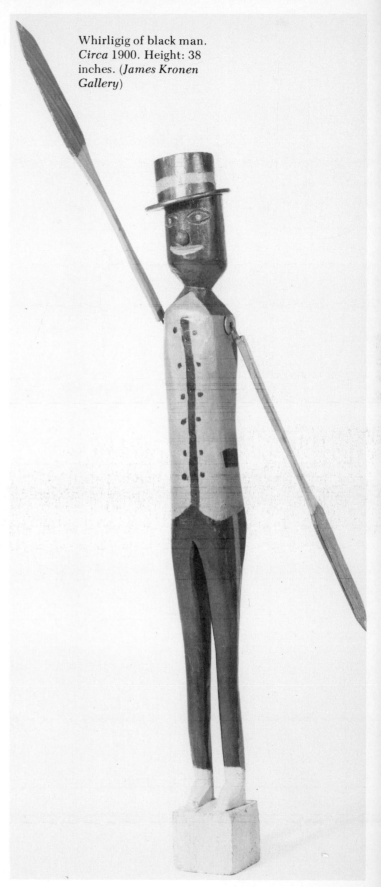

Whirligig of black man. *Circa* 1900. Height: 38 inches. (*James Kronen Gallery*)

55

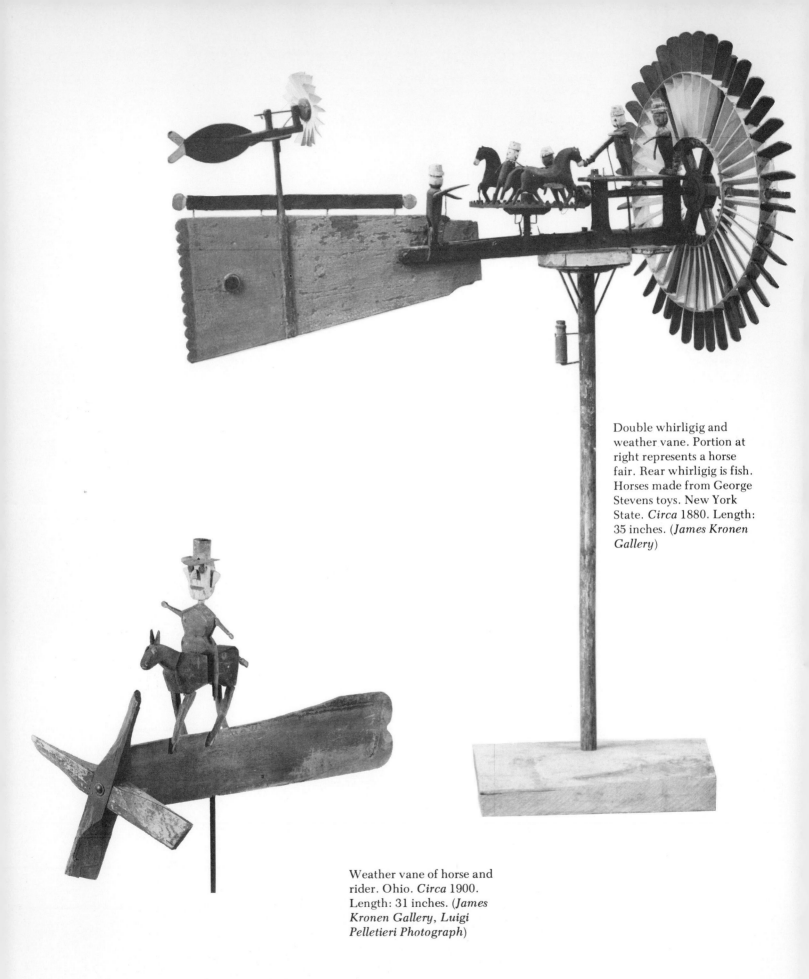

Double whirligig and weather vane. Portion at right represents a horse fair. Rear whirligig is fish. Horses made from George Stevens toys. New York State. *Circa* 1880. Length: 35 inches. (*James Kronen Gallery*)

Weather vane of horse and rider. Ohio. *Circa* 1900. Length: 31 inches. (*James Kronen Gallery, Luigi Pelletieri Photograph*)

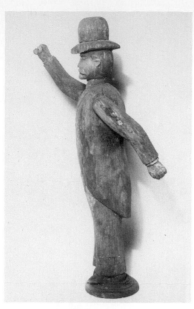

Man with derby hat whirligig. Late nineteenth century. Height: 17¼ inches. (*Collection of Harvey Kahn*)

Dancing man with bugle whirligig. Made and dated in 1950. Length: 39 inches. (*James Kronen Gallery, Luigi Pelletieri Photograph*)

7 Circus Carvings

Only those Americans over a "certain age" remember the excitement that pervaded an entire town on the day the circus arrived. While there are still a few small itinerant circuses in the country, the glitter and glamor of the "Greatest Show on Earth," seen under tents, can never be recaptured. Except for the very young, who don't know what the circus once was, there is something incongruous about a circus produced as an extravaganza in a modern coliseum rather than under the "Big Top." Of course, many features of the old circuses were undesirable, among them the freak sideshows and the fire hazard of so many thousands of feet of canvas. However, the excitement and pageantry of the circus as some of us knew it cannot be recaptured on television screens or in Madison Square Garden.

The earliest circuses in America were really equestrian shows or traveling menageries. These soon combined and grew through the first half of the nineteenth century until they became huge itinerant shows combining many elements of popular entertainment. By the latter half of the century, the circus belonging to the greatest of all promoters, Phineas T. Barnum, was challenged in size and variety only by that of the Ringling Brothers' organization. Barnum first entered the business in partnership with W. C. Troup in 1871, and later teamed up with James A. Bailey. In 1919, the two leading circuses combined to become the unchallenged "Greatest Show on Earth." By this period, after World War I, most of the smaller traveling circuses had gone out of business.

An important part of the American circus phenomenon was the parade of animals, musicians, acrobats, and clowns, who were driven through the main thoroughfare of the town before the first performance in brightly

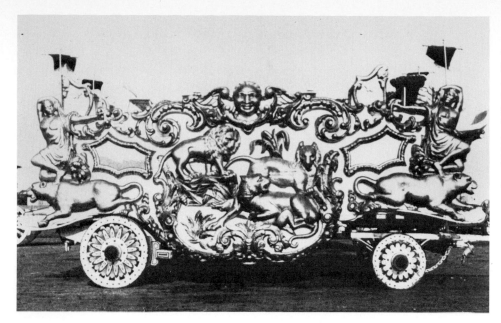

"Lion and Mirror" circus wagon. Built by Jacob Sebastian in 1879 for the Adam Forepaugh Circus. Carvings were done by Samuel Robb in New York. The wagon, 23 feet long, is now in Circus World Museum, Baraboo, Wisconsin. (*Barnum Museum*)

William Brinley's miniature carving of "Lion and Mirror" wagon (*Barnum Museum*)

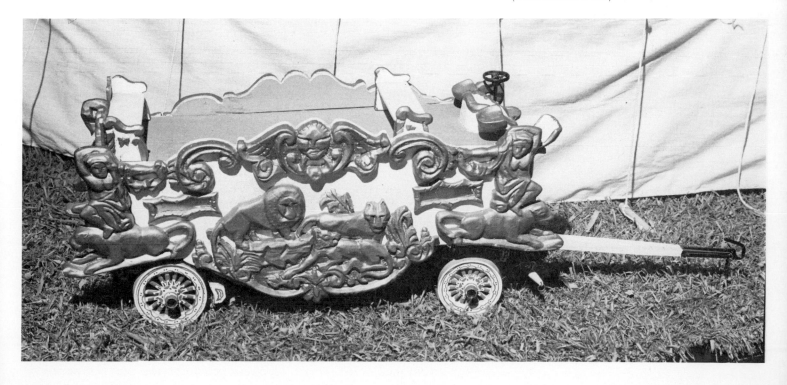

painted and gilded circus wagons. In the early days, the wagons also served as transportation, but by the time circuses began to travel by railroad car, the circus parade had become so well established as a means of "getting the customers under the tent" that the custom of using them in parades was continued.

Circus wagons were not inexpensive to build, and the wood-carvers who decorated them understood that overall effect was more important than attention to detail. Realism had no place in the circus, and many of the wagons were given themes from fables, fairy tales, mythology, geography, or history. The carvers who made figures that were applied in relief on the wagons and then painted or gilded were the same commercial wood-carvers who also made trade figures, ship carvings, and weather vanes.

Samuel Robb of New York was a wood-carver who worked almost exclusively for the Barnum circus during the 1870s. Working with the Sebastian Wagon Company, Robb made figures for circus wagons that he knew would be heavily painted and overpainted. The effect, as seen from a distance, had to be impressive and understood immediately. The wagons required constant recarving, repainting, and refurbishing.

Very few of the old circus wagons have survived. Many of the most expensive and famous passed through several hands before being retired to empty lots, where they rotted away. A few of the carvings that adorned them were saved, though they have shed their original coats of bright paint and gilding. From these fragments it is difficult to imagine the pageantry of the American circus procession.

Miniature circus wagon
carved by William Brinley
(*Barnum Museum*)

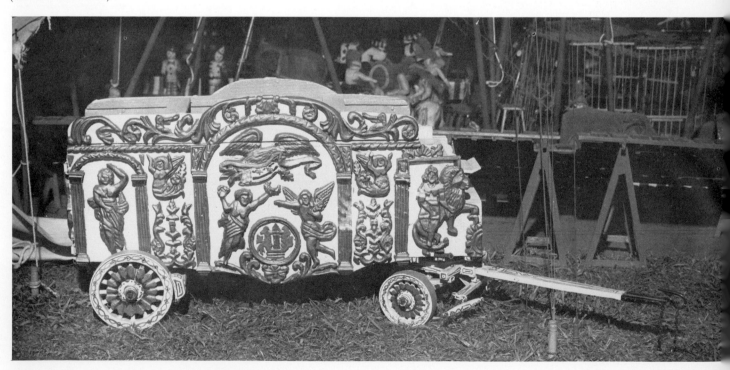

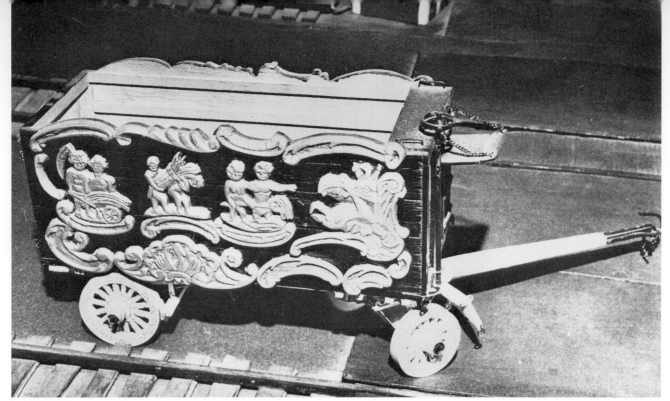

Miniature circus wagon
carved by William Brinley
(*Barnum Museum*)

Brinley miniature carving
of famous "Columbia
Bandwagon" (*Barnum
Museum*)

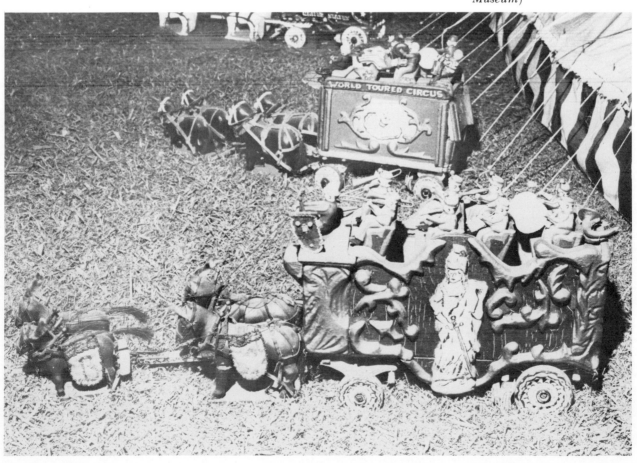

The history of the once famous circus wagon, "Africa Tableau," is typical of the life and demise of a kind of American wood carving and decorating. The wagon was built for a motorized circus in 1918 and was bought in 1924 by Robbins Brothers Circus to be placed on a wagon undercarriage. It was used in this manner to carry seats for the "Big Top" until 1937, when Cole Brothers bought the circus. Cole continued to use the wagon until it finally was burned in a fire in their winter headquarters in 1940.

Another famous circus wagon, the "Columbia Bandwagon," was built around 1903 for Barnum and Bailey, who used it until 1918. It was then sold to Christy Brothers and was part of their circus parade between 1927 and 1930. The ornate wagon was then utilized by Cole Brothers between 1935 and 1950, when it was finally retired to a storage field. There it would have rotted had not one circus enthusiast rescued it in 1953 and sold it to the Circus World Museum in Baraboo, Wisconsin.

The man who resurrected the "Columbia Bandwagon" is, perhaps than any other American, responsible for keeping alive the tradition of the circus as it used to be. William R. Brinley saw his first circus in his hometown in Connecticut in 1926 when he was nine years old. He was so impressed that he vowed to have his own circus someday and started to build it by carving his first wagon from a cheese box. His only tool was a pocketknife. The boyhood interest grew to a lifetime hobby and the result, still not finished, is a five-ring miniature circus that covers an area 30 by 60 feet.

The Brinley Circus is carved to a scale of ¾ inch to 1 foot. It represents an estimated 100,000 hours of work on the part of its creator. All of the thousands of animals and figures in the "Greatest Little Show on Earth" were hand-carved by Mr. Brinley. Many of the legendary circus wagons, including the aforementioned "Columbia Bandwagon" and "Africa

Carved figures of roustabouts are part of Brinley Circus. (*Barnum Museum*)

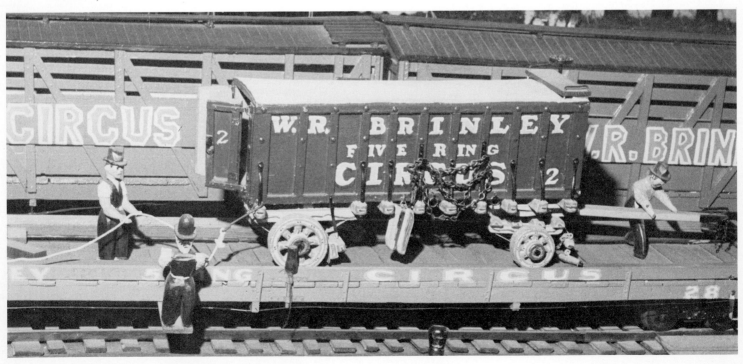

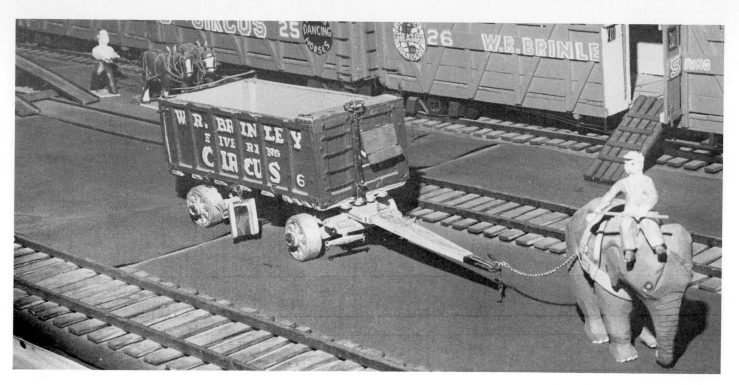

"Sideshow" of Brinley Circus. Carved and painted figures of musicians, barker, and performers are shown attempting to get the customers in under the tent. (*Barnum Museum*)

Brinley Circus figures demonstrate how elephants were used as beasts of burden as well as in parades and performances. All of Brinley's animal and figure carvings have vigor and realism. (*Barnum Museum*)

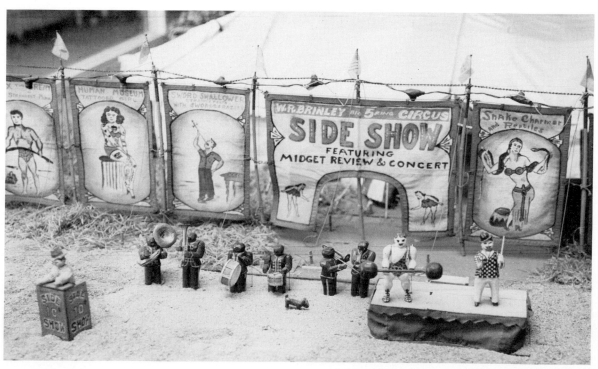

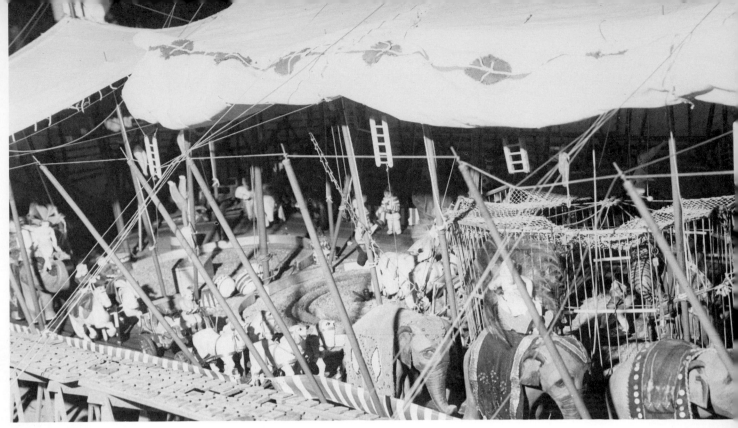

Tableau," were copied in miniature by Brinley with a faithfulness to detail that can only be described as amazing.

Through the years the Brinley Circus has been added to and has toured the country from coast to coast in its own railroad car. It has been shown on television many times. Recently, the Brinley Circus, which has an estimated 500,000 parts, was put on permanent display in the Barnum Museum in Bridgeport, Connecticut, where it continues to delight children of all ages and is an inspiration to the many circus miniature-carvers in America. In addition, Mr. Brinley donated several full-size circus wagons to the museum. Two of these are restored original wagons and show us something of the other-world illusionary art that made up the circus parade.

The few circus carvings that have survived give us little idea of the brilliance and pageantry of the long circus procession. Most of the figures, made of soft wood, have long since lost all their gilding and bright paint. The few wagons that do remain intact in museums are only a static reminder of a popular art that was part of the American entertainment scene for so many years. Nostalgia for the day the circus came to town is obvious in the work of the miniature circus figure-carvers, who are students of the history of the American circus and faithfully attempt to reproduce the great legendary wagons that were illustrated on the bright posters advertising our leading circuses. That this work can be done with a high degree of success is illustrated in the Brinley Circus figures. Throughout the country, there are miniature circus-carvers who will leave an eyewitness record of the great American circus.

8 Carousel Figures

An important attraction of any traveling circus or permanent amusement park was the carousel, with its parade of brightly painted animals, glittering mirrors, and inviting music. The history of the carousel goes back many centuries and is, of course, international in scope. However, the American carousel, with horses or other animals that had an up-and-down movement, came about after the invention of the steam engine and its application as a driving mechanism. Therefore, the carved carousel figures that can be found in this country today date from the last quarter of the nineteenth century up to about 1940. With the invention and development of electricity, carousels became an extremely popular form of amusement, and many were made in the first quarter of this century, when the industry flourished.

There are relatively few operating carousels in America today. Of the thousands that were made, less than one hundred merry-go-rounds with wooden animals are still intact. Some carousels were destroyed by flood or fire, and others just rotted from neglect. It is only in recent years that folk art collectors have given some attention to the marvelous carved figures from the early carousels. The brightly painted fanciful animals that were once destined to travel perpetually in circles to the tunes played by band organs have finally come to a standstill in some of our museums and private collections.

The horse, carved in a variety of attitudes and raiment, has always been the most popular carousel figure. He was sometimes portrayed as a snarling charger and less often as a docile beast. In order to give the animals the illusion of movement even when the carousel stood still, most of the carvings were made with legs thrust outward. Even the carved rooster illustrated here appears to be running.

Docile burro is early
American carousel figure.
(*Collection of Harvey
Kahn*)

Carousel figure of pig.
Length: 46 inches. (*The
Eleanor and Mabel Van
Alstyne Collection,
Smithsonian Institution*)

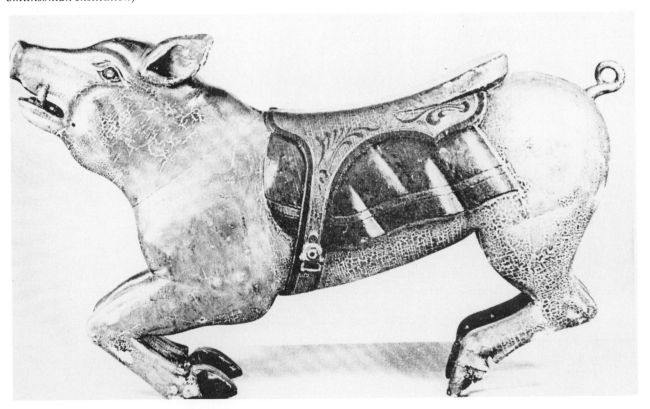

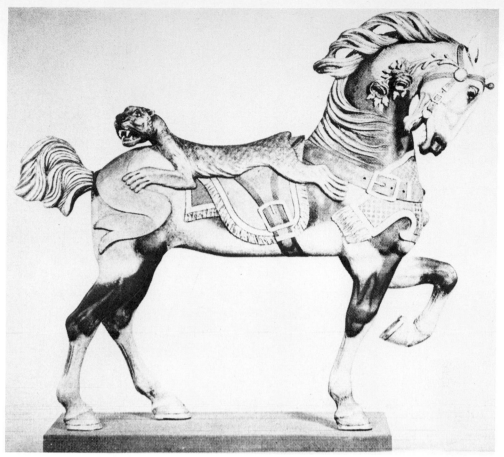

Carousel figure of horse. Late nineteenth century. Length: 71 inches. (*The Eleanor and Mabel Van Alstyne Collection, Smithsonian Institution*)

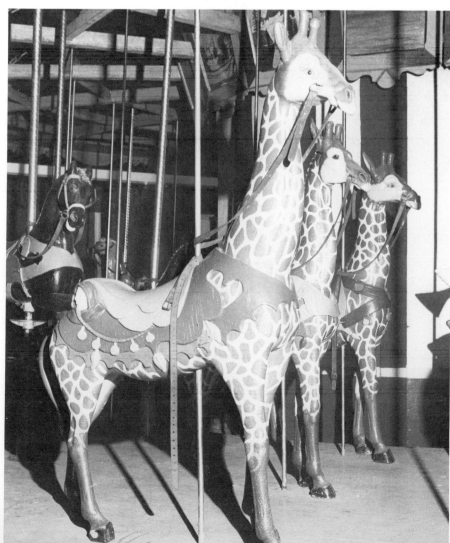

Carousel figures of giraffes. Late nineteenth or early twentieth century. Made by Philadelphia Tobagan Company (*Lake Quassapaug Amusement Park, Middlebury, Connecticut*)

67

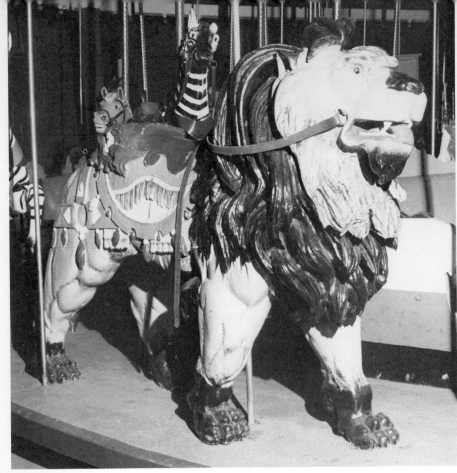

Carousel figure of lion.
Made by Philadelphia
Tobagan Co. *Circa* 1900.
(*Lake Quassapaug Amuse-
ment Park, Middlebury,
Conn.*)

Carousel figure of smiling
pig. Late nineteenth
century. (*Lake Quassa-
paug Amusement Park,
Middlebury, Connecticut*)

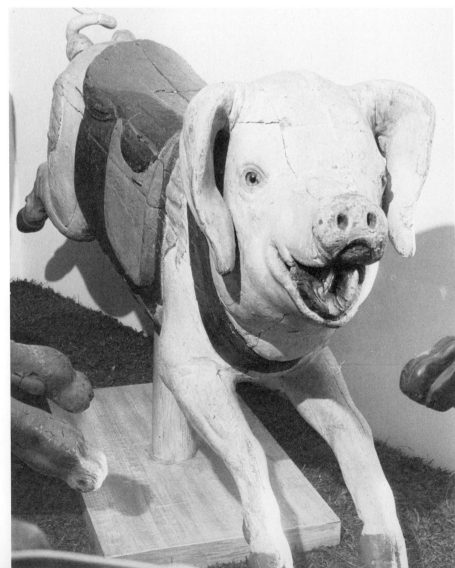

Animals other than the popular horse added appeal to the wooden menageries. Ostriches, lions, tigers, seals, pigs, elephants, bears, frogs, deer, cats, camels, dogs, and swans are some of the realistic animals to be found. More fanciful carvings, such as seahorses and dragons, were also included in some carousels. All were brightly painted to attract young riders. The older and more daring children chose the animals, usually horses, that moved up and down while the carousel turned. "Sissies" and the very young, sometimes in their parents' arms, rode in the safer chariots. The bravest of all chose the outside animals so that they could grab for the brass ring that would assure them a free ride.

Carousel carving may be considered functional sculpture. Although it originated much later than ship carving and most trade carving, it is closely related to the earlier forms in that it is an art that grew out of commerce. Many of the ship-carvers whose services were no longer needed found work in the shops that provided the figures for merry-go-rounds.

The styles of the carved wooden carousel figures range from neoclassic to totally imaginary. The late-nineteenth-century seahorse illustrated here is an example of the real and fanciful combined in a single figure.

Most of the carvers of carousel animals cannot be traced today. They were usually men who had trained in other areas of commercial carving, who eventually found work in carving animals for the carousel manufacturers. Many were immigrants from Germany or Italy, and their work was not signed or in any way identified, except infrequently by the manufacturer for whom they worked.

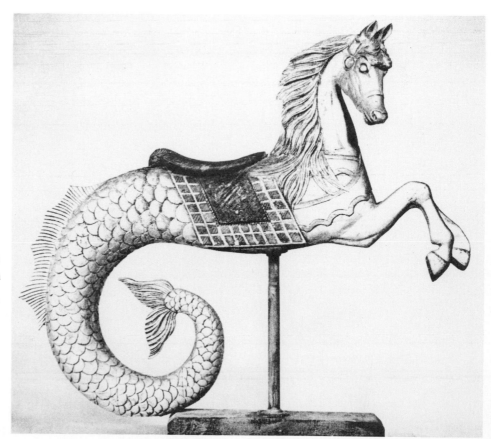

Carved carousel figure of seahorse. Late nineteenth century. Length: 62 inches. (*The Eleanor and Mabel Van Alstyne Collection, Smithsonian Institution*)

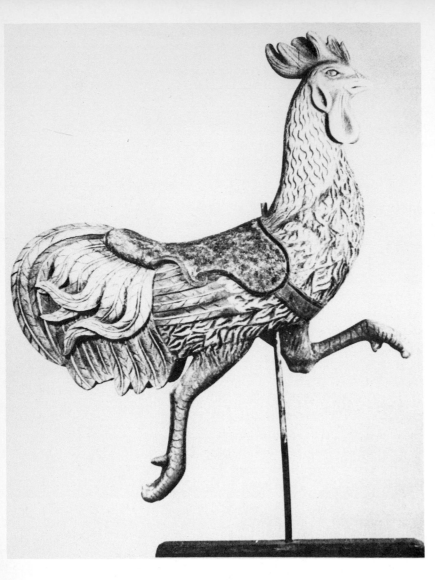

Carousel figure of rooster.
Late nineteenth century.
Length: 56 inches. (*The
Eleanor and Mabel Van
Alstyne Collection,
Smithsonian Institution*)

Carousel figure of sea lion.
Late nineteenth century.
(*The Eleanor and Mabel
Van Alstyne Collection,
Smithsonian Institution*)

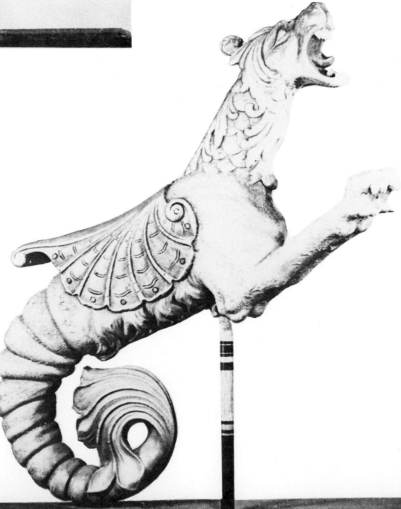

Carousel figure of rabbit with pink glass eyes (*Mahopac Country Museum*)

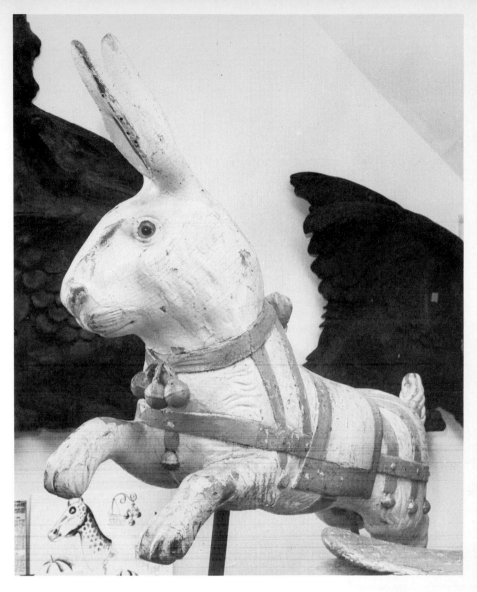

Elaborate carvings were used on carousels. Gilt dragon decorates chariot from carousel still in operation at Lake Quassapaug Amusement Park in Middlebury, Connecticut.

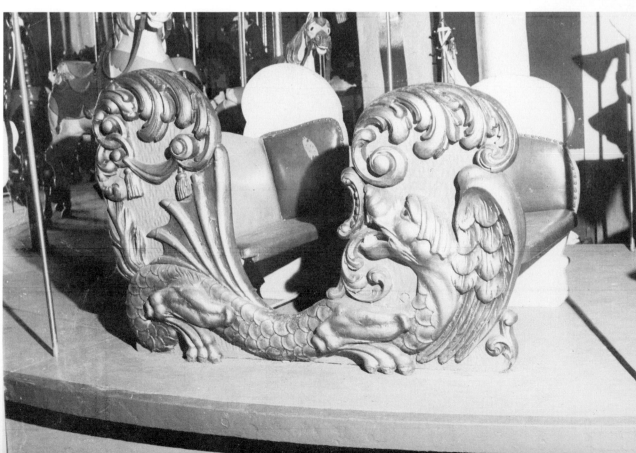

There were a few manufacturers who were also carvers and a little more is known about these men. The earliest and perhaps the most outstanding of these carver-manufacturers was Chalres I. D. Looff, who erected his first carousel at Coney Island in Brooklyn, New York, in 1876. Looff was an immigrant from Schleswig-Holstein (then part of Denmark) who worked in a furniture company and carved his carousel figures in his spare time. After having made and installed three carousels, he went into the business full-time and after several years hired other carvers to help him.

Among other known carousel carvers were Salvatore Cernigiaro, an Italian immigrant who worked for the firm owned by Gustav A. Dentzel in Philadelphia, and Marcus Charles Illions, a Polish immigrant, who had his own carving shop in Brooklyn, New York. Since the more successful carving shops employed as many as twenty-five wood-carvers, it is impossible to identify the makers of more than a minute percentage of the surviving carousel figures. Most of the existing wood figures were long ago removed from their original localities, and it is even difficult to discern which were carved by American artists and which were imported. Nevertheless, all carousel carvings found in this country can be considered a part of our history of recreation and entertainment, and as such, it is sad that more of them were not preserved.

9 Ventriloquists' Dummies and Carnival Carvings

There is a category of American folk carving that is closely associated with our entertainment history and that has previously been ignored by writers on our country's folk art. These are the sad reminders of our country's attitude and treatment of the black man. The carnival figures and ventriloquists' dummies that still exist, while they represent an embarrassing and unhappy era in our history, should not be ignored or hidden. As the United States emerges in the last third of this century from an era of racial inequities, these carvings serve as a reminder that humor at the expense of others often has terrible repercussions. Rather than sweeping all evidence of the evils of black oppression under the rug, many museum people and collectors of Americana are beginning to realize the importance of black collectibles to the complete story of our past.

Ventriloquists' dummies are a rather unique form of American wood carving. Although it is possible that a few of the black figures that still exist were used by black performers, most of them were made by or for white actors who did solo routines in nineteenth-century minstrel shows and carnivals. The minstrels, featuring Negro songs and dances, were part of American theatrical entertainment throughout the entire nineteenth century and lasted until 1928, when the last of the popular troupes, Al G. Field Minstrels, went out of business. The American minstrel shows were performed mostly by white men in blackface makeup, and thus did not even give employment to talented black actors and comedians.

A conventional pattern was set for American minstrels by the middle of the nineteenth century by the E. P. Christy Minstrels. During the first half of the show, the performers sat in a semicircle with a comedian called the

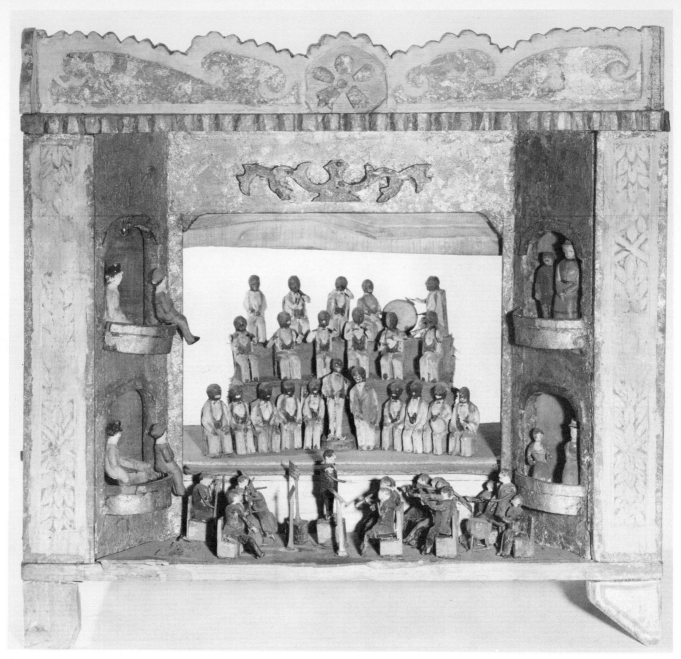

Tramp carving of American minstrel show. Figures on stage are in blackface makeup. (*Gary C. Cole*)

endman at either end. One was Mr. Tambo, who carried a tambourine; the other, Mr. Bones, who shook rattle bones. In the front center was Mr. Interlocutor, the straight man, who invited jokes from the comedians by asking questions. The second half of the minstrel show, the olio, was a variety show that often included a ventriloquist. The show usually ended in a farce comedy and a hoedown dance in which the entire company took part.

Although black performers who sang songs of their race appeared on the American stage as early as the late eighteenth century, by the beginning of the nineteenth century white performers in blackface had begun to utilize Negro music and lyrics and thus competed with the originators of the music, who could no longer find work performing their own material.

In addition, songs that degraded the black man became nationally popular through minstrel performances, and ventriloquists sang or spoke through their carved dummies in what was thought to be an amusing Negro dialect. This tradition was carried on by blackface performers of the early vaudeville and radio days.

Along with the trade, circus, and carnival figures that were made by former ship-carvers, ventriloquists' dummies were also advertised. Illustrated here is a white dummy head showing the intricacies of the mechanism that made the eyes, mouth, and scalp move. Obviously, great care was taken with the carving of professionally made dummies' heads, since their owners' success on the stage depended upon the figure's humorous appearance and "personality." There exists today a disproportionate number of white dummies to black. The most interesting are those made by their owners or other unprofessional carvers. Illustrated here is a black dummy of soft pine with a ragged and badly sewn costume, obviously made by an amateur. The simple carved and painted features display an amusing and lively expression. Another black ventriloquist's dummy is wearing a velvet jacket and has an oversize head with real hair. The professionally carved dummy of a later period sports plaid trousers and a well-tailored shirt and necktie.

Ventriloquist's dummy dressed in velvet jacket. Nineteenth century. (*Collection of Alan Cober*)

Ventriloquist's dummy head. Nineteenth century. (*Collection of Harvey Kahn*)

Back is removed from dummy head to show how eyes and mouth were operated. (*Collection of Harvey Kahn*)

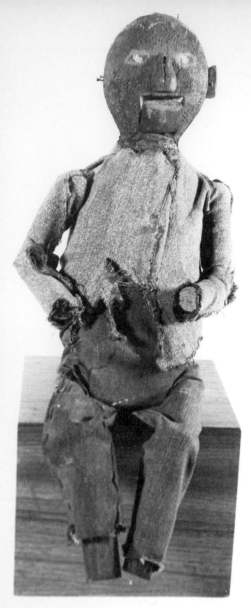

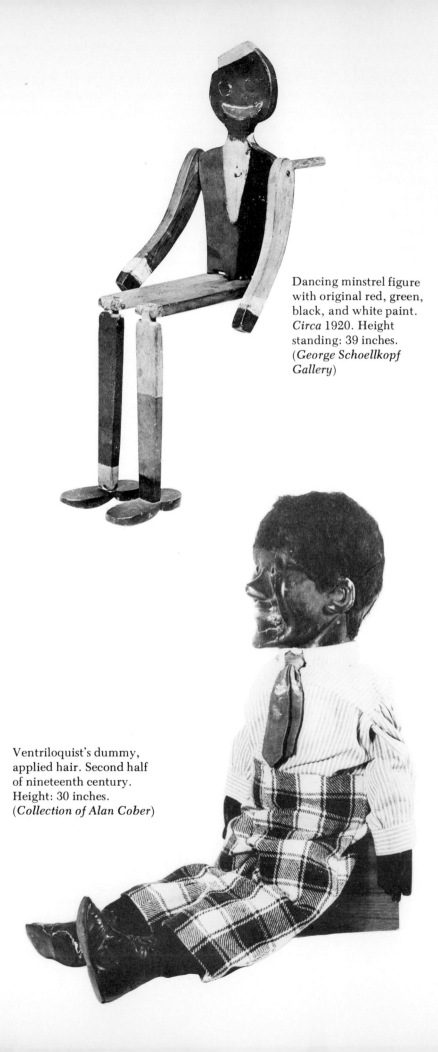

Dancing minstrel figure
with original red, green,
black, and white paint.
Circa 1920. Height
standing: 39 inches.
(*George Schoellkopf
Gallery*)

Primitive black
ventriloquist's dummy.
Found in Lancaster,
Pennsylvania. Nineteenth
century. (*Collection of
Alan Cober*)

Ventriloquist's dummy,
applied hair. Second half
of nineteenth century.
Height: 30 inches.
(*Collection of Alan Cober*)

Certainly, the blackface minstrel performer would not get as much as a smile today were he to repeat his nineteenth-century routines in front of a modern audience. Fortunately, American values have changed enough so that the black ventriloquists' dummies that survive are now considered only in the aspect of folk art of the past. They are reminders that, while no one would want to repeat the circumstances that caused their popularity, all aspects of American black history and the white man's treatment of black citizens should be preserved.

Wood carvings of a closely related nature are those of blacks used as carnival figures. Again, these may be an embarrassing reminder of a prejudiced past. Touring carnivals and the more permanent amusement parks of the nineteenth and early twentieth centuries offered the traditional games of skill that can still be found in modern carnivals and country fairs. More often than not, the heads and figures used in "dodge-em" games at carnivals and amusement parks were carvings of black men. These were evidently thought of as satisfying targets at which to test one's accuracy with a ball, arrow, or gun.

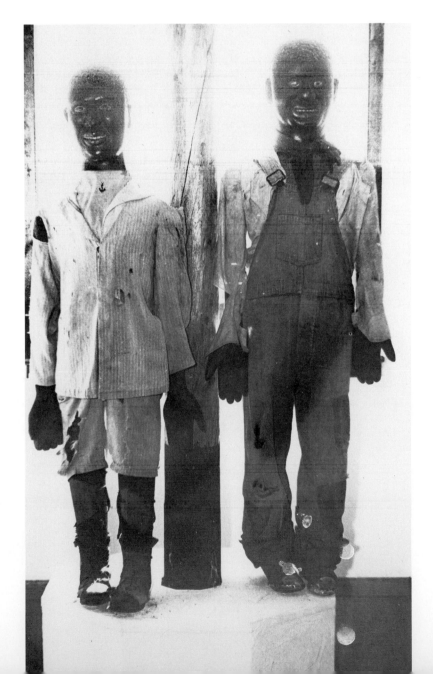

Pair of black dancing figures. One leg of each figure is articulated at the knee. Original use unknown, but probably minstrel or carnival figures. Nineteenth century. Height: 54 inches. (*Mahopac Country Museum*)

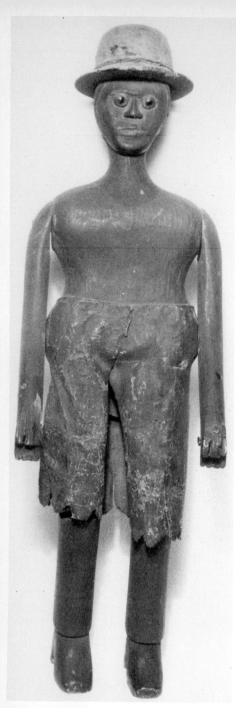

One nineteenth-century carnival carving of a black man originally had clay pipes fixed in either corner of the mouth. Baseballs, or some other missile, were thrown at this target, which was a moving one. Evidence of this is the holes drilled in the back of the head through which ropes were drawn so that the head could dodge the oncoming ball. Two other full-figure black men appear to be professionally carved carnival figures and their original purpose is now unknown.

The black man was often depicted as a comedy figure on toys or carved novelties. Typical is the carved patent model of an "automatic dancer," dated 1863, and another small figure dressed in bowler and tattered cloth trousers. This figure has articulated arms and legs and was probably part of a toy. More encouraging is the toy illustrated here, which has figures of a black and a white man. As the pieces of wood are manipulated, each takes a turn in hitting the anvil in rhythm and harmony.

There are few wood carvings of the nineteenth century that can actually be attributed to black carvers, although probably many existed. Several carvings found in the area of Killingworth, Connecticut, are thought to have been made by a black man whose name is now lost to us. However, his heads and figures have certain similarities, conveniently classified as "the Killingworth image." The heads always have similarly shaped tin ears and the facial features are all so similar that it is obvious that all of this work was done by the same person. Also characteristic of this man's work are the flat-topped heads. Facial features consist of incised and painted eyes and mouth and a separately carved and nailed nose.

With the exception of "the Killingworth head," all of the black wood carvings illustrated here were made as objects of entertainment. The fact that we have some physical evidence that black dummies, carnival grotesques, or an articulated black dancing doll patented under the name of "Crow" were once considered amusing and entertaining objects should be instructive to future generations of Americans, who might find it difficult to understand the nature of the oppression of an entire race solely through the reading of history books.

Black figure wearing derby hat. Articulated at knees and arms. Painted cotton breeches. Glass eyes. Nineteenth century. Height: 17 inches. (*Collection of Harvey Kahn*)

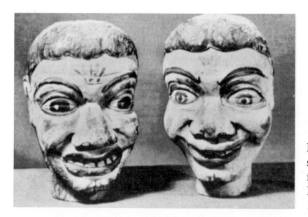

Pair of carved and painted shooting gallery heads from Steeplechase, Coney Island, New York. Height: 11 inches.

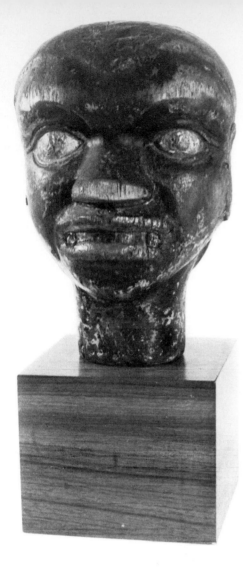

Nineteenth-century carnival head. Corners of mouth held clay pipes at which baseballs could be thrown. Back of head has holes drilled for ropes which could be used to turn head to dodge balls. *Circa* 1860. Height: 10 inches. (*Collection of Alan Cober*)

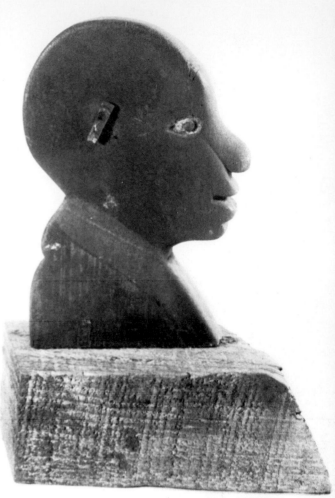

Head carved from flat board. Possibly a carnival figure. Nineteenth century. Height of head: 8 inches. (*Collection of Alan Cober*)

Patent model of articulated Negro dancer by "S. N. and J. N. Crow." Dated 1863. Height: 8 inches. (*Collection of Alan Cober*)

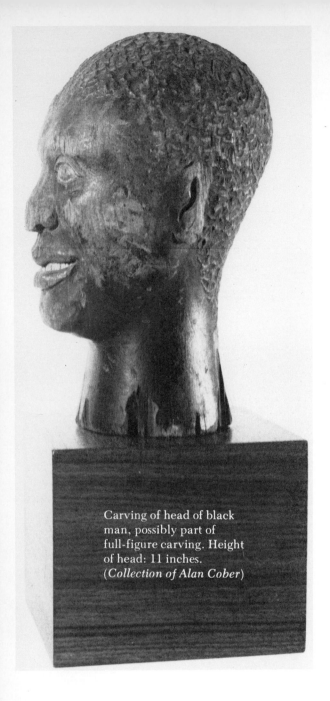

Carving of head of black man, possibly part of full-figure carving. Height of head: 11 inches. (*Collection of Alan Cober*)

"The Killingworth Image." Carved by anonymous black man of Killingworth, Connecticut. Some of his carvings are known to have been made in full-figure. Flat head and tin ears typify his work. Late nineteenth century. Height: 9 inches. (*Collection of Harvey Kahn*)

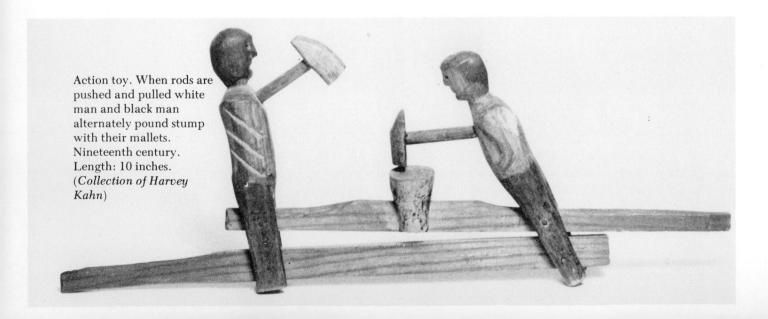

Action toy. When rods are pushed and pulled white man and black man alternately pound stump with their mallets. Nineteenth century. Length: 10 inches. (*Collection of Harvey Kahn*)

10 Civil War Wood Carvings

Long before the phrase "occupational therapy" was popular, people confined to one place for a long time recognized their need to do something that would help pass the time and keep their minds off their problems. This seems to be particularly true of prisoners of war who, in many cases, were granted some privileges that would have been denied men committed to prison for other reasons. Obviously, any tool that could be used as a weapon would not be allowed to men confined for violent crimes. However, political prisoners seemed historically to have been granted this privilege, or perhaps, they were less carefully searched. The magnificent model ships made by French prisoners of war in England in the eighteenth century are highly prized today. A few American prisoners in the same circumstances and period made ships from bone as well. They often sold these to their captors to earn money for tobacco and other amenities.

American Civil War prisoners recorded the anguish of that four-year conflict in a variety of superb wood carvings that have received little attention. Union prisoners held in the infamous Andersonville Prison and other southern prisons carved their patriotic and political sentiments in elaborate and intricate patterns on pipe bowls and walking sticks. Any object larger than these might have been confiscated or stolen, but a pipe could easily be hidden while being carved, and it is more than probable that the canes were used by the wounded and carved in odd moments after having aided their owners in walking into prison.

One walking stick that tells this story is illustrated here. It is carved in high relief over its entire surface and has the legend "Carved from the East woods of the Antietam Battlefield." The remainder of its surface has the names of the Union commanders of the Civil War. Other prisoners of war canes have snakes twisted around their entire surfaces or lizards crawling down them.

Section of walking stick carved in high relief over its entire surface. Made by Civil War prisoner. Writing includes list of names of Union commanders and the legend "Cut from the East woods of the Antietam Battlefield." (*Collection of Norman Flayderman*)

Perhaps the most unique Civil War carvings are the pipes made by Union soldiers incarcerated in military prisons such as Andersonville or Libby Prison in Richmond. The intricate work done on these elaborately carved pipes indicates that many men attempted to keep their sanity under the worst possible living conditions by concentrating their attention on a single project that, by its complexity, would take their minds off their problems. Many of the Civil War pipes are *tours de force* that only someone faced with endless hours of idleness would attempt. The end product was certainly of less importance to them than the process.

The carved wood Civil War pipes are, perhaps, some of the best examples of American folk carving as an indigenous art form. Patriotic devices are the most prevalent motifs; the American eagle is the decoration most often used, but other symbols of the Union army are found as well. Weapons were the second most popular decoration. Cannon, rifles, and pistols in miniature relief were carved into the pipe bowls. Patriotic slogans, such as "The Union and the Constitution Must and Shall be Preserved," were used. Ambitious listings of important battles of the war or commanders of the Union Army were sometimes included on the pipes, along with the carver's name or division.

The carved wood pipe bowls that have survived from the Civil War period are in a variety of shapes, and show the wood-carver's imagination and talent in carving designs on an extremely limited surface. One especially interesting pipe bowl has the figure of a Union Soldier sitting on top of a cannon. Other pipe bowls that still exist are self-portraits of the soldiers who carved them.

Three Civil War canes. Top: heavily carved and painted snake. Center: carved head with nailhead eyes. Painted figure of woman, house, deer, trees. Bottom: cane was carved by Confederate prisoner of war at Johnston's Island and was presented to General William Seward Perigo, who was in charge of the prison on the Ohio River. (*Collection of Norman Flayderman*) *Flayderman*)

While most of these Civil War pipes can be documented as having been made by prisoners, some were carved by soldiers as souvenirs of a particular fort or camp. Others were probably made as presentation pieces for favored officers or to be sold for pocket money.

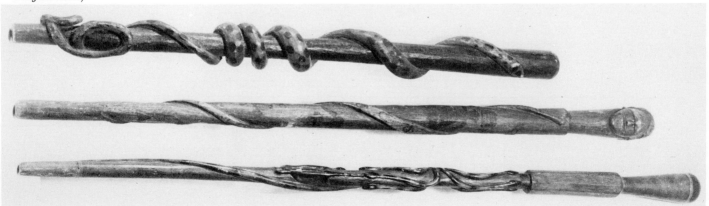

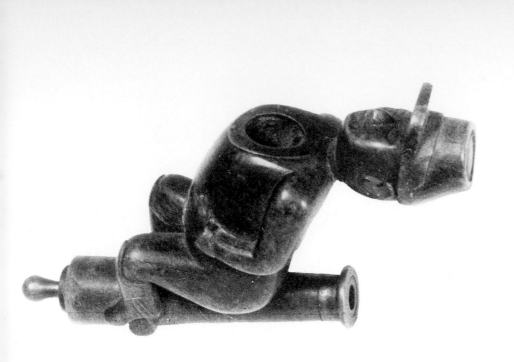

Civil War pipe head of
Union soldier sitting on
cannon (*Collection of
Norman Flayderman*)

Prisoner of war pipe with
eagle and shield
(*Collection of Norman
Flayderman*)

Civil War pipe with legend
"The Union must & shall
be preserved." Civil War
weapons carved on front.
(*Collection of Norman
Flayderman*)

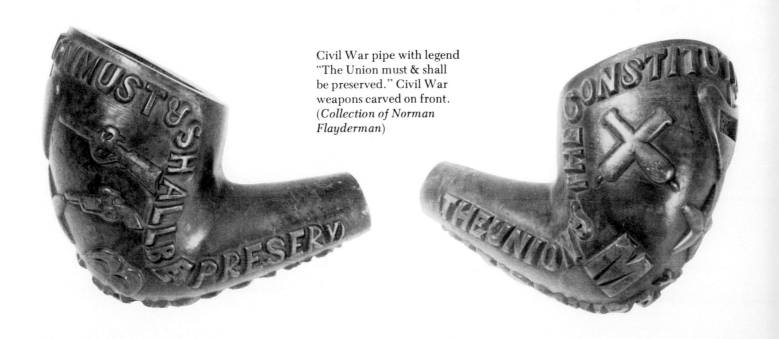

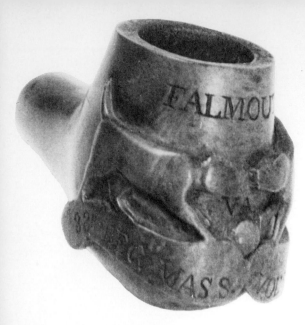

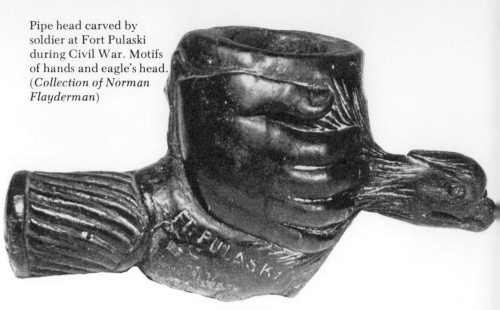

Pipe head carved by
soldier at Fort Pulaski
during Civil War. Motifs
of hands and eagle's head.
(*Collection of Norman
Flayderman*)

Pipe head carved by
member of Massachusetts
regiment during Civil War
(*Collection of Norman
Flayderman*)

Pipe head carved and
signed by O. G. Kidder has
list of important battles of
Civil War. (*Collection of
Norman Flayderman*)

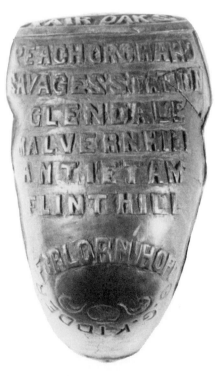

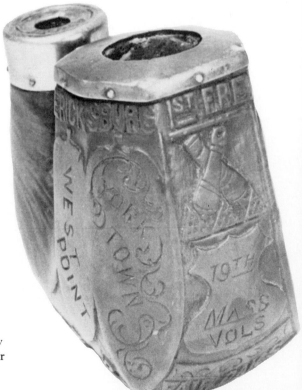

Fredericksburg pipe
carved in Libby Prison,
Richmond, Virginia, by
John Oakford, a Quaker
wagon driver for the
Union. (*Collection of
Norman Flayderman*)

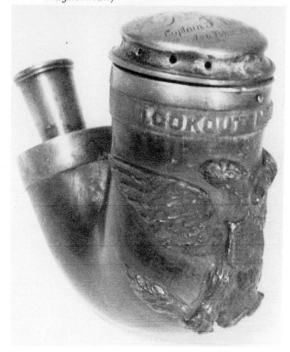

Presentation pipe made
during Civil War with
eagle and shield motif
(*Collection of Norman
Flayderman*)

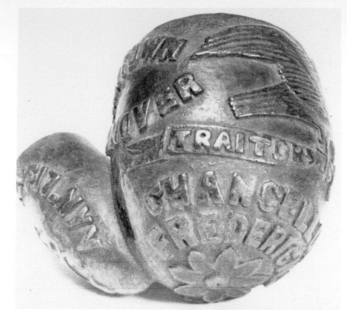

Pipe head carved by Union
soldier has word "traitors"
carved into side.
(*Collection of Norman
Flayderman*)

The carved Civil War pipes were certainly more decorative than prac-
tical. Material most suitable for pipes, meerschaum or briar, was not
available to the carvers, so native wood, such as oak and walnut, were
used. Occasionally, a good laurel root was found that was suitable for pipe
carving, but the usual local woods led to a condition called "burn-out," a
term familiar to any pipe smoker. This rendered many of the Civil War
pipes unsuitable for practical use.

Comparatively few Civil War pipes have survived. Those that have are
certainly prized items in the category of American wood carving. In ad-
dition to their importance as historical relics, the pipes prove that the art of
wood carving was well established in this country by the time of the Civil
War.

There are a few other unique wood carvings done by Civil War soldiers
that survive today due to the efforts of history-oriented dealers and col-
lectors who appreciate the value of handmade objects that represent spe-
cific happenings in our past. Two particularly fine examples of Civil War
wood carving are represented here. The first is a small figure of a Union
soldier. The face is gaunt, emaciated, almost Christlike; it is probably a
self-portrait done by a prisoner of war. The second, a wooden dagger, its
handle a fully carved head of a soldier wearing a Union cap, is also es-
pecially well carved.

Two plaques are also illustrated, each representing a different side of
the American conflict. One is a "tree," the "trunk" of which has "Battles of

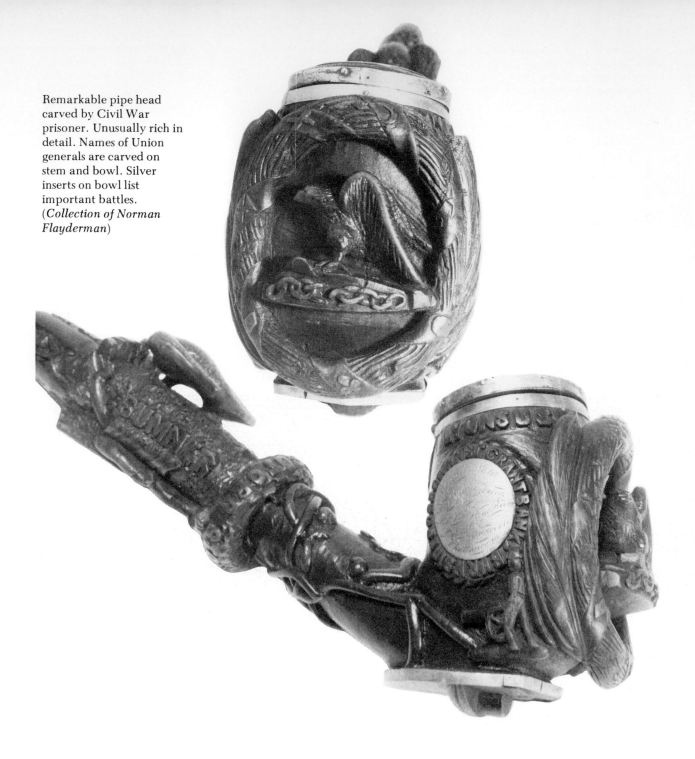

Remarkable pipe head carved by Civil War prisoner. Unusually rich in detail. Names of Union generals are carved on stem and bowl. Silver inserts on bowl list important battles. (*Collection of Norman Flayderman*)

the Union," while the battles are carved in relief on the "leaves." Bone was used in this plaque as inlay for the corner stars and frame insert.

A carved and polychromed plaque expresses the viewpoint of the Confederate maker after his cause was lost.

Furl that banner Softly, Slowly
Treat it gently—it is holy
For it droops above the dead
Touch it not—unfold it never
Let it droop there furled forever
For its people's hopes are dead

There are few relics of wood carving from any later American wars. One rather unusual item that represents World War I has been found and is illustrated here. It is the blade of a wooden propellor carefully carved into a picture frame. In this way, one American skilled in the art of wood carving carried on a centuries-old tradition by leaving a record of his own part in a military conflict.

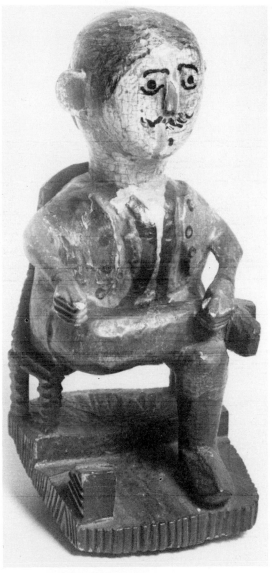

Superb miniature folk carving of Union soldier. Pennsylvania. Civil War carving. (*Collection of Dr. William S. Greenspon*)

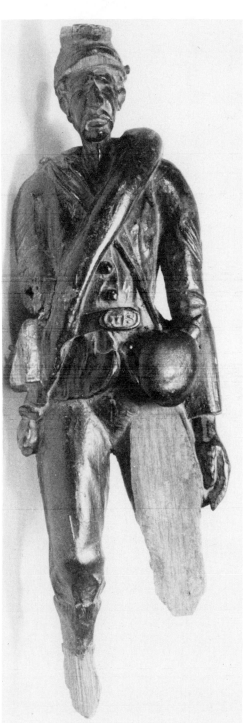

Prisoner carving of Civil War Union soldier (*Collection of Norman Flayderman*)

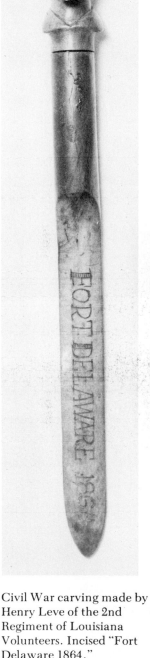

Civil War carving made by Henry Leve of the 2nd Regiment of Louisiana Volunteers. Incised "Fort Delaware 1864." (*Collection of Norman Flayderman*)

87

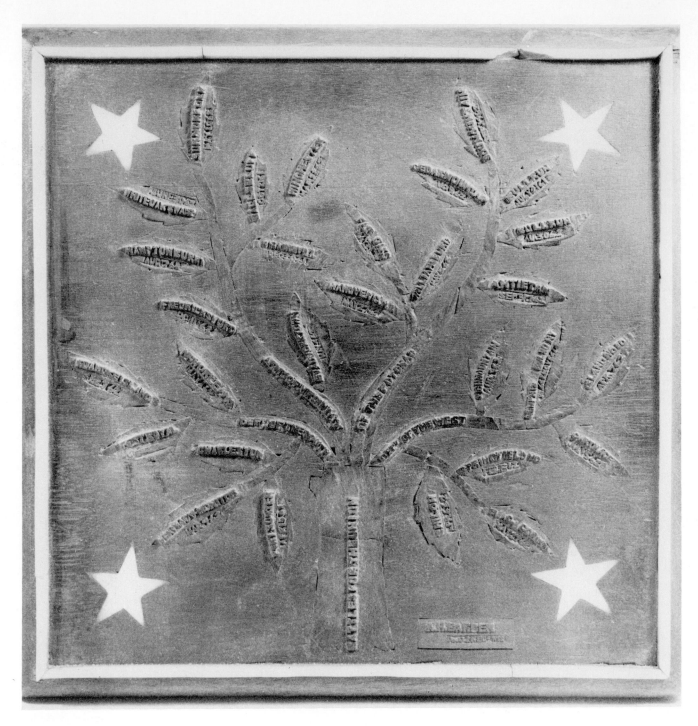

Carved wood Civil War
plaque: "Battles for the
Union." Made and signed
by A. H. Barber, ec.c, 2nd
Regiment, Wisconsin.
(*Collection of Norman
Flayderman*)

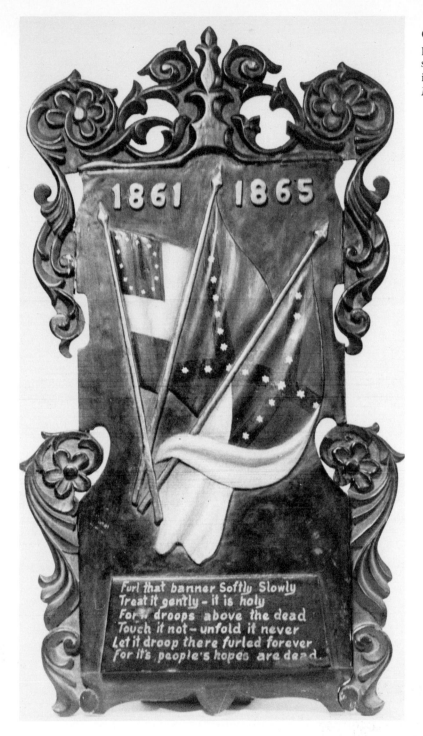

Carved and painted plaque with Confederate sentiments. Height: 36 inches. (*Collection of Norman Flayderman*)

On plaque:

1861 1865

Furl that banner Softly Slowly
Treat it gently - it is holy
For it droops above the dead
Touch it not - unfold it never
Let it droop there furled forever
for it's people's hopes are dead

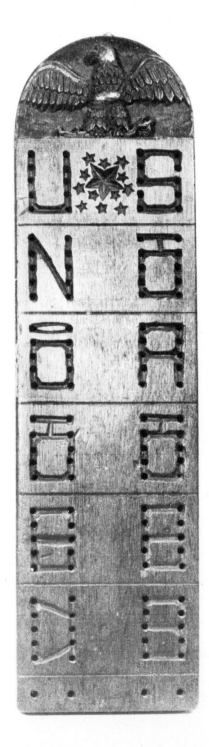

Carved cribbage board of unknown origin spells out "United States." (*Collection of Mr. and Mrs. Harold Corbin*)

89

Carved and painted scene depicting Union officer supervising clearing of a wood prior to Battle of the Wilderness. Carved in relief and painted. Made in German settlement in Maine. *Circa* 1865. Height: 7 inches. (*Collection of Harvey Kahn*)

World War I carving is done on propellor blade and made into picture frame. (*Collection of Norman Flayderman*)

11 Toys, Dolls, and Small Animal Figures

In early colonial times, when survival was the prime purpose of all human activity, children made do with any objects that could be found to entertain them. It is probable that a few doting fathers managed to whittle a toy or two in their precious leisure moments, but no toys from the earliest period of American settlement seem to have survived. By the eighteenth century, more playthings were being made, but it was in the nineteenth century that the carvers of children's toys became prolific. These wood carvings are the delight of collectors of American folk art.

Perhaps the most popular of all carved wooden toys is the rocking horse. There still exists a great variety of eighteenth- and nineteenth-century hobbyhorses made in many styles and sizes. Some were one-of-a-kind toys carved by a father or uncle, but many were produced by local cabinetmakers and professional wood carvers. The types of carved horses range from simple rough-hewn logs with stylized horses' heads and long rockers to more realistically carved and painted animals with real horsehair tails and manes. The most fortunate children were given rocking horses with leather saddles and brass stirrups, on which they could ride in comfort and style to any imaginary destination. Some horses were placed on platforms with wheels, thereby giving their riders the ability to travel rather than merely rock in a stationary place.

The superb horse from Connecticut, shown here, was made around 1870 and is an example of a homemade horse. It is carved of rough wood pieces bolted together, and the stylized head has flaring nostrils and leather ears. A more realistically painted and carved rocking horse has a hair tail and a comfortable saddle.

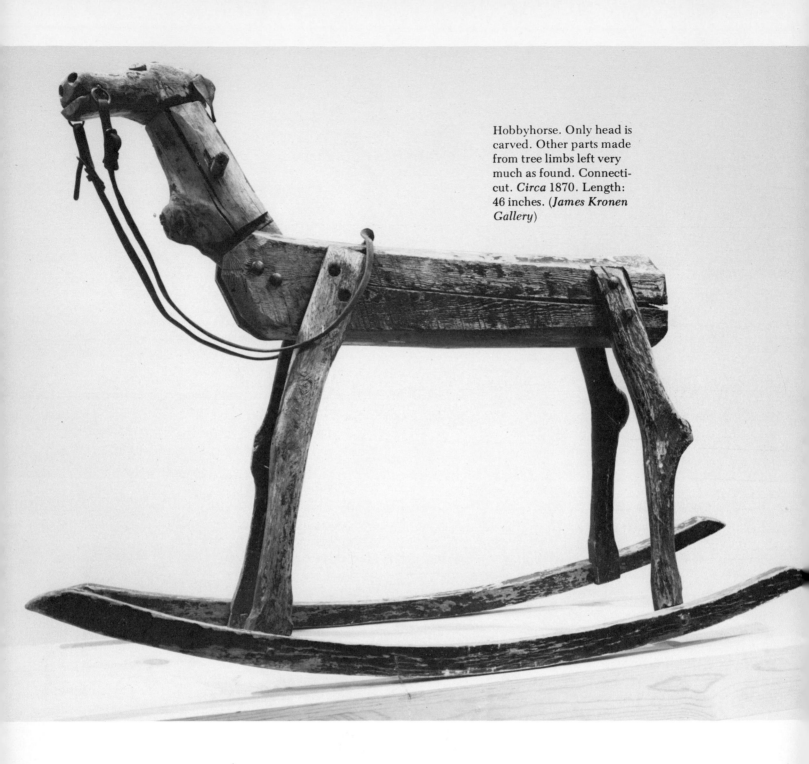

Hobbyhorse. Only head is carved. Other parts made from tree limbs left very much as found. Connecticut. *Circa* 1870. Length: 46 inches. (*James Kronen Gallery*)

92

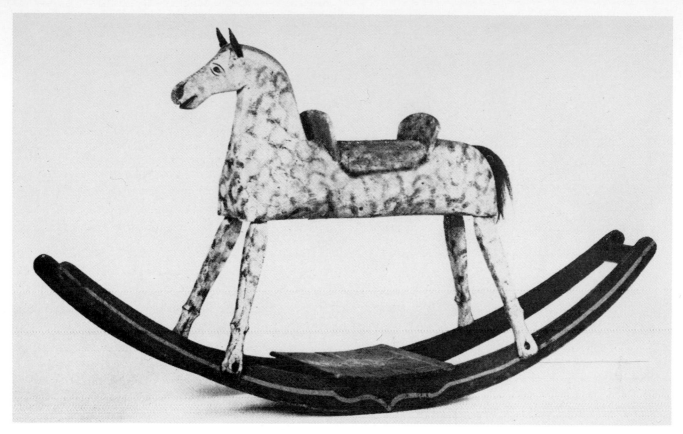

Miniature animals were also carved and placed on wheeled platforms so that their owners could push or pull them across the floor. Horses seem to have been the most popular animals for these pull toys. These, too, were carved with varying degrees of realism, depending upon the ability of the carver. The wheeled horse with straight dowels for legs was made around 1840 and is a charming primitive. Even miniature horses were sometimes outfitted with real hair tails and manes and leather trappings, and often detailed wagons or carriages were made to go with a carved horse. These made extremely satisfying toys for children, who could put smaller toys in the wagon in imitation of their farmer fathers.

Other barnyard animals carved from wood were the delight of children in the nineteenth century. The yoke of oxen illustrated here is a superb folk carving from New Hampshire and dates from around 1820. Although extremely simple in detail, the oxen are in perfect proportion to the farm wagon they are pulling. Cows, sheep, and pigs were also carved, although with less frequency than horses. Illustrated here is a charming pig from the Zoar Colony in Ohio. It is painted yellow and black and is an example of the excellent workmanship turned out in many of our nineteenth-century communes.

Itinerant New England carvers and the Pennsylvania German settlers made many miniature carvings that were sold both for children's toys and for house decorations. The realism of the animal depended, of course, on the carver's skill. Sometimes the animals were painted, but more often they were left in natural wood tones with the carving suggesting their fur and markings.

Miniature dog of
unidentified breed.
Pennsylvania. Nineteenth
century. Length: 4 inches.

Poodle carved in the
manner of Aaron Mountz
of Pennsylvania. Late
nineteenth century.
(*Private Collection*)

Poodle, possibly by Aaron
Mountz. Pennsylvania.
Late nineteenth century.
Length: 8 inches. (*Private
Collection*)

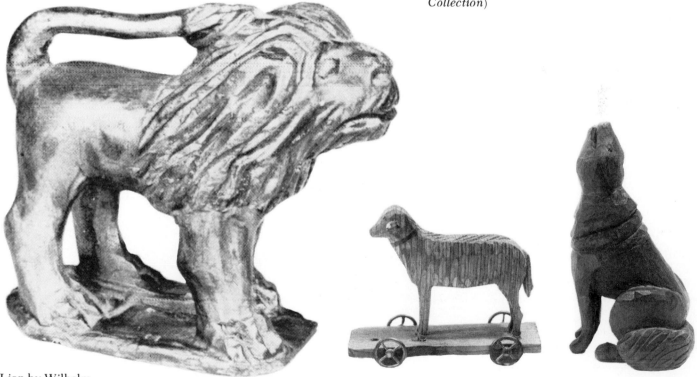

Lion by Wilhelm
Schimmel. Pennsylvania.
Circa 1880. Length: 6
inches. (*The Eleanor and
Mabel Van Alstyne
Collection, Smithsonian
Institution*)

Two miniature toys from
Pennsylvania region.
Nineteenth century.
Height of baying dog: 5
inches. (*Collection of Alan
Cober*)

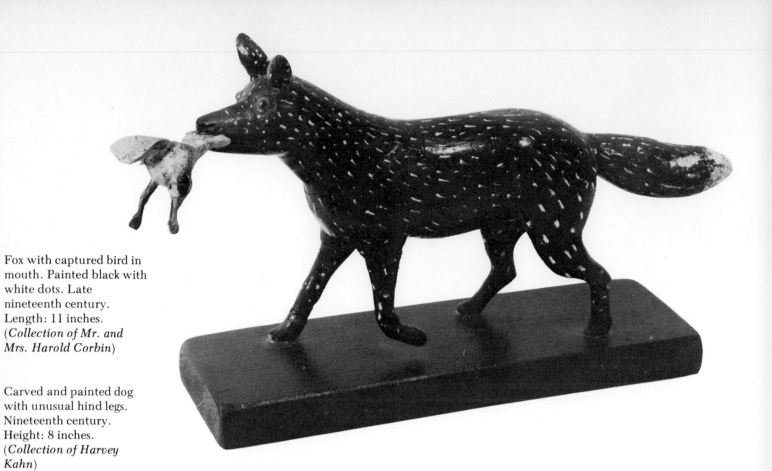

Fox with captured bird in mouth. Painted black with white dots. Late nineteenth century. Length: 11 inches. (*Collection of Mr. and Mrs. Harold Corbin*)

Carved and painted dog with unusual hind legs. Nineteenth century. Height: 8 inches. (*Collection of Harvey Kahn*)

Carved figure believed to represent a bull, but looking more like a bear. Painted gray. Nineteenth century. Height: 4½ inches. (*Collection of Harvey Kahn*)

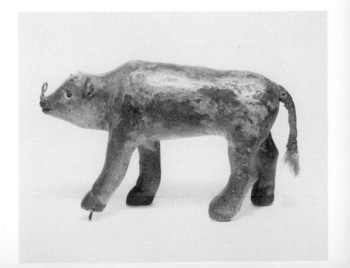

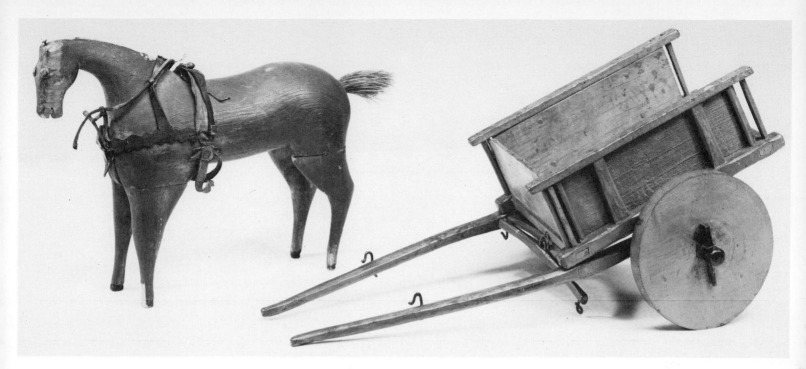

Superbly carved horse and
wagon. New Hampshire.
Circa 1820. (*George
Schoellkopf Gallery*)

Handsome oxen and cart.
New Hampshire. *Circa*
1820. (*George Schoellkopf
Gallery*)

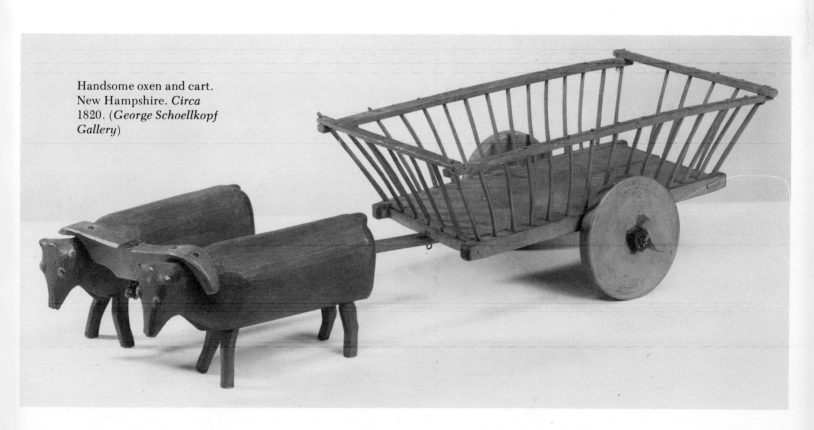

Long-legged bull with brown, white, and yellow markings. Nineteenth century. Height: 8 inches. (*Collection of Harvey Kahn*)

Horse, carved in primitive manner with hair tail. Nineteenth century. Height: 6 inches. (*Collection of Harvey Kahn*)

Pig, painted yellow and black. Zoar Colony, Ohio. Mid-nineteenth century. Length: 7 inches. (*James Kronen Gallery, Luigi Pelletieri Photograph*)

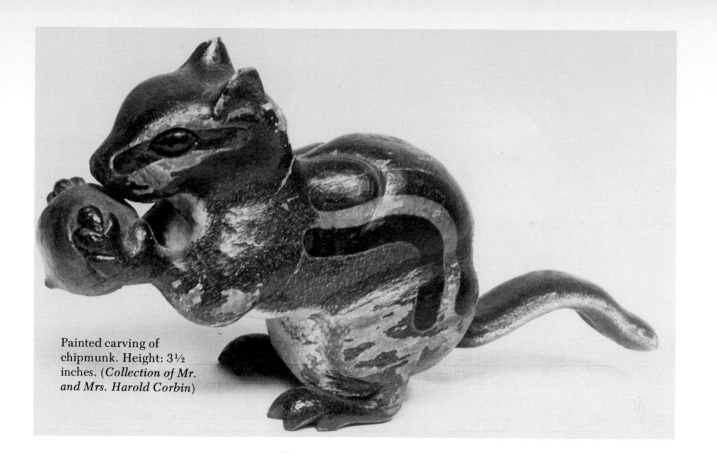

Painted carving of chipmunk. Height: 3½ inches. (*Collection of Mr. and Mrs. Harold Corbin*)

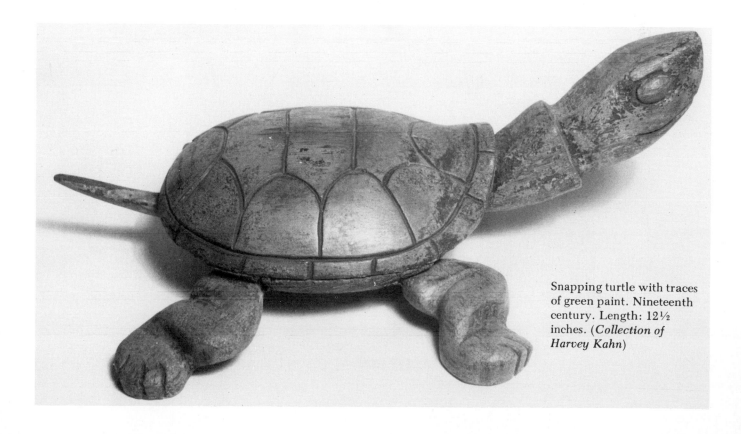

Snapping turtle with traces of green paint. Nineteenth century. Length: 12½ inches. (*Collection of Harvey Kahn*)

The Pennsylvania carvers were especially talented in the making of small animals, and they devised many small animal shapes that were unusual and delightful. A shaggy mane of a horse or dog was suggested in the carving of Wilhelm Schimmel by the device of cutting a pineapple or waffle effect.

Figures and groups taken from biblical subjects were known as "Sunday toys" because they were thought to be instructive and moralistic enough for children to play with on the Sabbath. Noah's arks were popular subjects of this type, and the wood-carvers made pairs of animals, mostly of the familiar barnyard variety, for the simple arks. Dollhouse furniture was also carved, and the most exciting of these carvings included all items used in real nineteenth-century houses.

More intricate toys were carved with moving parts and these would still delight any child today. Many of these mechanical toys were made by the Pennsylvania wood-carvers. A singular example is the small wooden turtle enclosed in an inlaid wooden box with a glass top. The turtle, mounted on a hidden spring mechanism, appears to be swimming in air when the box is tilted.

Children have always been fascinated by wheeled toys, and those that survive represent in miniature the history of the rapid development of transportation in nineteenth-century America. Carriages and horses, sailing ships, steamboats, and trains were made of wood. While most of these were commercially manufactured, some were hand-carved. Other popular toys were tops, sleds, wooden soldiers, and other human figures.

Chunky-bodied horse with black fur mane, horsehair tail, and leather harness. Possibly made originally as a pull-toy. Nineteenth century. Height: 10 inches. (*Collection of Harvey Kahn*)

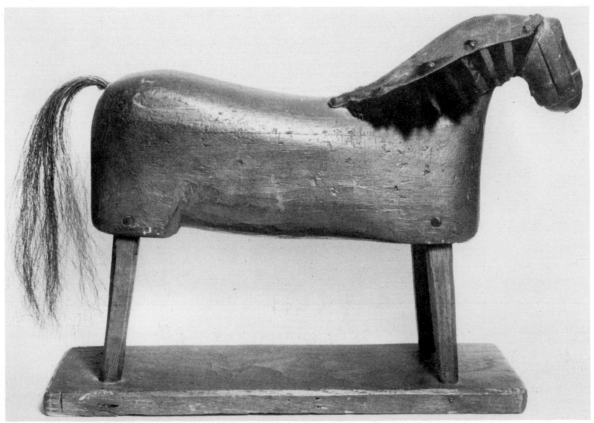

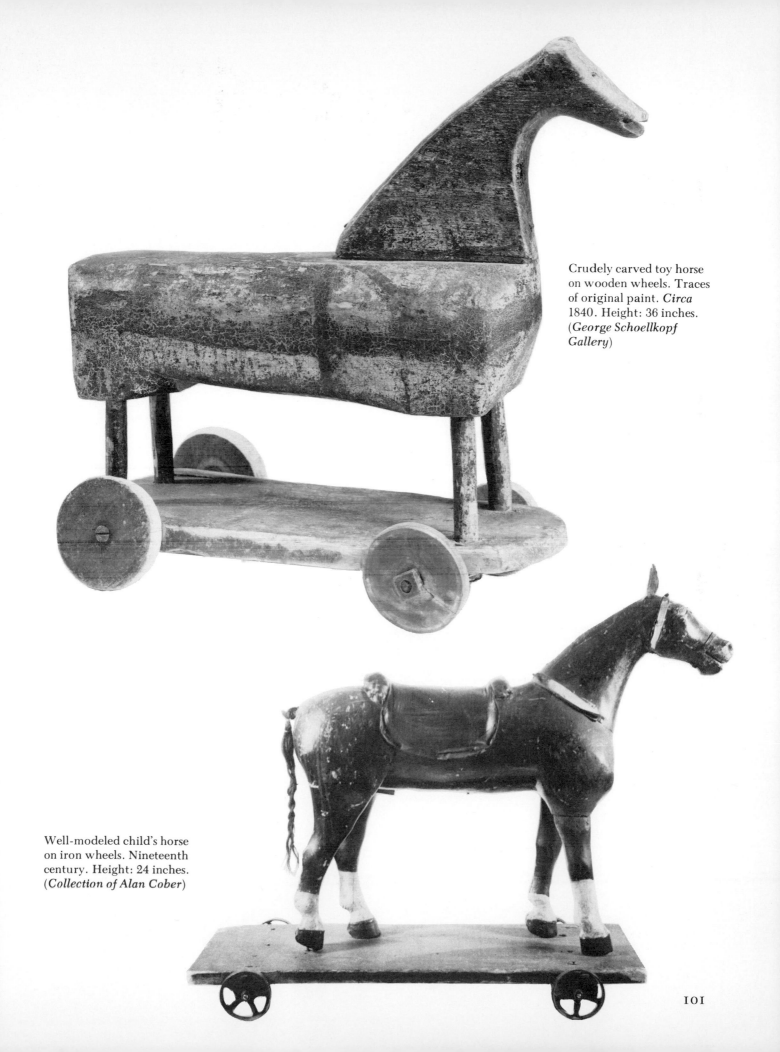

Crudely carved toy horse
on wooden wheels. Traces
of original paint. *Circa*
1840. Height: 36 inches.
(*George Schoellkopf
Gallery*)

Well-modeled child's horse
on iron wheels. Nineteenth
century. Height: 24 inches.
(*Collection of Alan Cober*)

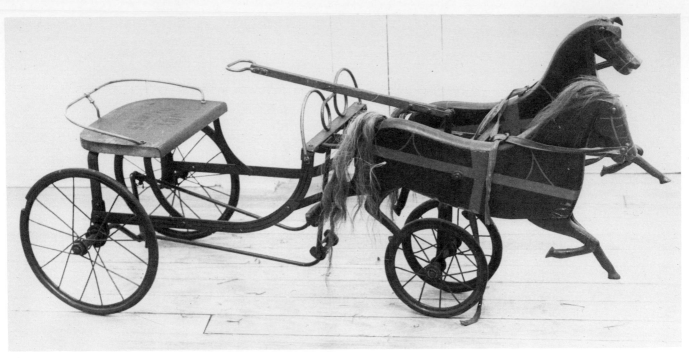

Child's pedal-operated go-cart. These carts were called "Joy Ponies" and this name is stenciled on seat. Early twentieth century. Length: 60 inches. (*Mahopac Country Museum*)

Pull-toy of man on horseback. Nineteenth century. Height: 16 inches. (*Collection of Harvey Kahn*)

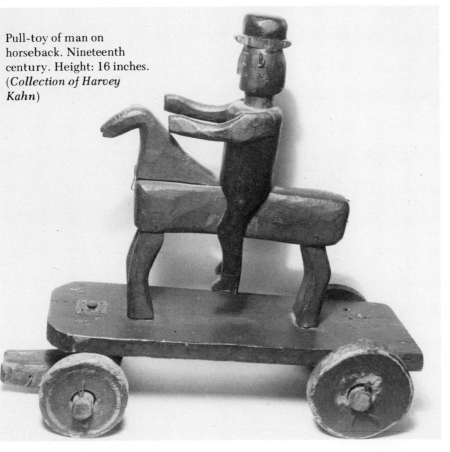

Action toy, man chopping wood. Articulated at shoulders and hips. Painted with blue boots, yellow pants, pink shirt. Nineteenth century. Height: 11½ inches. (*Collection of Harvey Kahn*)

102

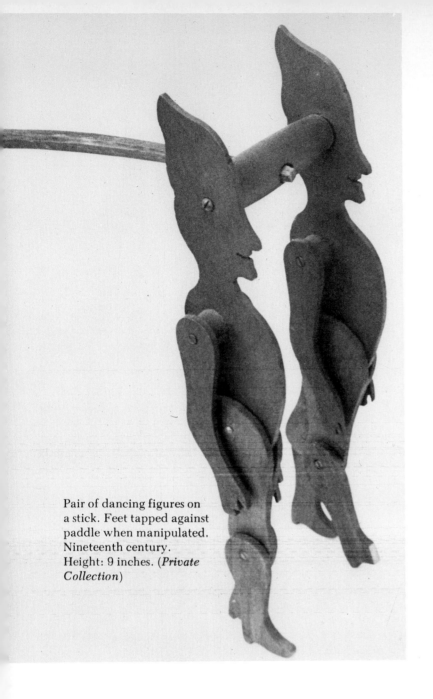

Pair of dancing figures on a stick. Feet tapped against paddle when manipulated. Nineteenth century. Height: 9 inches. (*Private Collection*)

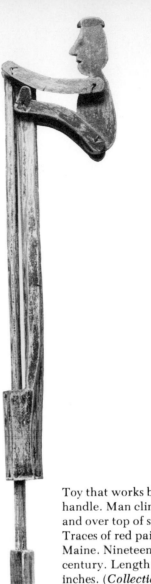

Toy that works by pushing handle. Man climbs up and over top of stick. Traces of red paint. Maine. Nineteenth century. Length: 30 inches. (*Collection of Harvey Kahn*)

Amusing turtle toy. Turtle is inside inlaid glass-front box. Head and legs are mounted on springs and move freely. Pennsylvania. Nineteenth century. Box measures 5 by 6½ inches. (*Private Collection*)

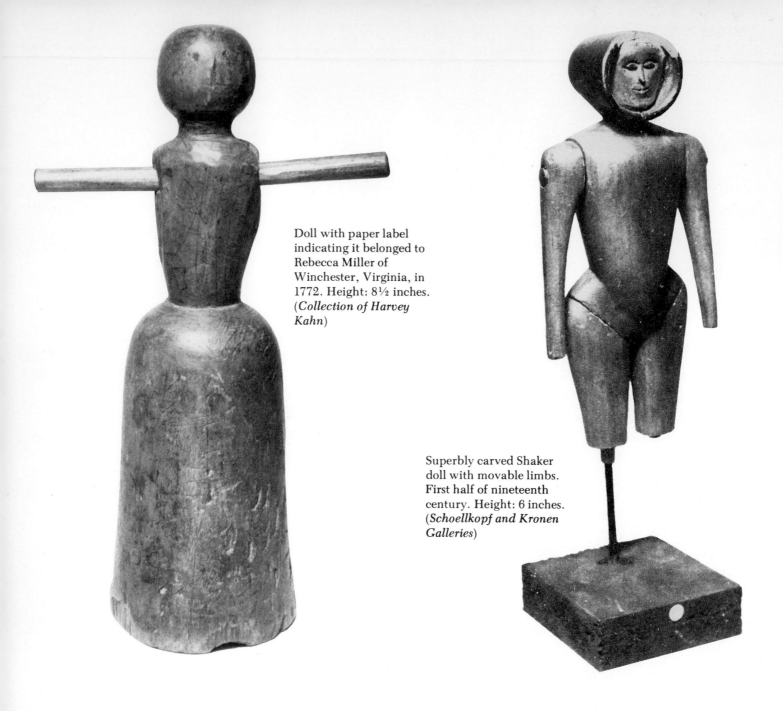

Doll with paper label
indicating it belonged to
Rebecca Miller of
Winchester, Virginia, in
1772. Height: 8½ inches.
(*Collection of Harvey
Kahn*)

Superbly carved Shaker
doll with movable limbs.
First half of nineteenth
century. Height: 6 inches.
(*Schoellkopf and Kronen
Galleries*)

While it is universally accepted that a soft rag doll is more satisfying to
own than a stiff wooden one, many wooden dolls were hand-carved and
probably much loved. Before the manufactured dolls were available on
the market in the nineteenth century, any material that could be formed in
the human shape was used by the home craftsman to provide a doll for a
small child. Frequently, only the heads and limbs were carved of wood
and a softer material was used for the body. But the wood-carver's pen-
chant for carving the human form seems to have been irresistible, and
some charming nineteenth-century wooden dolls exist today.

Some of these wooden dolls have stern faces that are in startling
contrast to the baby-doll faces that were later made by commercial doll-
makers. The Creole doll shown here is an example of a carver's skill at
fashioning heads, although the disproportionate body is less carefully

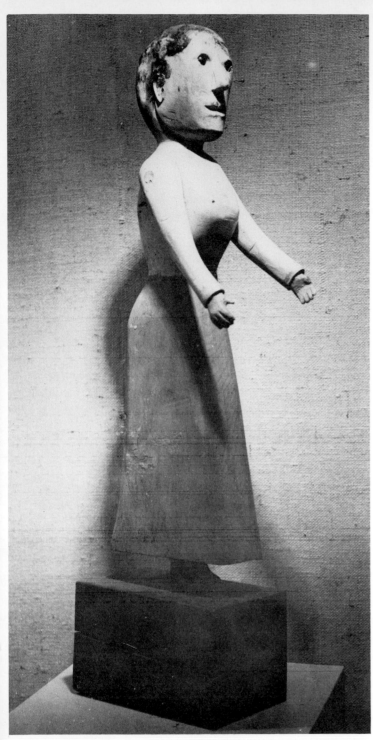

Doll. New England.
Nineteenth century.
Height: 20 inches. (*George Schoellkopf Gallery*)

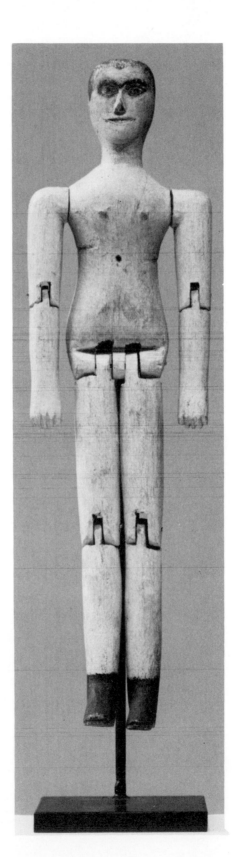

Articulated male doll.
Vermont. *Circa* 1890.
Height: 8 inches. (*James Kronen Gallery, Luigi Pelletieri Photograph*)

made. The Shaker doll, carved in the first quarter of the nineteenth century, has a more appealing facial expression. As with all Shaker products, this doll is masterfully made and very rare.

Two nineteenth-century dolls, one a female in painted costume and the other a male doll with articulated limbs, illustrate the great variety in styles and methods of doll making by the amateur carver.

One of the earliest and most primitive types of American carved dolls is the Conestoga wagon doll illustrated here. The Conestoga wagon, which originated in the Conestoga Valley of Lancaster, Pennsylvania, as early as 1755, was the prototype of every covered wagon that we see in modern movies about the settling of the West. Household goods, food, and clothing were carried in them, as well as the families of the adventurous German settlers. To keep their children occupied, fathers hurriedly whittled these simple dolls. Carved from a single block of soft wood, the shape was probably derived from that of a swaddled Indian papoose. Facial features and a blanket design were scratched in with a sharp instrument or the point of a knife.

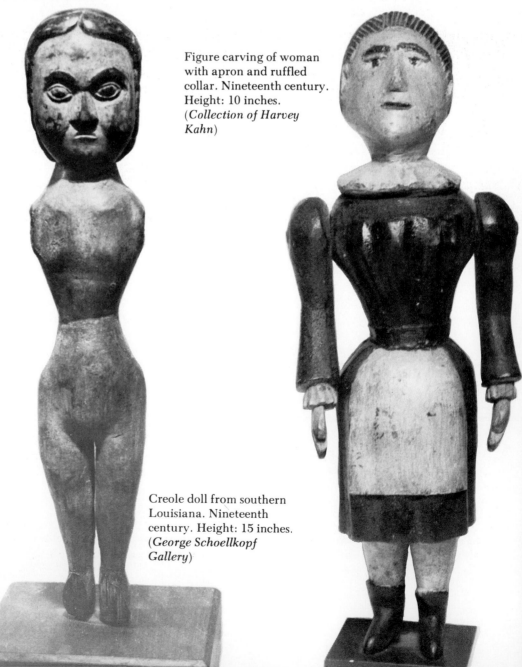

Doll of the type carved for children of families traveling west on the Conestoga wagons. Only decoration is crosshatching indicating costume. *Circa* 1830. Height: 10½ inches. (*Collection of Harvey Kahn*)

Figure carving of woman with apron and ruffled collar. Nineteenth century. Height: 10 inches. (*Collection of Harvey Kahn*)

Creole doll from southern Louisiana. Nineteenth century. Height: 15 inches. (*George Schoellkopf Gallery*)

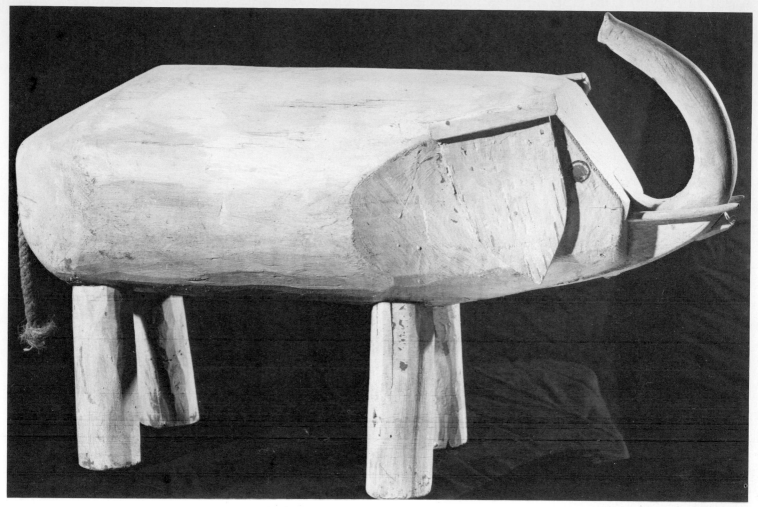

All hand-carved children's toys, made in their most simplistic forms by
our early artisans, are now considered prime examples of American folk
art. The horse and wagon illustrated earlier in this chapter, made by an
anonymous carver from New Hampshire, have all the essential elements of
what they are supposed to represent and little unnecessary detail. This is
especially true, also, of the oxcart and oxen, which come from the same
area.

The simple carved wooden animal shape that suggests rather than
defines the subject's anatomy continued in handmade children's toys into
this century. The amusing elephant with the rope tail is large enough and
sturdy enough for a small child to sit on its back. Although it is clearly an
elephant, it also resembles a barnyard pig.

Our children have been brought up with elaborate mechanical toys.
Realistic dolls that talk, sing, and perform just about every human func-
tion and battery-operated transportation toys that require no imagination
on the part of their owners are now being challenged by educators and
parents. Playthings of an earlier era are being studied, and it is easy to see
that the satisfying and predictable movement of a carved jumping jack or
of two figures of workmen who alternately hit a log with their axes every
time the toy is manipulated is far more satisfying than a rocket whose bat-
teries run down every other time it is launched.

12　Butter Molds and Other Carved Household Objects

Most of the utensils used for preparing and serving food in early American kitchens were made of wood, but few had any carved decoration. However, there is one outstanding category of carved wood collectibles in this area that was once somewhat plentiful but has now become scarce and valued. These are the molds made to shape and decorate butter that were popular in all regions of the country where the family cow was the mainstay of the diet. Butter prints have special appeal as collectors' items. They are decorative, small, and offer an almost unlimited variety of American folk motifs.

In the late eighteenth and throughout the nineteenth century, butter was seldom served without first having been pressed in to a decorative mold, and some farmers brought their butter to market in easily identifiable shapes or with an individual design. A few molds have been found with advertising slogans offering a particular farmer's quality butter. However, fewer of these molds were made than those with chip-carved or incised decorative designs. More often, butter molds were made strictly for family use and had no function except to make the table butter look attractive. At a time in history when most people's homes had few embellishments, wooden butter molds were an exception. Most molds found today date from the first half of the nineteenth century, and the earliest ones were carved by amateur whittlers. Later molds were turned out in factories that produced all sorts of household wooden ware.

Butter molds range from simple hand-stamp shapes to more complicated two-part devices with turned handles attached to an outer shell. They vary in size and shape, according to the carver's whim, but the

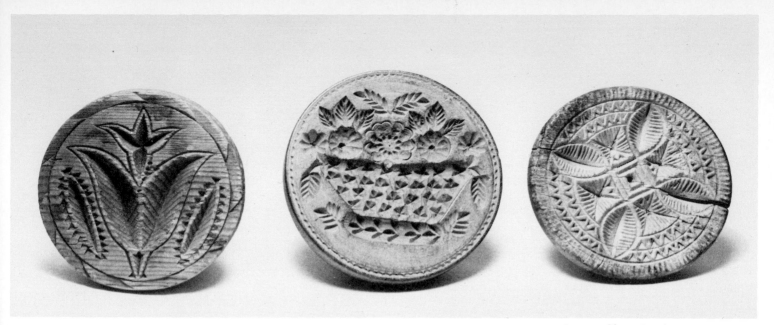

Group of butter prints,
tulip, basket of flowers,
and hex sign designs
(*Private Collection*)

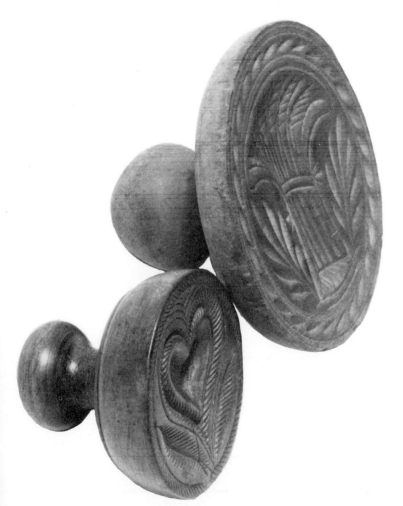

Butter prints with heart
and sheaf-of-wheat designs
(*Private Collection*)

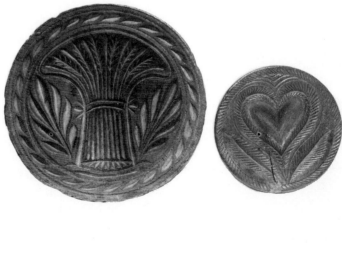

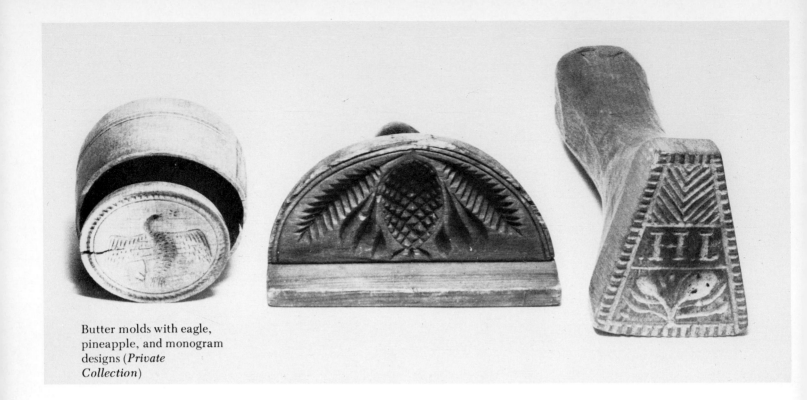

Butter molds with eagle,
pineapple, and monogram
designs (*Private
Collection*)

majority are round. Elliptical, oval, and square-shaped butter prints are
the most scarce. The woods used were those that were easiest to carve;
poplar and pine are most frequently found, but harder woods such as
maple were also used where readily available.

The tradition of using butter prints was brought to the United States by
British and other European settlers, and the motifs found on very early
molds are often British. This type of mold design, formal and symmetrical,
usually consists of the foliage and flower patterns associated with the
formal furniture of the Federal period. Many of the early molds were
made by professional wood-carvers and do not have the primitive charm
of those carved by New England or Pennsylvania farmers.

Patriotic designs, especially the figure of the American eagle, appear as
incised decoration on a quantity of butter molds made in the first quarter
of the nineteenth century. The eagle differs from mold to mold in detail
and attitude, sometimes appearing as a fierce warlike bird and usually
simplified to a minimum of detail. Sometimes a single star or an olive
branch or shield appears above the bird. The outer rims of most butter
molds are simple striated patterns.

Not surprisingly, the cow, serenely standing beneath the spreading
branch of a tree, was a popular design for butter prints. The cow is shown
with a full udder and is standing amid tall blades of grass. Many Middle
European immigrants, especially those who settled in the Pennsylvania
area, brought with them their native folk motifs and adapted them to their
butter print carvings. Tulip and hex signs are found on the molds made by
these farmers. Hearts, sheaves of wheat, and the pineapple, a symbol of
abundance, were used to imprint butter that was consumed by the family

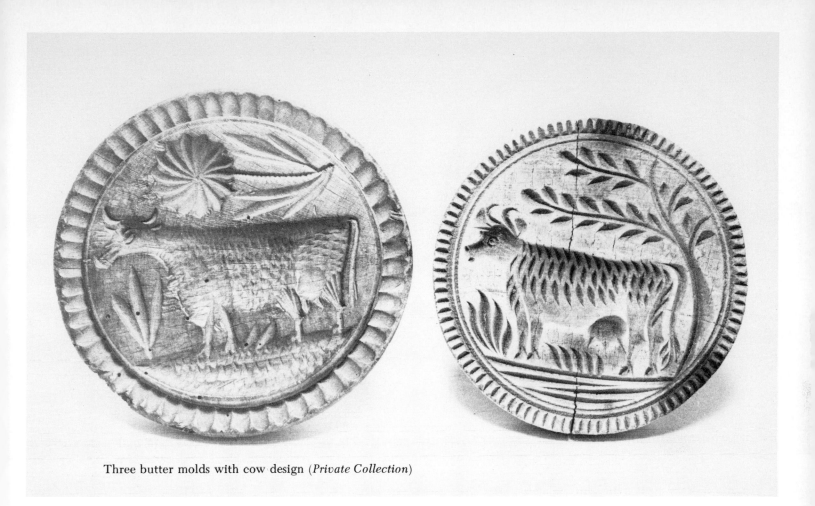

Three butter molds with cow design (*Private Collection*)

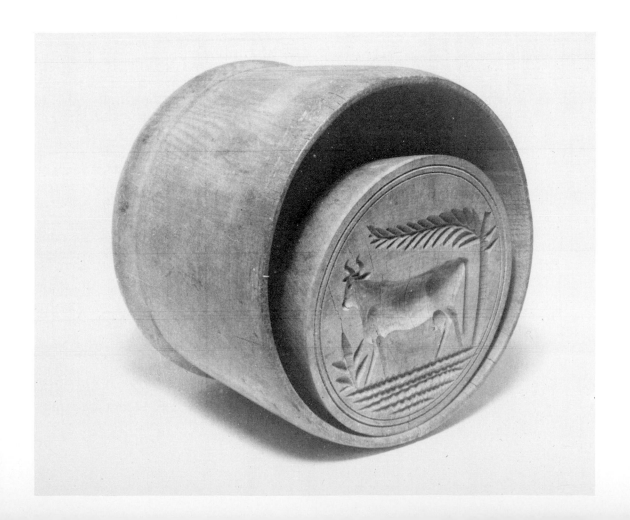

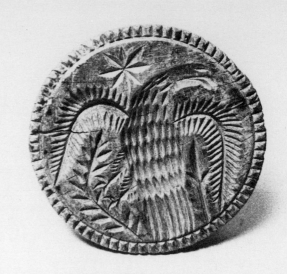

Butter prints with
American eagle design
(*Private Collection*)

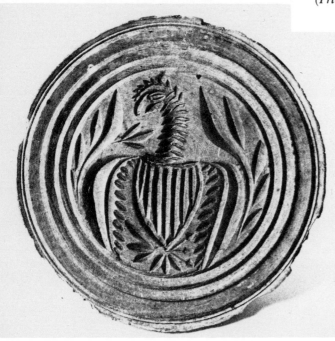

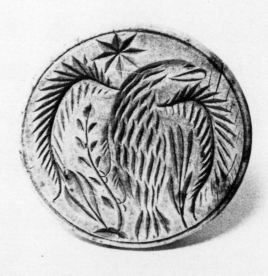

or sent to market. Monograms were sometimes used, as were birds or any other living creature familiar to the carver. An unusual mold pattern is the anchor illustrated here. Another is the mold with incised Masonic emblems.

Cookie molds and cake boards were other efforts of the wood-carver to please the family cook. These were larger and gave the carver more leeway as to imaginative motifs. The designs were often human figures of kings and queens, animals, birds, and floral patterns. These boards were used mainly by the Swiss immigrants in Ohio and the German and Dutch immigrants in Pennsylvania. It has been thought that at least some of the cake boards may have been brought to this country from Europe, but certainly new ones were carved as needed by the immigrant groups after their arrival.

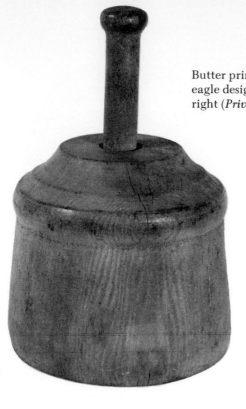

Butter print with stylized
eagle design, shown at
right (*Private Collection*)

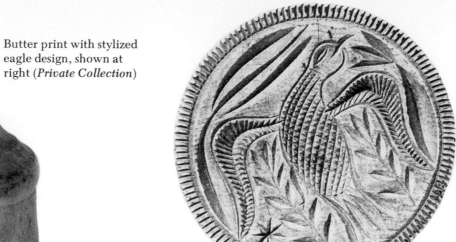

Butter mold in elliptical
shape (*Private Collection*)

Three rare butter molds:
bird, anchor, and swan
designs (*Private
Collection*)

Butter mold or cookie
board with Masonic
emblems (*Private
Collection*)

Cake board with deer
design (*Private Collection*)

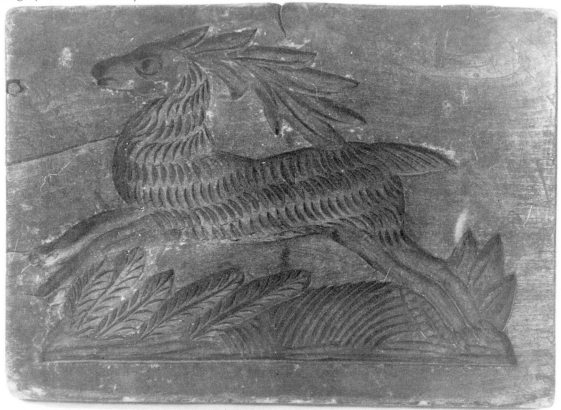

Carved wood doorstop.
Nineteenth century.
(*Private Collection*)

Carved wood box made in
Pennsylvania. Nineteenth
century. Measurements:
11¾ inches by 9¾ inches.
(*George Schoellkopf
Gallery*)

Shovel carved out of a
single piece of wood.
Nineteenth century.
Height: 54 inches.
(*Collection of Norman
Flayderman*)

Box made to contain ink bottle and pens. Initialed G.S.S. and dated 1833. Pennsylvania. Length: 11 inches. (*Collection of Harvey Kahn*)

Glove stretchers made by Shakers. Nineteenth century. (*Old Chatham Shaker Museum*)

Box with sliding top carved from one piece of bird's eye maple. Maine. Nineteenth century. Height: 5 inches. (*Collection of Harvey Kahn*)

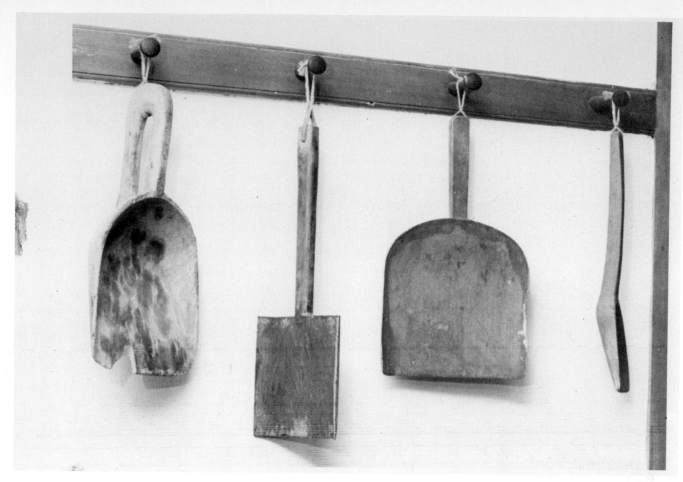

Early Shaker tools for kitchen were hand-crafted in woodworking shop of brethren. (*Hancock Shaker Village*)

Of unusual interest is the monogrammed cake or pudding mold illustrated here. Although found in California, its origins are unknown. The four side panels have alternate matching designs. They are hinged and the mold closes with the insertion of a wood pin. The interior of the separate domed lid is also elaborately carved. The mold is initialed and dated 1827.

Although only ten years ago butter prints and other wooden molds used in the kitchen were of minor interest to collectors, they are now in great demand by devotees of American wood carving and folk art. Once thought of only as decorative objects for the country kitchen, American carved butter molds now share display space with other fine examples of the whittler's and carver's talents.

There is great beauty in the functional and simple objects made by the wood-carver, usually with no extraneous patterns cut in, that were needed to perform simple household or farm tasks. One example illustrated here is the early shovel carved from a single piece of wood, which shows evidence of a great deal of use and wear.

No book on American wood carving would be complete without some examples of Shaker products. Although the use of extraneous design was forbidden in the Shaker communes, many practical objects were hand-crafted of wood. The Shakers were so adept at wood-carving that even a simple object such as a glove form has a sculptural quality. Wooden kitchen utensils were made in quantity for the great Shaker communal

kitchens of the nineteenth century, and the Shaker brethren provided these from their woodworking shops. Excellence and simplicity in design were important tenets of the American Shakers, and the qualities can be seen in the hand-carved shoe form and wooden heel illustrated here. The perfectly balanced hand mirror and the puzzling darning egg where no seam is visible in the casing that holds the revolving ball are two more examples of the beauty in simplicity that is typical of all Shaker handicrafts.

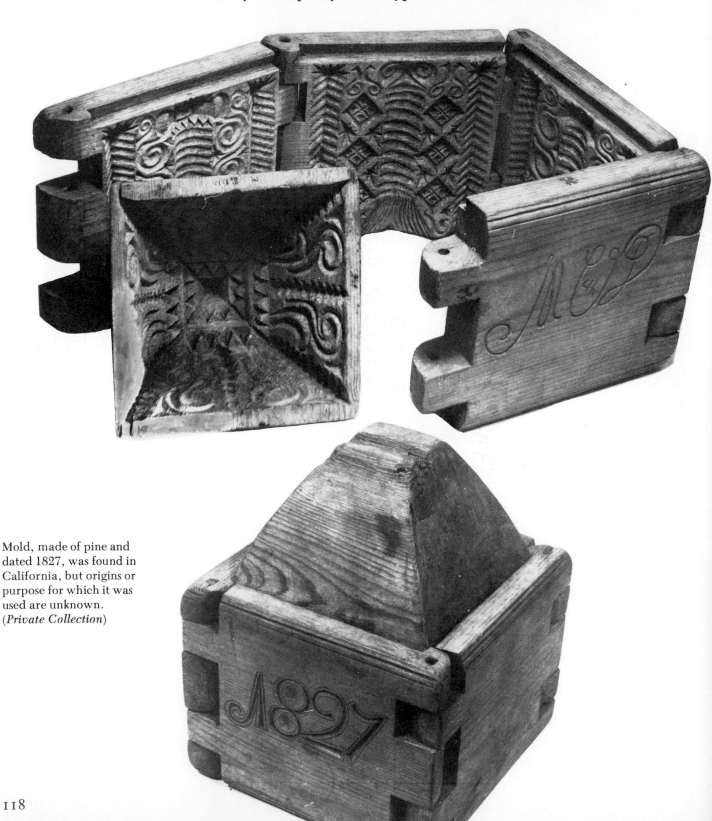

Mold, made of pine and dated 1827, was found in California, but origins or purpose for which it was used are unknown. (*Private Collection*)

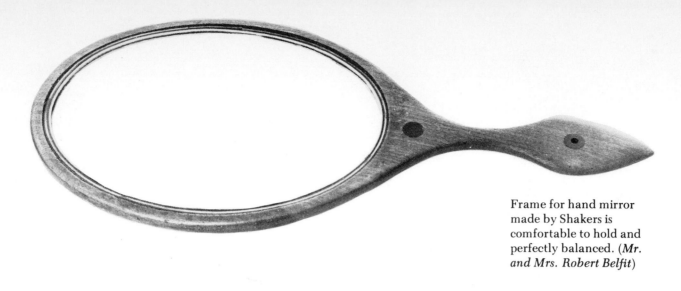

Frame for hand mirror made by Shakers is comfortable to hold and perfectly balanced. (*Mr. and Mrs. Robert Belfit*)

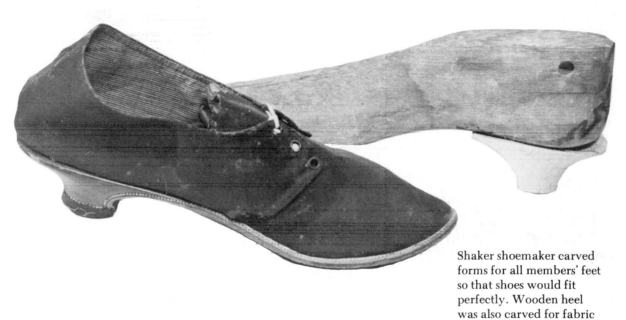

Shaker shoemaker carved forms for all members' feet so that shoes would fit perfectly. Wooden heel was also carved for fabric shoes. First half of nineteenth century. (*Old Chatham Shaker Museum*)

Simple darning ball within case is thing of beauty when made in Shaker shop. There are no visible seams on case and ball moves freely within. (*Old Chatham Shaker Museum*)

13 Figures and Faces in Wood Carving

The human figure in sizes ranging in height from a few inches to larger than life has long been a favorite subject of many wood-carvers, both amateur and professional. Sometimes figure carvings were made for practical purposes and come under other categories of folk art, such as trade figures or dolls. Others were used as store mannequins, ventriloquists' dummies, or whirligigs. One especially interesting wood figure carving in life-size was made as a combination whirligig-scarecrow and has the facial features of a pig. All figure carvings made of wood in the past are of interest today, and many transcend the area of folk art and can be considered examples of good sculpture.

Frequently, in figure carving in wood, paint was added to create realistic facial features and clothing. Such is the case with a life-size carving of a man found on Indian Island in the Penobscot River north of Bangor, Maine. The carving is vigorous and the face and attitude convey strength and masculinity.

Another Maine figure, life-size and female, is illustrated here. The nude woman's figure was found outside a mess hall of a Maine lumber camp. She has an ample body and a rather stern face and probably adorned the lumber camp site for many seasons.

There are some life-size figures with jointed limbs that are folk carvings put to the practical use of displaying clothing in a store. An especially interesting pair of such figures is the mother and child illustrated here. These figures were carved around 1920 and were found in upper New York State. They were probably used in a maternity and children's clothing shop. When found, the belly of the female figure was wrapped and built up with strips of burlap. The amusing child's figure more closely

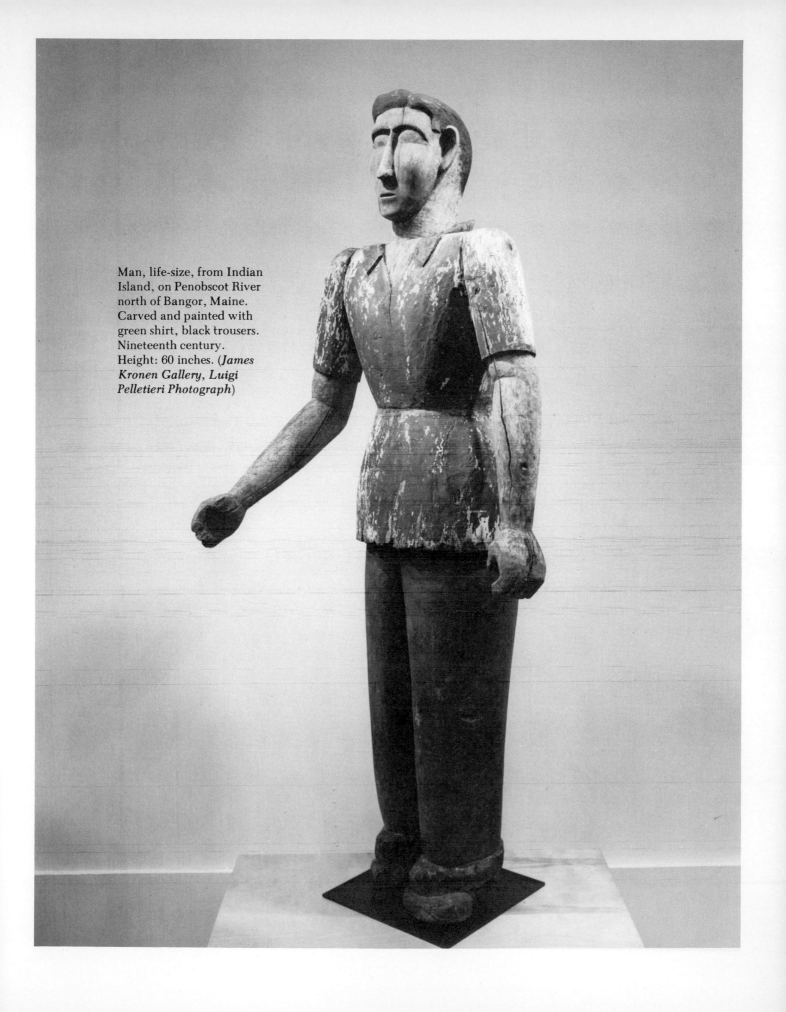

Man, life-size, from Indian Island, on Penobscot River north of Bangor, Maine. Carved and painted with green shirt, black trousers. Nineteenth century. Height: 60 inches. (*James Kronen Gallery, Luigi Pelletieri Photograph*)

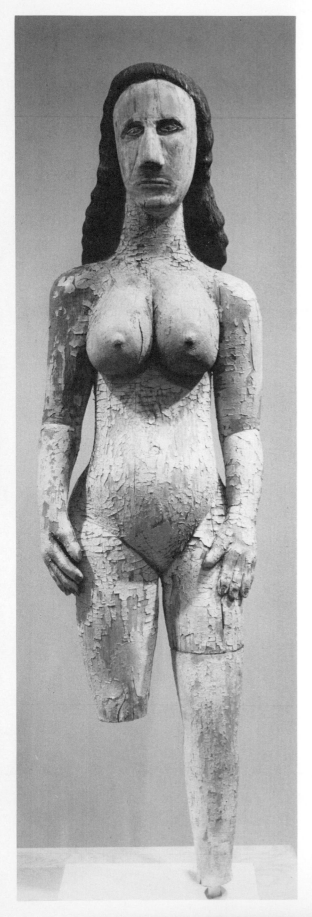

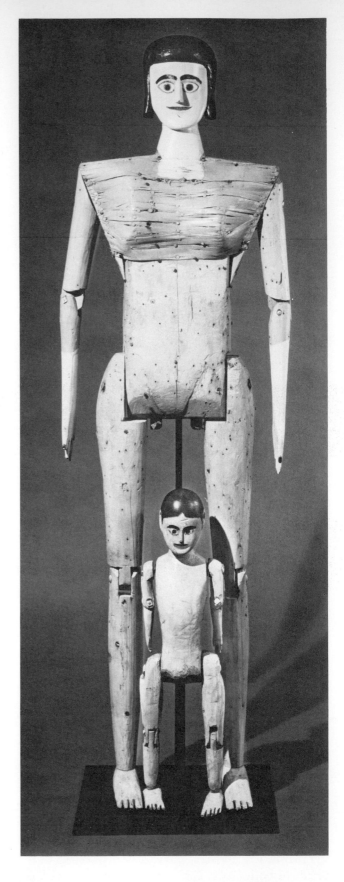

Female figure, life-size. Found outside mess hall in lumber camp in Maine and known as "Lumber Camp Lady." Height: 50 inches. (*James Kronen Gallery, Luigi Pelletieri Photograph*)

Mannequin figures, mother and child. Probably from maternity shop as belly was built up and covered with burlap strips when found. Upper New York State. *Circa* 1920. Height: 58 inches. (*James Kronen Gallery*)

resembles that of a midget, but it should be remembered that at the beginning of this century, small boys' clothing was copied from grown-ups' styles. Another mannequin of a young boy is professionally made and the slickly painted wood head is in sharp contrast to the homemade model. Mannequins were carved by the same firms that made trade figures and were available in wood or metal.

Included with the life-size carvings of people is the aforementioned remarkable scarecrow built of found lumber. Its carved and painted face has the features of a pig. One leg and both arms are articulated, and the block-shaped hands probably once held paddles and worked as a giant whirligig. In addition to this movement, the head bobs up and down. Certainly, this strange-looking creature should have been enough to save any corn crop from disaster.

An extremely interesting and beautiful smaller carving of a female figure comes from South Carolina. It is a nude woman encoiled by a large snake and is probably associated with a snake worship cult from that section of the country. The figure is carved from one end of a slender log, the remainder of which forms a tall plinth.

Small human figures have been carved by artists now unknown, and many of these carvings are magnificent for their simplicity and balance, and the carver's understanding of his material. A few of these small carvings transcend the realm of folk art and are superb sculpture. One female figure that fits into this category is the small lady from New Hampshire, carved in 1878 by an artist whose name is now lost to us. The figure is only 6½ inches tall and in form and face is highly stylized, predicting late-nineteenth-century Impressionistic sculpture. Through the soft curves carved by the artist and the minimal facial features, we get a clear idea of what the model looked like. The subject has a grace and delicacy that distinguishes it from many other carvings made in the middle of the nineteenth century. By suggestion, rather than realistic carving, the maker created a sensual figure that stands quite apart from the ordinary.

Professional carvers who made figureheads, trade figures, and other commercial products sometimes turned their talents to a commissioned bust portrait. Relatively few of these classic-style busts were made. Wealthy seacoast shippers and merchants who had access to the figurehead carvers probably commissioned their portraits for display in their own homes. These busts are extremely important to historians since the professional and realistic painting gives one a clear idea of what the now weathered and repainted figureheads once looked like. Little attention has been given to the skilled painters who worked for the carvers, since their work cannot be seen on most existing figureheads. It does, however, remain intact on most of the well-protected portrait busts.

In contrast to the carved and painted classic realism of the ship owner or merchant portrait bust is the carved bust of Admiral Dewey previously shown. The Dewey bust depends on the carving alone for its realism and the portrait conveys a strength of character befitting a great naval hero.

Miniature figures, carved and painted in a naïve style, are special favorites of collectors. Often these figures, only a few inches high, were part of a panorama of people in a related environment. This is true of the hundreds of figures in the previously discussed Brinley Circus. A test of the

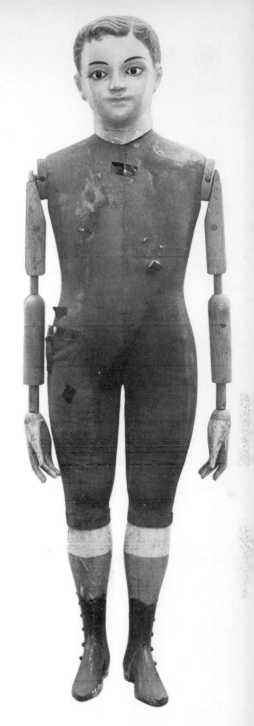

Clothing store mannequin of boy. Carved wooden head, legs, and jointed arms. *Circa* 1900. Height: 48 inches. (*Mahopac Country Museum*)

123

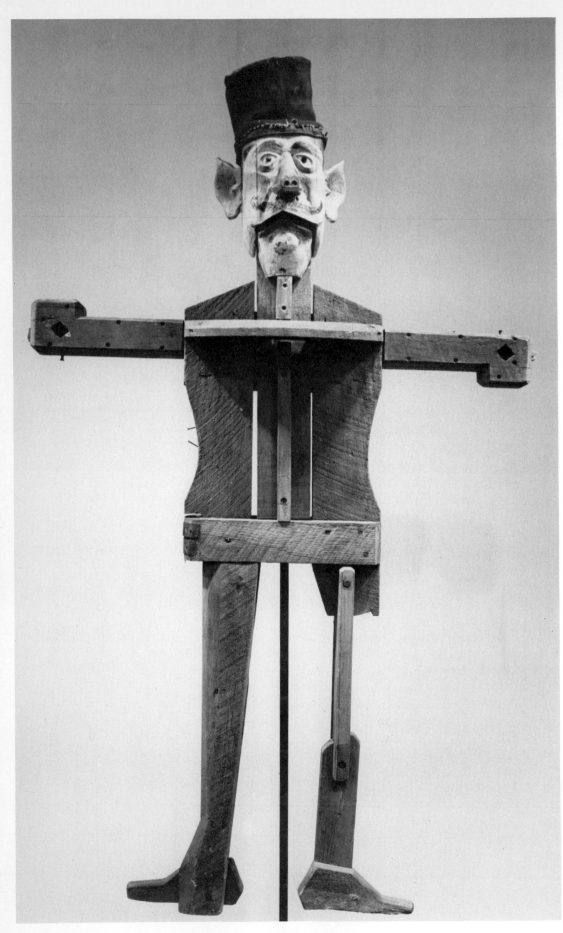

Scarecrow, full human
height with carved wood
pig face. One leg and both
arms articulated. Probably
made with paddles on
arms to work as whirligig.
Head moves up and down.
Nineteenth century.
(*James Kronen Gallery,
Luigi Pelletieri
Photograph*)

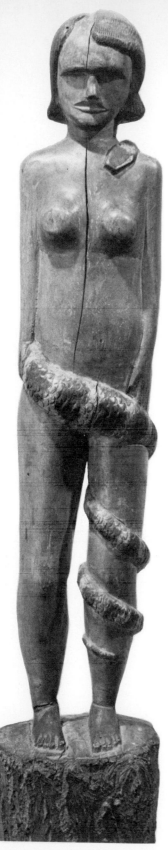

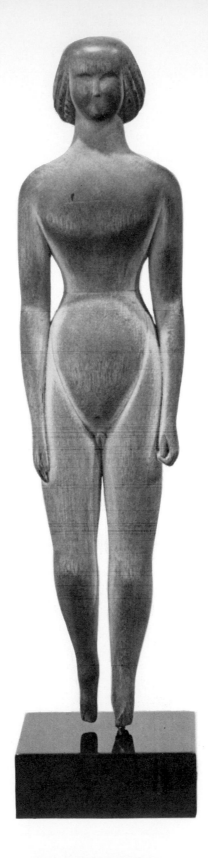

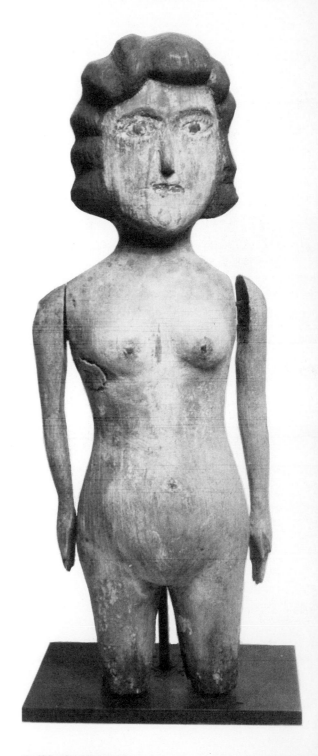

Carving of lady and snake
from South Carolina.
Possibly associated with
snake worship cult.
Height: 16 inches. (*James
Kronen Gallery, Luigi
Pelletieri Photograph*)

Exceptional carving of
female figure was made in
New Hampshire. *Circa*
1878. Height: 6½ inches.
(*James Kronen Gallery,
Luigi Pelletieri
Photograph*)

Doll body of mature
woman painted with pink
flesh tones and brown
hair. Height: 9 inches.
(*Collection of Harvey
Kahn*)

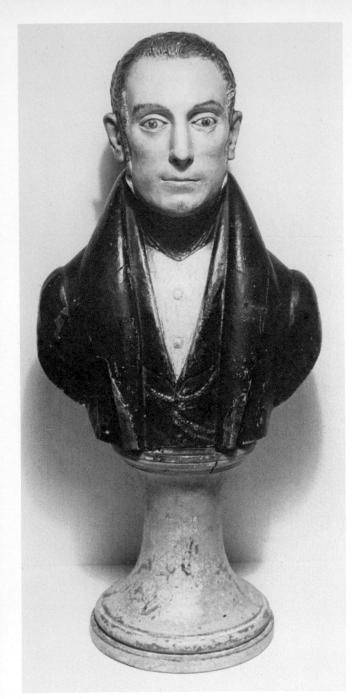

Portrait bust from either New Bedford or Nantucket, Massachusetts. Probably done by skilled ship-carver. Gesso over wood, realistically painted in manner of figureheads. First half of nineteenth century. Height including pedestal: 28 inches. (*Collection of Dr. William S. Greenspon*)

Bust of woman. Traces of white paint. New England. Eighteenth century. Height: 20 inches. (*Collection of Dr. William S. Greenspon*)

Female mannequin head.
Nineteenth century.
Height: 12 inches.
(*Collection of Harvey Kahn*)

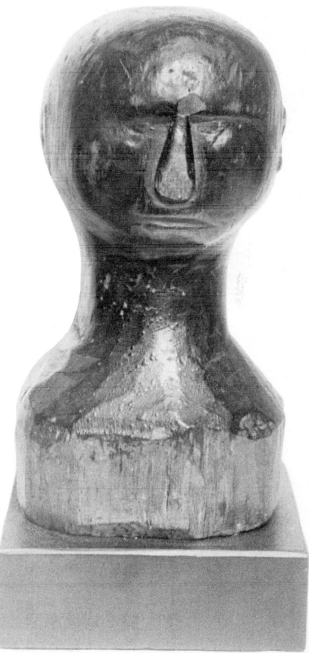

Primitive carving of head
by unknown maker is
distinguished by strong,
direct expression. Height:
6 inches. (*Collection of Harvey Kahn*)

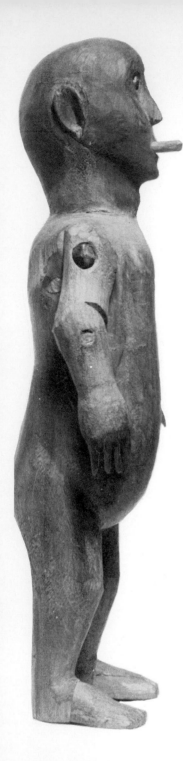

carver's talent is whether the tiny figures, when removed from their background, have sufficient merit to appeal individually. In some cases, the figures, which were meant to be seen as part of a whole picture, are oversimplified or lack strength and character.

The tiny primitive carvings from the "Automatic World" of Ohio folk carver James McCallister Edgington (1862-1942), taken individually from a large and complicated carved villiage, pass all tests for good figure carving. None of the figures is over a few inches high, yet each conveys humor and character. Whether displayed as an entire picture, as in the butcher shop portrayed here, or taken individually, each little figure has an easily understandable expression that the artist was able to create with very simplified carved and painted facial features and position of the body.

Carving of man with cigar. Both arms are separately carved and fastened at shoulder. Right arm articulated at elbow. Nineteenth century. Height: 13 inches. (*Collection of Harvey Kahn*)

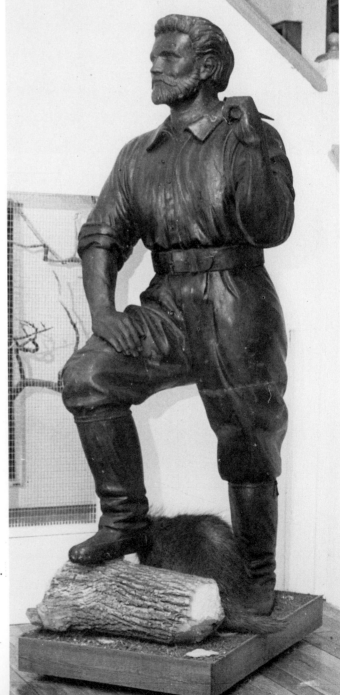

Heroic-size figure of Paul Bunyan, legendary woodsman of American Middlewest. Carved from 327 separate pieces of wood. Late nineteenth century. Height: 96 inches. (*Mahopac Country Museum*)

An earlier miniature figure carving of a Civil War soldier in a Union uniform is by an unknown carver. The personality of the subject is conveyed in the simple carving and few lines of paint. The seated figure has personality and character and is both amusing and serious at the same time. In addition, his clenched fists and firm posture tell us something of the Pennsylvania carver who made him.

An extremely rare type of miniature carving is the figure of a Russian naval officer illustrated here. The work is attributed to a northwestern Indian tribe, the Haida, and the figure is wood with a carved ivory face. The uniform and hat are painted blue, and the face and figure are both extremely expressive. This small figure is a masterpiece of American folk art.

The above are only a few of the many types of human figures that have been carved from wood. The ability of the artist to see his subject inside a piece of wood and to work from the outside inward until he has achieved his goal in creating his own conception of the human form varies, of course, with his talent. The folk artist sometimes used paint and scraps of lumber to create his "people." Many collectors agree that it is the folk carver who tells us the most about ourselves and our history.

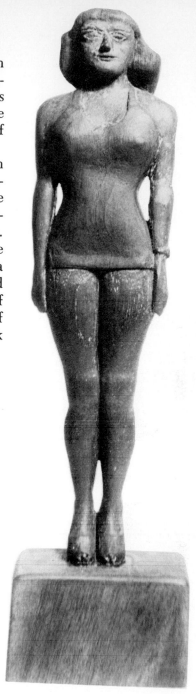

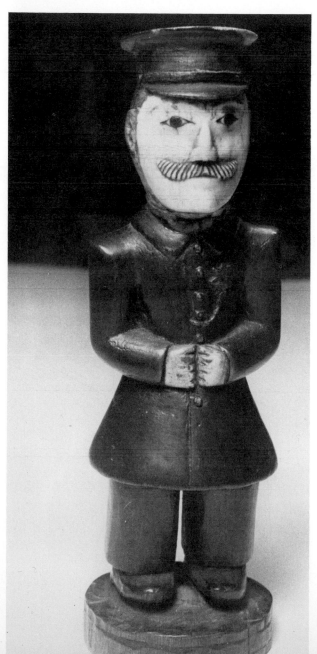

Figure of Russian naval officer carved by Haida Indians of British Columbia, Canada, and southern Alaska. Painted wooden body with bone or ivory face. Height: 6 inches. (*Collection of Dr. William S. Greenspon*)

Carved figure of bathing beauty of the 1920s. Height: 11 inches. (*Collection of Harvey Kahn*)

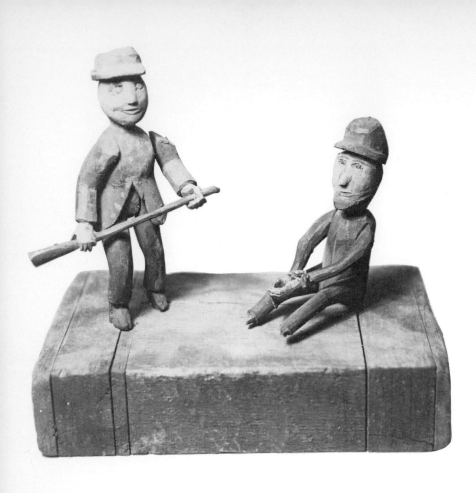

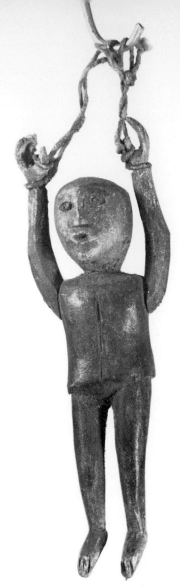

Group of figures done by Ohio folk carver James McCallister Edgington who died in 1942 at the age of eighty. Typical figure height: 3½ inches. (*George Schoellkopf Gallery*)

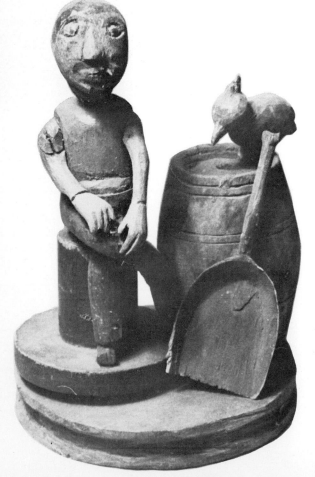

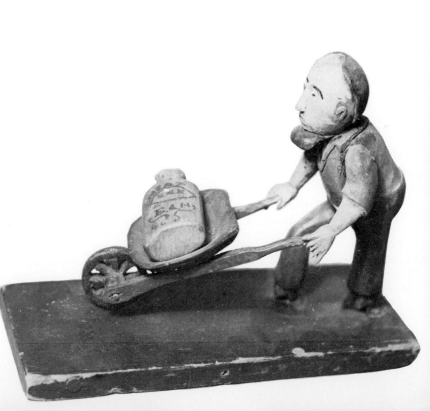

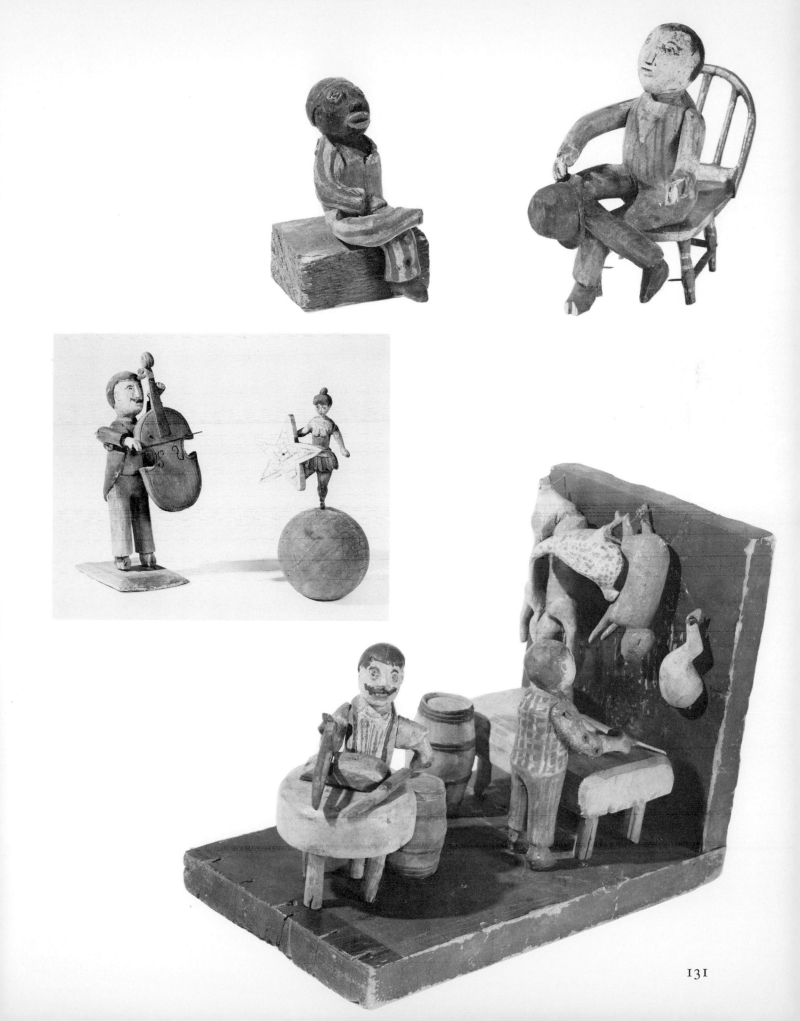

14 Bird Decoys

Perhaps no other area of wood carving is as closely associated with the American craftsman as the bird decoy. The decoy is usually thought of as a realistically carved duck used to lure his high-flying brethren within range of a sportsman's shotgun. While this is true to a degree, carvers in this country have developed such a broad range of decoy subjects, styles, and attitudes as to make the carving of decoys a uniquely American folk art.

Some form of decoy had been used for centuries in Europe, and the ancient Egyptians are said to have tied live ducks to entice migrating birds into their snares. But the early New World colonists learned of the art and effectiveness of the decoy from the American Indian. Indian decoys were crude, sometimes mere blocks of wood, stuffed skins, or bundled straw. The settlers gradually improved on the Indian models by evolving lifelike models of the hunted species that were accurate to the last detail of size, configuration, and coloring.

Decoy making was given its greatest impetus in the latter half of the nineteenth century as the population of the cities began to grow and fewer people were able to raise food for their own table. The western grazing ranges with their huge herds of beef cattle and the railroads to bring them to eastern markets were still in the future. A much cheaper source of meat existed in the numberless flocks of migratory wild fowl that periodically darkened the skies over coastal areas and inland feeding grounds.

To deliver this apparently inexhaustible supply of food to a meat-hungry populace, there grew up a special breed of hunter known as "market gunners." These skilled marksmen were aided by the introduction of the more efficient and economical breech-loading guns that replaced the cumbersome and inaccurate flintlocks and muzzle-loaders. With the supply of wild fowl so plentiful and cheap, it was important to the market

gunners that their quarry be brought down in great numbers within the limited range of their guns in order to conserve ammunition and make each shot more productive.

Each gunner succeeded in doing just that by whittling for himself a set of decoys (sometimes known as a rig) realistic and natural enough to bring an inquisitive, yet cautious, quarry within gunshot. The size of a professional hunter's rig could range from fewer than a dozen birds to as many as several hundred. The number and variety of species, sexes, sizes, and attitudes making up a rig were determined by each hunter's long experience and remained his private formula for a successful day's shooting.

Since the rig and the individual decoys that comprised it were essential to the livelihood of these men, it is natural that a considerable amount of time and attention was devoted to their improvement. An effort was made to make the decoys appear as natural as possible, float properly, and be sturdy enough to withstand rough handling and long exposure to water and weather. It is remarkable how well some of the hunters accomplished this task. Working with only such rudimentary tools as a hatchet, jack-knife, and wood rasp or file, some of them turned out hundreds and even thousands of decoys that are now esteemed as folk art of the highest order.

The wholesale slaughter of edible birds went on for about seventy-five years, until 1918, when the United States Congress passed the Migratory Bird Treaty Act. The bill was designed to protect our remaining wild fowl and prevent the extermination of species other than the passenger pigeon, labrador duck, and the heath hen, which by that time had already been killed off.

Along with the decoys produced by the hunters, there developed a kind of cottage industry among those carvers skilled enough to make decoys for sale. These they supplied to the casual hunters who shot birds just for their own table or for the sport. Some decoy-makers worked at this pursuit full-time, while with others it was a spare-time hobby and a way to earn a small supplementary income. The amount of this extra pocket money was assuredly quite modest seventy-five or a hundred years ago, since the best work by the most outstanding carvers rarely earned them more than fifty cents apiece.

Technically, more is involved in fashioning a good working decoy than merely carving a block of wood into the shape of a particular species of bird. In order to float properly on a still-water pond or rough waters along the ocean shore, a decoy must first have a suitable degree of seaworthiness. Early decoys, carved from a single block of white pine or cedar, tended to ride too low in the water. This characteristic was overcome by hollowing out two blocks of wood for the body and fastening them together. Some makers gouged out the interior of both halves, while others took most of the material out of a thick top slab and used a thin plank for the bottom.

In order for the decoy to retain an upright position in the water, a keel, or bottom weight, had to be applied. Most makers used lead for this purpose, and we find a wide variety of keel shapes, sizes, and means of application to the body. Some makers used a teardrop weight screwed to the body; others used a lead strip that ran the length of the underside of the model. A more painstaking method was to countersink a cavity into the bottom plank, insert a brass screw, and fill the hole with molten lead. This

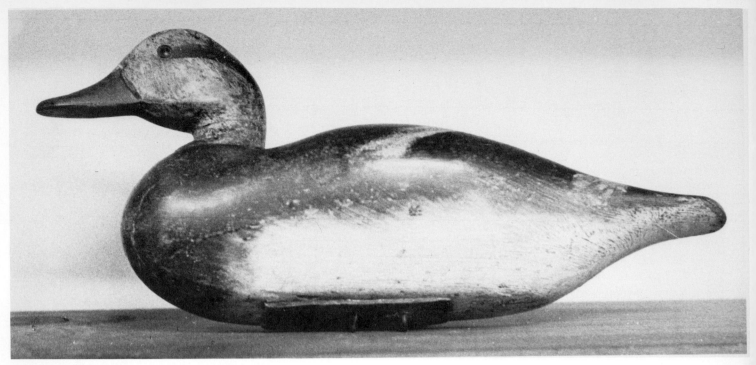

Antique decoy showing keel-weight and eyelets on bottom used to secure anchor. (*Charles Murphy*)

provided a smooth surface and allowed the bird to be displayed better, although it did not make a better-working decoy.

One of the finest and most prolific carvers of the late nineteenth and early twentieth centuries, Harry Shourdes of Tuckerton, New Jersey, along with other workers in this area, weighted birds in an unusual manner. These men gouged out a trough around the inside of the hollowed-out bottom half of their birds and filled this canal with molten lead. This method worked perfectly well as a ballast, but the hot lead burned the wood, causing the charred area to rot eventually and the lead to become loose.

Each floating decoy was also fitted with a screw eye or hole drilled across the bottom to which an anchor line could be attached. The anchors prevented the birds from floating away and preserved the pattern of the rig as it was set out by the hunter.

The head for each decoy was usually carved from a separate piece of wood, preferably harder than the cedar or pine used to make the body. Heads, and especially the bills, were the parts most susceptible to accidents in handling and transporting the decoys. Being able to replace a damaged head on a sound body was a definite advantage. Various methods have been used to attach the heads, ranging from simple nailing and gluing to the use of wooden dowels or long brass screws. Decoy-makers from the Monhegan Island region in Maine developed a distinctive means of mounting the head to the body that involved carving out a portion of the body and countersinking the heads into the resulting mortise.

A well-made collectible decoy must be judged not only on the fidelity of the carving to the intended species and its overall workmanship and durability. The finish of the decoy in terms of detailed carving and painting is equally important. The additional effort required in carving tail or wing feathers, careful attention to the placement of the painted or glass eyes, down to drilling nostril holes in the bills, are all points on which excellence in decoy carving is judged.

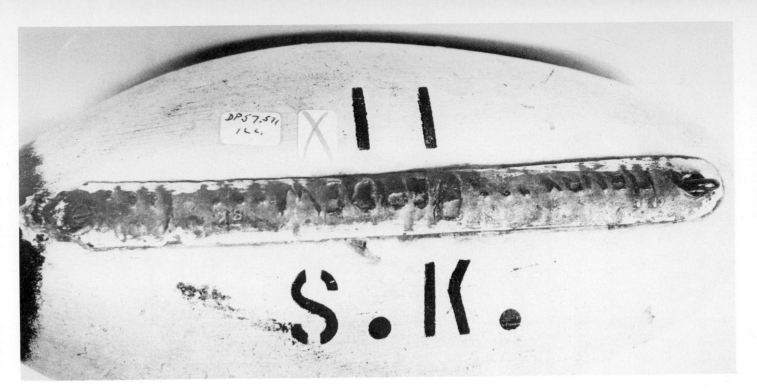

Lead weight on bottom of Perdew decoy identifies maker. Intials are those of decoy's owner. (*Collection of Harold Corbin*)

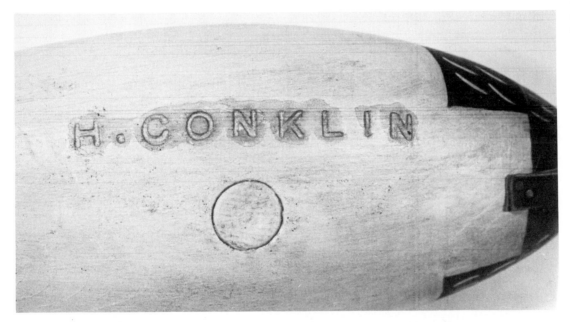

Signature of Conklin decoy is burned with brand into bottom. Circle is where lead weight has been introduced and hole covered with wooden peg. (*Collection of Harold Corbin*)

While there have been many skilled and adroit carvers of decoys, the true masters of the art are distinguished by their painting of finished birds. Paint color should be faithful to the natural appearance of the species, extremely durable, and have a dull finish. Many fine decoys were painted in a bold, stylized fashion, but the best examples give the impression that each feather is separate, with its texture and lines painted in.

Each of the great wild fowl hunting grounds produced decoys of the species that were the most plentiful and desirable in that area. South from Maine, along the Atlantic coastline, to the Carolinas, the most frequently found decoys are those representing the eider, black, canvasback, and

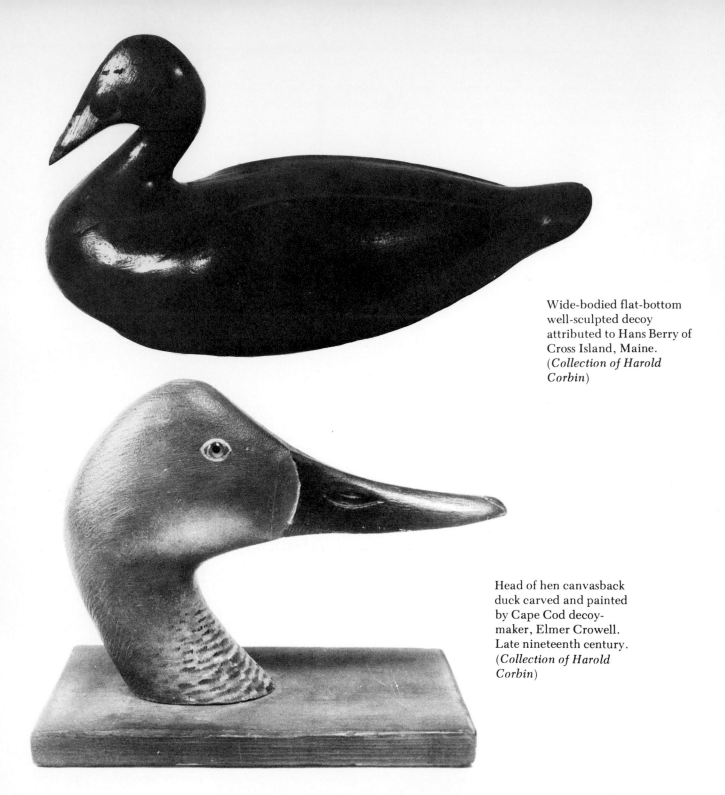

Wide-bodied flat-bottom well-sculpted decoy attributed to Hans Berry of Cross Island, Maine. (*Collection of Harold Corbin*)

Head of hen canvasback duck carved and painted by Cape Cod decoy-maker, Elmer Crowell. Late nineteenth century. (*Collection of Harold Corbin*)

pintail ducks, the Canada goose, and greater scaup. Especially numerous and just about as indigenous to the East Coast are the decoys of such shorebirds as the plover, curlew, yellowlegs, sandpiper, and dowitcher. Decoys of these small, perky birds were called "stickups," because they were not made to float, but to stand on the shore or in marshes on thin sticks pushed into the sand.

Most of these shorebirds were fairly edible but did not come under heavy attack until the constant hunting of the more satisfying ducks and other large fowl began to thin their numbers significantly. Since they are

small, shorebird decoys could usually be carved from a single piece of wood, although some early models had separate heads carved from a suitably shaped root or limb. The long bills peculiar to these species were made of a hard wood, such as oak or locust, and, in New England, were inserted partway into the head with a tight fit. Elsewhere, the bills went completely through to the back of the head where they were secured with a wooden spline or wedge.

The great flocks of shorebirds diminished considerably between the beginning of this century and the 1920s, when their shooting was prohibited by law due to the excessive hunting by sportsmen and market gunners. It was during this period that the finest shorebird decoys were made. In order to lure the dwindling numbers of the now more wary birds, greater effort was put into producing more lifelike decoys. Formerly, any crude likeness, such as cardboard cutouts or flat boards or sticks, would serve the purpose. Now, attention was paid to carving full-bodied birds, accurately painted in attitudes of running, preening, feeding, and even giving evidence of being wounded. Today, shorebird decoys may be found that exhibit a great variety of attitudes, colors, sizes, and shapes.

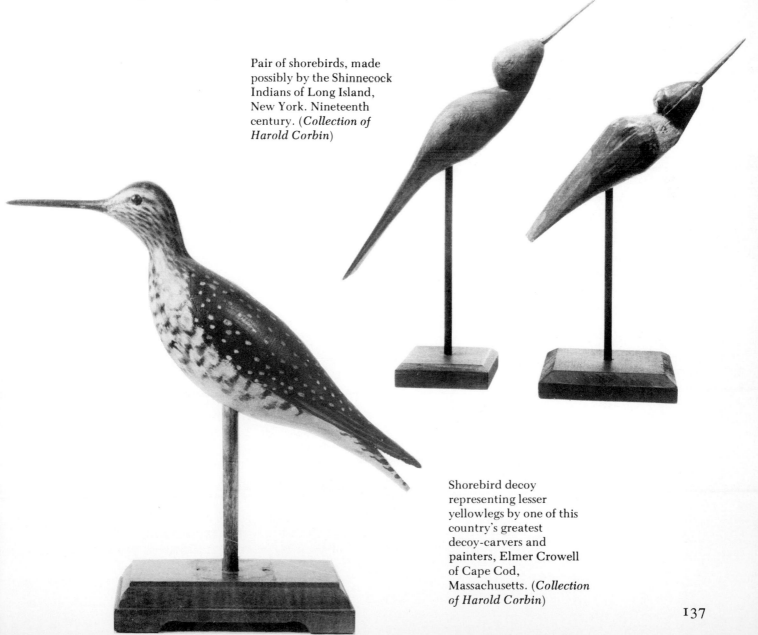

Pair of shorebirds, made possibly by the Shinnecock Indians of Long Island, New York. Nineteenth century. (*Collection of Harold Corbin*)

Shorebird decoy representing lesser yellowlegs by one of this country's greatest decoy-carvers and painters, Elmer Crowell of Cape Cod, Massachusetts. (*Collection of Harold Corbin*)

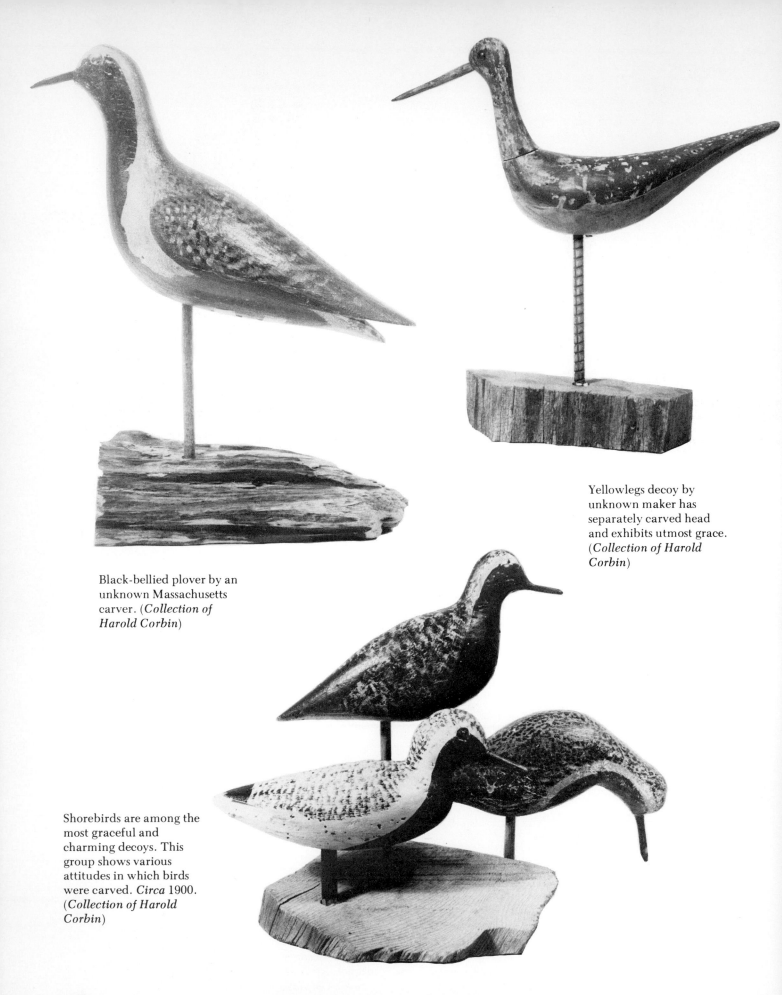

Black-bellied plover by an unknown Massachusetts carver. (*Collection of Harold Corbin*)

Yellowlegs decoy by unknown maker has separately carved head and exhibits utmost grace. (*Collection of Harold Corbin*)

Shorebirds are among the most graceful and charming decoys. This group shows various attitudes in which birds were carved. *Circa* 1900. (*Collection of Harold Corbin*)

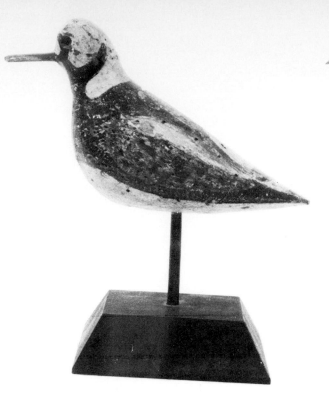

Shot marks on this ruddy turnstone from New Jersey indicates that it was a working decoy. (*Collection of Harold Corbin*)

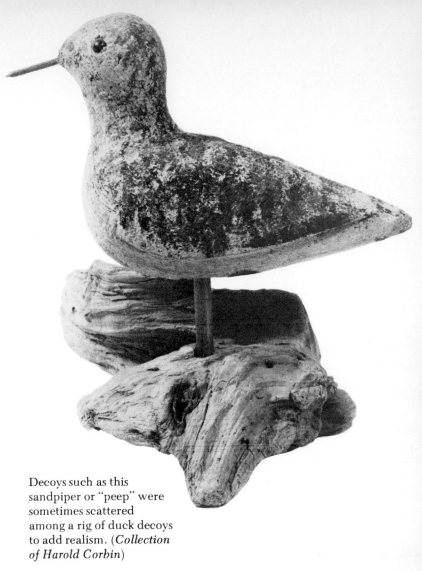

Decoys such as this sandpiper or "peep" were sometimes scattered among a rig of duck decoys to add realism. (*Collection of Harold Corbin*)

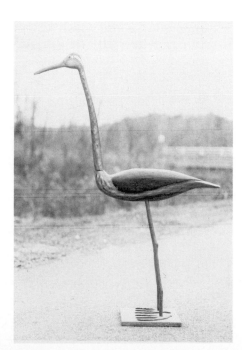

Great blue heron decoy possibly from New Jersey stands over 4 feet tall. Herons were supposedly a delectable bird. (*Collection of Harold Corbin*)

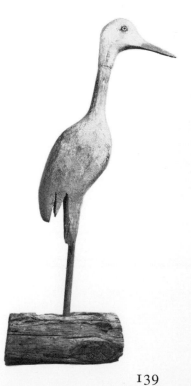

American egret decoy possibly from Long Island or New Jersey. In the North, egrets were hunted for food rather than for their plumage. By 1900 they had become almost extinct. (*Collection of Harold Corbin*)

139

Other limited but important categories of decoys are those of birds not hunted for food and those that were made to enhance the credibility of a rig of duck or shorebird decoys. In the first group would be decoys of crows and owls. Crows were hunted as pests or for sport when the game bird population declined, and limits were placed upon the number that could be bagged and on the length of the season during which they could be shot.

Crows are wary birds, and after being shot at for a while, they learn to avoid congregating in large flocks on exposed tree branches or open fields. However, they are a curious bird and tend to feel secure in the company of their fellows. This trait, plus a natural antipathy for the owl, played into the hands of the gunners.

Hunters found that decoys made to look like the crow, coupled with a homemade or commercially available crow call, would bring the flocks within range. Owls, either stuffed or carved, incited the crows' aggressive tendencies, and they would come in flocks to bother and screech at the dummy owl. As collectible decoys, the crows offer no variety in their painting, of course, but their sleek, simple shapes are an example of sound carving and good folk art.

The other type of decoy of a bird of the nonedible variety is the so-called confidence decoy. Early hunters found that the addition of a carved gull to a number of duck decoys made the rig more effective. Apparently, the ducks felt that the gull was smarter than they were, and if a gull was feeding along with a dozen or more ducks down below, things were probably pretty peaceful.

To a lesser degree, swans were used as decoys, not only to lure young edible swans to be shot, but also as confidence decoys set in the attitude of feeding to attract nondiving breeds of ducks to the ponds. The swan is a bottom feeder, and its long neck allows it to tear up food and bring it near the surface. Attracted by the thought of an easy meal, the nondivers would fly in to get their share of the leftover food.

As in many folk arts, the majority of the men who made the collectible decoys are unknown to us. This may be because their output was limited to the birds they carved for use in their own rigs or gave or sold to a few friends and neighbors. Also, fifty to one hundred years ago decoys were so common and in such wide use that their utility was taken for granted and their value as art unrecognized. However, there are some men whose work was so superior or innovative that its merit was appreciated by their contemporaries. Their work can be satisfactorily documented.

The foremost of these artists is generally considered to be Albert Laing of Stratford, Connecticut. Laing, originally from New Jersey, moved to Stratford in 1865, when he was fifty-four years old. He brought with him the New Jersey technique of the hollow-body decoy, and very shortly his decoys and copies of them replaced the heavy, awkward solid-body models then in use along the Connecticut shoreline. Laing died in 1886, but in the twenty years he lived in Stratford he influenced the work of Benjamin Holmes, and through Holmes, that of Charles E. ("Shang") Wheeler.

"Shang" Wheeler, who died in 1949 at the age of seventy-five, was an avid sportsman and hunter and his decoys were practical as well as aesthetic. His technique was so masterful that most of his later work was

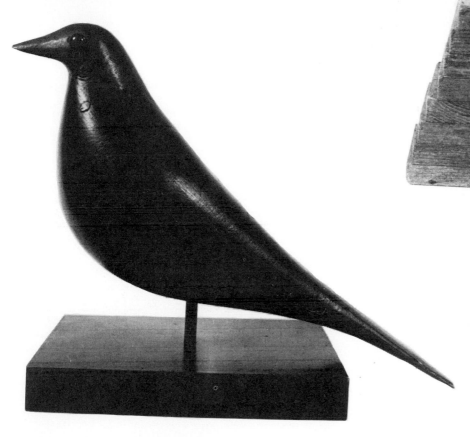

Crows were hunted extensively for sport or bounty when game birds were scarce or season was closed. This crow by Charles Perdew of Illinois is a classic shape which influenced most later crow decoys. (*Collection of Harold Corbin*)

Crow decoys were made commercially in the twentieth century. This one is by the Mason Decoy Factory of Detroit, Michigan. (*Collection of Harold Corbin*)

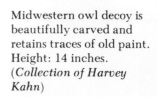

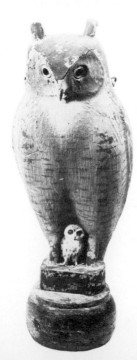

Owls were used as decoys for crows, which could not resist harassing them. This great horned owl is 16 inches tall and was made by the Herter Sporting Goods Company of Wauseka, Minnesota. (*Collection of Harold Corbin*)

Midwestern owl decoy is beautifully carved and retains traces of old paint. Height: 14 inches. (*Collection of Harvey Kahn*)

141

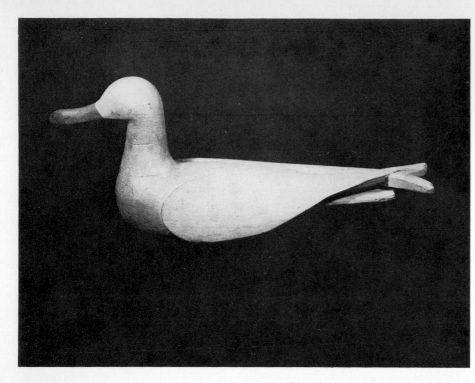

Gull used as confidence decoy was added to group of duck decoys to make scene appear peaceful to ducks flying overhead. (*Collection of Harold Corbin*)

Swan was also used as confidence decoy to attract ducks, and other swans, which were shot for food. (*Collection of Harold Corbin*)

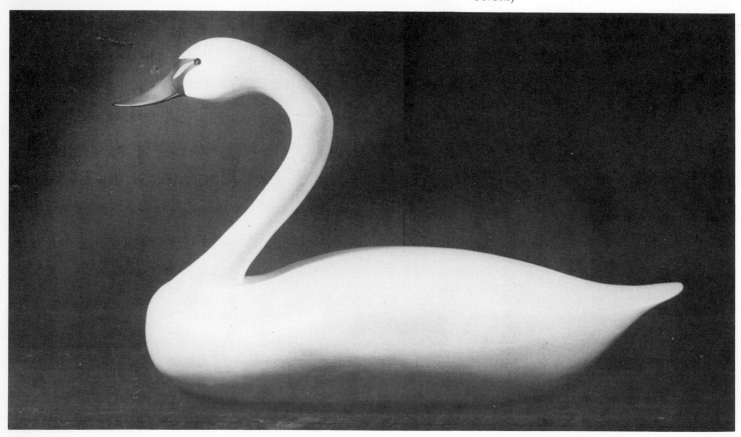

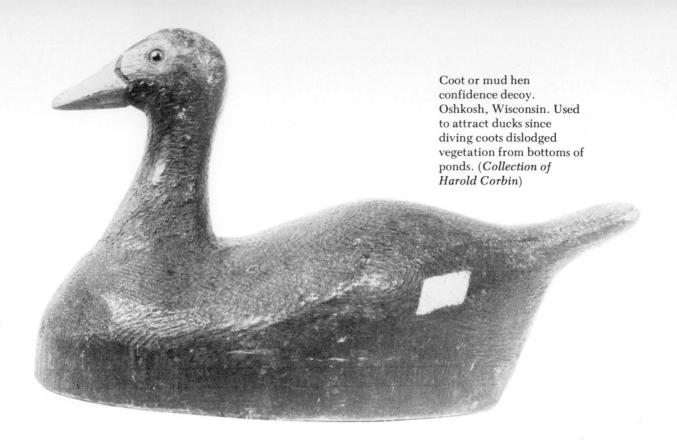

Coot or mud hen confidence decoy. Oshkosh, Wisconsin. Used to attract ducks since diving coots dislodged vegetation from bottoms of ponds. (*Collection of Harold Corbin*)

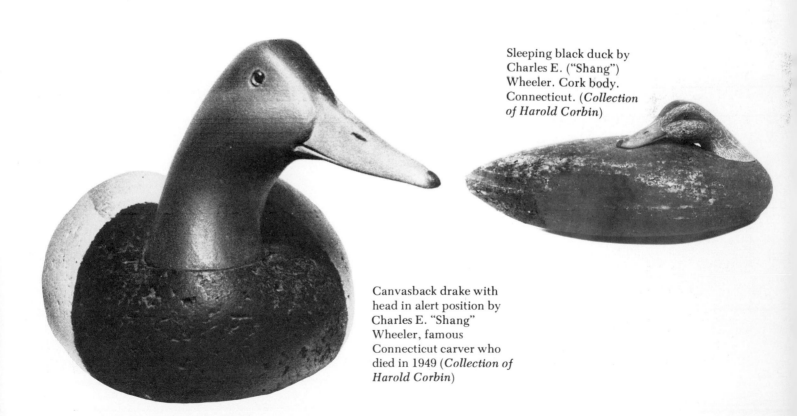

Sleeping black duck by Charles E. ("Shang") Wheeler. Cork body. Connecticut. (*Collection of Harold Corbin*)

Canvasback drake with head in alert position by Charles E. "Shang" Wheeler, famous Connecticut carver who died in 1949 (*Collection of Harold Corbin*)

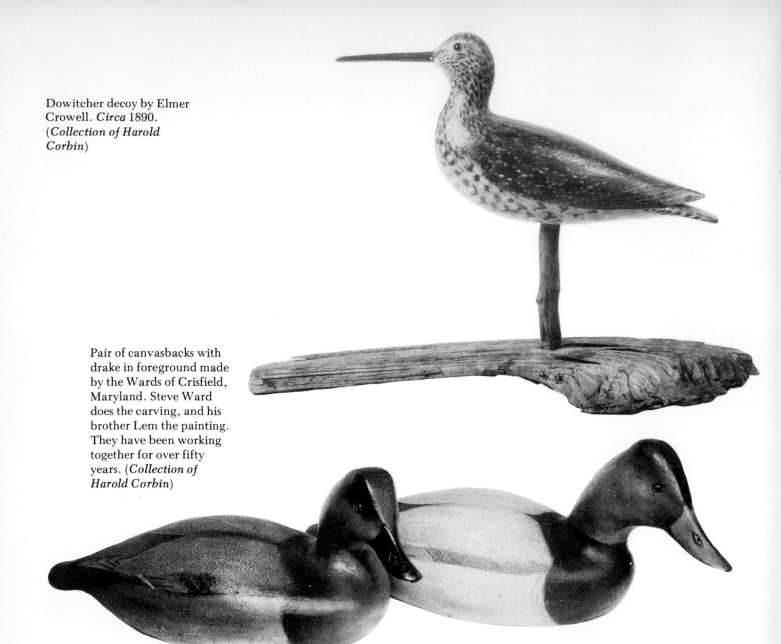

Dowitcher decoy by Elmer
Crowell. *Circa* 1890.
(*Collection of Harold
Corbin*)

Pair of canvasbacks with
drake in foreground made
by the Wards of Crisfield,
Maryland. Steve Ward
does the carving, and his
brother Lem the painting.
They have been working
together for over fifty
years. (*Collection of
Harold Corbin*)

Signature on decoy made
by the Ward Brothers.
1973. (*Collection of
Harold Corbin*)

considered ornamental and displayed as prized pieces rather than used as working decoys.

In the late nineteenth century, Cape Cod was an extremely productive hunting territory, and Elmer Crowell, one of its market gunners and guides, is recognized as the area's outstanding decoy maker. Born in 1862, Crowell produced a considerable output, and after market hunting declined around 1900, he devoted most of the rest of his ninety years to carving ornamental birds. Crowell's early decoys are the most sought after by collectors, as they exhibit the greatest amount of carving and detail of finish. His later models are of simpler workmanship, but were still painted with his unmistakable artistry.

Each great hunting area produced its share of important craftsmen in the art of decoy carving. The southern shore of New Jersey was the home of the previously mentioned Harry Shourdes, and, farther south on Chesapeake Bay in Crisfield, Maryland, the brothers Steve and Lem Ward are among the most notable decoy-makers. Steve does the carving, and Lem the painting. They have been active for over fifty years and are still producing decoys of remarkable quality, mostly on commission from sophisticated collectors.

In the Middle West, along the great Mississippi Flyway, serious market gunning started later than in the East. This was mainly due to the abundance of other game, such as deer and buffalo, and the easier-to-bag birds, such as partridge, quail, prairie chicken, and the passenger pigeon. For this reason, it was not until after 1880 that fine duck decoys began to appear on the Illinois River and other tributaries of the Mississippi.

Southern Illinois was the home of four highly regarded decoy-makers. The first, and most influential, was Robert Elliston who, after working and traveling in the eastern part of the country, settled permanently in Illinois around 1880 and worked professionally as a decoy-carver. Elliston's decoys give evidence of methods and techniques learned from the study of Connecticut-style decoys, most probably those of Ben Holmes. It is known that Holmes entered and won a decoy competition at the Centennial Exposition in Philadelphia in 1876. Either Elliston had the opportunity to study the Holmes rig at the fair, or reports of Holmes' decoys filtered back to Illinois through other enthusiasts.

Illinois produced four noteworthy decoy-makers who worked from the late nineteenth century well into the twentieth. The first was Robert Elliston, who died in 1915. His pintail duck decoy is shown here. (*Collection of Harold Corbin*)

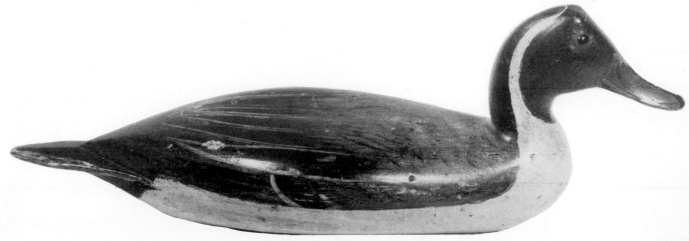

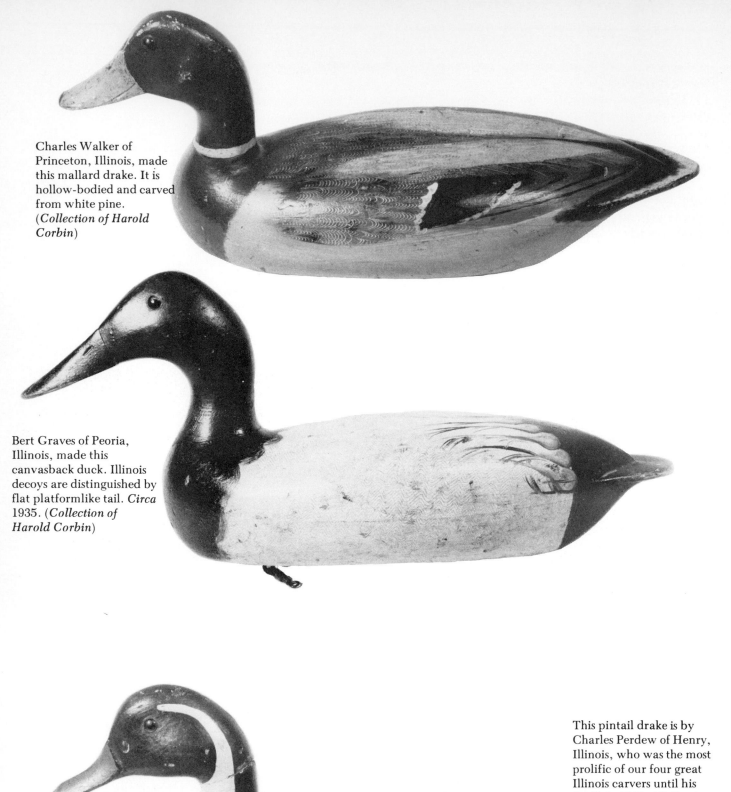

Charles Walker of Princeton, Illinois, made this mallard drake. It is hollow-bodied and carved from white pine. (*Collection of Harold Corbin*)

Bert Graves of Peoria, Illinois, made this canvasback duck. Illinois decoys are distinguished by flat platformlike tail. *Circa* 1935. (*Collection of Harold Corbin*)

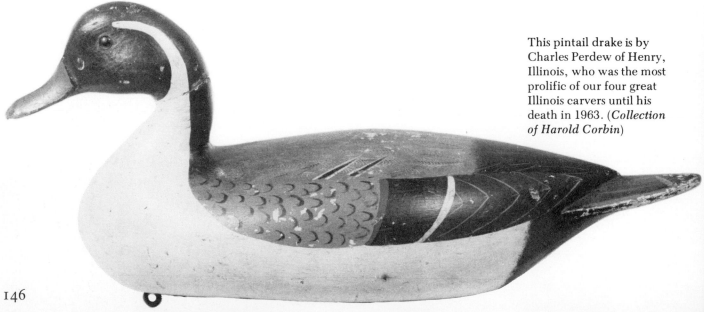

This pintail drake is by Charles Perdew of Henry, Illinois, who was the most prolific of our four great Illinois carvers until his death in 1963. (*Collection of Harold Corbin*)

In any case, his decoys were hollow-bodied and painted with the combed feather patterns that originated in Connecticut. Elliston died in 1915, and was succeeded by Bert Graves of Peoria, Charles Walker of Princeton, and Charles Perdew of Henry, Illinois. Perdew worked for nearly fifty years and his career was the most productive. At his death in 1963, he had outlived Walker by nine years and Graves, who only made decoys professionally for eight years, by nineteen.

The duck decoys made by these four Illinois carvers all have one distinctive characteristic: the flatness of the tail where it meets the body. Perdew, among his other accomplishments, is noted particularly for the excellence of his crow decoys. These are now regarded as classics wherever decoys are collected.

True working decoys have only become recognized as an indigenous American folk art within the past forty years, and within the past decade their value has skyrocketed. This is obvious from the excitement generated when documented examples or outstanding collections come up for auction at prominent galleries. Once neglected or ignored, these formerly ubiquitous and unassuming birds are no longer exposed to the wind and water, but have found a permanent shelter in museum collections and on proud collectors' mantels and shelves.

Mallard drake by "Tube" Dawson of Putnam, Illinois, showing typical flat tail carving. (*Collection of Harold Corbin*)

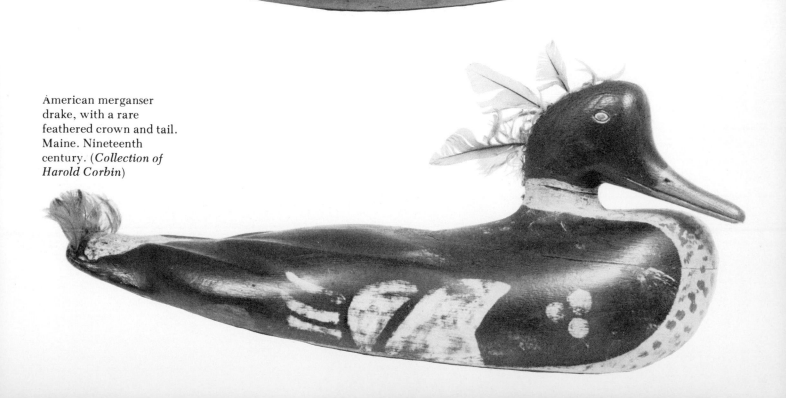

American merganser drake, with a rare feathered crown and tail. Maine. Nineteenth century. (*Collection of Harold Corbin*)

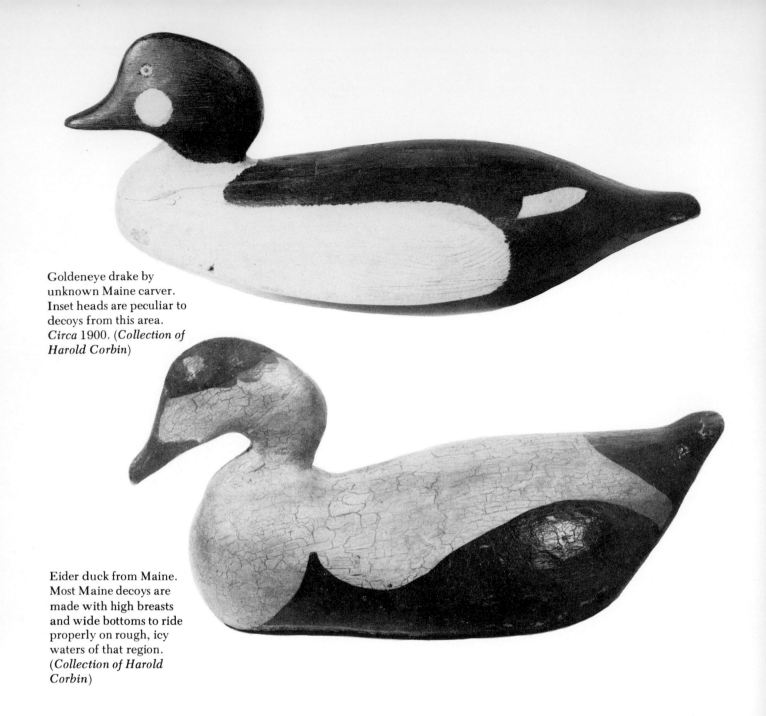

Goldeneye drake by unknown Maine carver. Inset heads are peculiar to decoys from this area. *Circa* 1900. (*Collection of Harold Corbin*)

Eider duck from Maine. Most Maine decoys are made with high breasts and wide bottoms to ride properly on rough, icy waters of that region. (*Collection of Harold Corbin*)

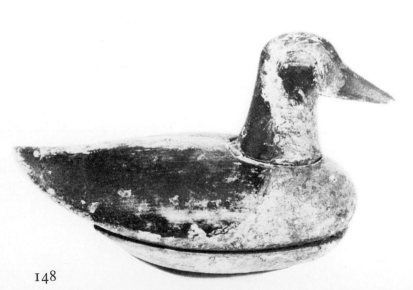

Miniature decoy of oldsquaw duck. A primitive from the interior of Maine. Length: 7 inches. (*Collection of Harold Corbin*)

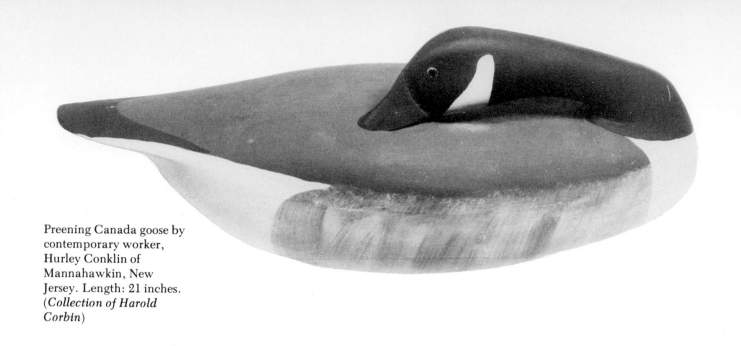

Preening Canada goose by
contemporary worker,
Hurley Conklin of
Mannahawkin, New
Jersey. Length: 21 inches.
(*Collection of Harold
Corbin*)

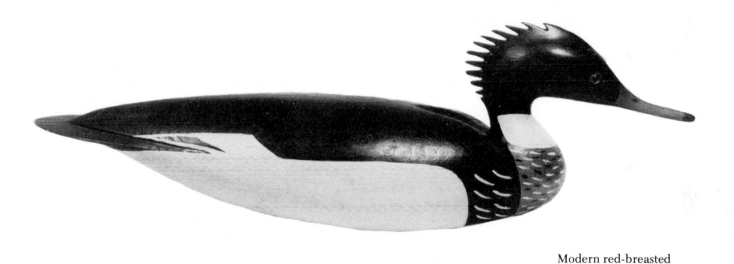

Modern red-breasted
merganser by Hurley
Conklin of New Jersey is
sleekly stylized. (*Collection
of Harold Corbin*)

Canvasback drake by Jim
Titus of Astoria, Oregon.
Solid body. West coast
examples are rare. *Circa*
1925. (*Collection of
Harold Corbin*)

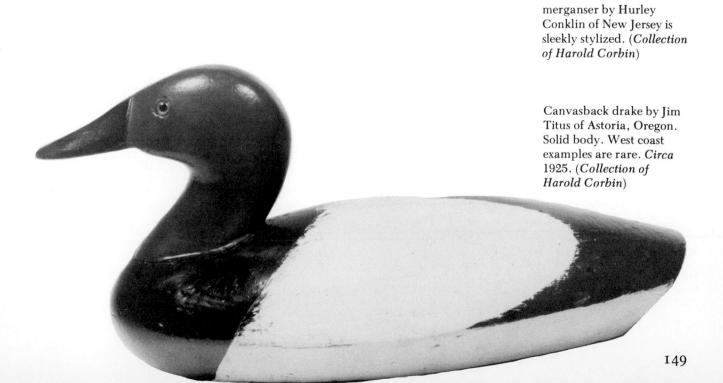

149

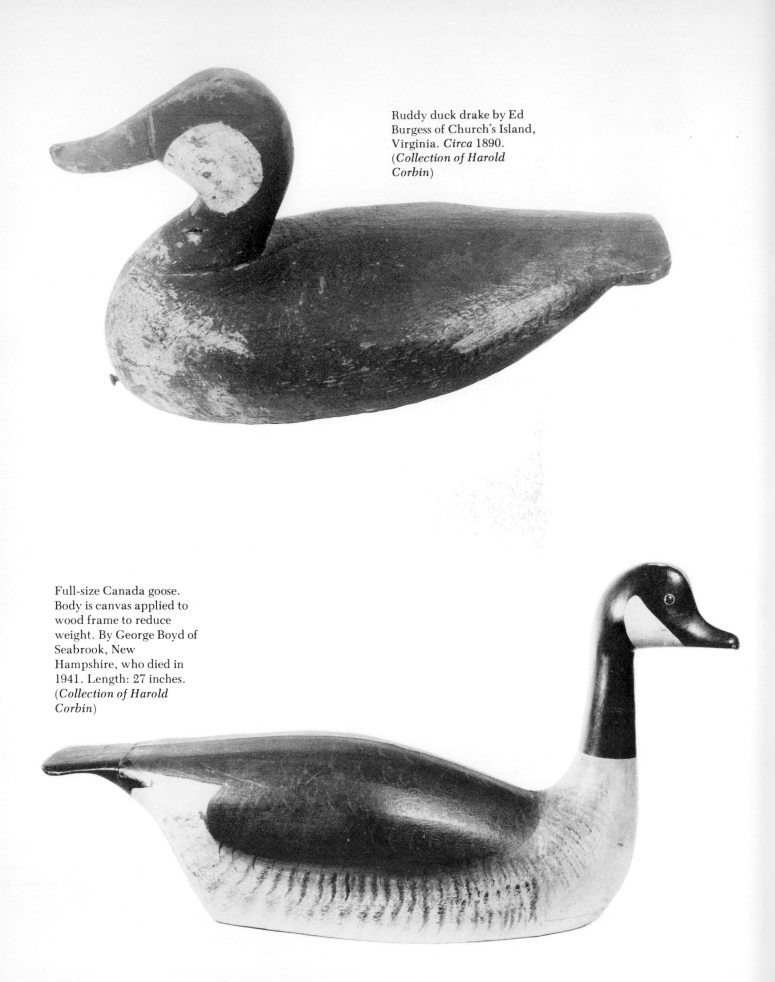

Ruddy duck drake by Ed Burgess of Church's Island, Virginia. *Circa* 1890. (*Collection of Harold Corbin*)

Full-size Canada goose. Body is canvas applied to wood frame to reduce weight. By George Boyd of Seabrook, New Hampshire, who died in 1941. Length: 27 inches. (*Collection of Harold Corbin*)

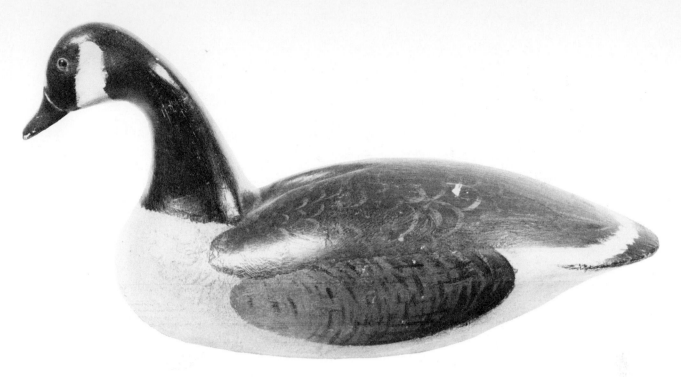

Rare small Hutchin's
goose. Hollow-bodied bird
is by unknown southern
New Jersey maker.
Length: 17 inches.
(*Collection of Harold
Corbin*)

Brant with head made
from appropriately shaped
root. Possibly from Long
Island, New York. *Circa
1890.* (*Collection of
Harold Corbin*)

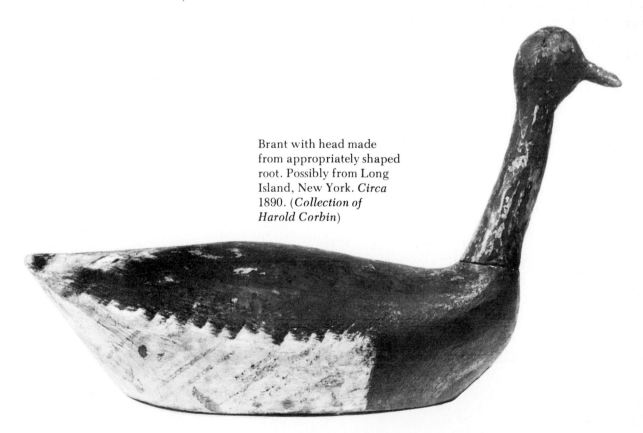

15 Bird Carving as an American Folk Art

Among whittlers, both professional and amateur, there has long been a fascination with birds. It may be that the relatively simple shapes and graceful lines of these subjects encouraged the novice, who found birds less challenging to reproduce than four-legged fauna. Any exhibition of the work of present-day carvers contains a disproportionate number of bird carvings in relation to other subjects.

A comprehensive collection of American wood carvings would include birds carved in styles ranging from primitive or naïve to the highly finished exact replicas made by modern craftsmen. The most prized specimens in the primitive category are those made by Wilhelm Schimmel and Aaron Mountz in Pennsylvania in the latter part of the nineteenth century. Schimmel was an itinerant wood-carver who existed by selling or trading his carvings for food and shelter. From all accounts, he had a surly disposition and all but a few of his fellow Pennsylvania-German neighbors abhorred his uncouth appearance and blasphemous language. His productive period extends from the time he arrived in the Cumberland Valley of Pennsylvania after the Civil War until his death in a Carlisle, Pennsylvania, poorhouse in 1890. The legends surrounding his life during the twenty-five years he lived and worked in that area are almost as interesting as the work for which he is now renowned.

Schimmel was said to have wandered on foot across the countryside with a bag of his small carved and painted animals, which he sold for a few cents at any farmhouse where he could find a customer. Sometimes he would pick up a block of his favorite soft pine, and with only a sharp jackknife, quickly execute whatever his customer fancied. The characteristics that mark Schimmel's work are boldness, simplicity, and the freedom of his carving, in which no cut is superfluous but rather each contributes to the vigor of the finished piece.

Bird-carver Robert Foraner, whittling bird from rough wood blanks

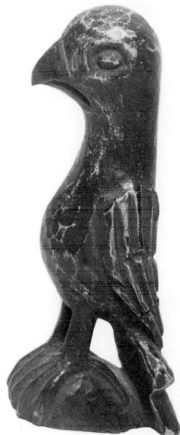

"Distlefink," Pennsylvania-German term for thistle finch, made by Wilhelm Schimmel. Brown paint. (*Collection of Dr. William S. Greenspon*)

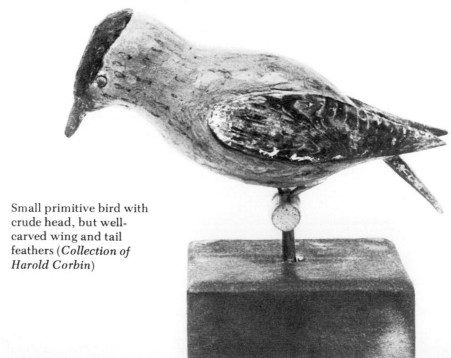

Small primitive bird with crude head, but well-carved wing and tail feathers (*Collection of Harold Corbin*)

153

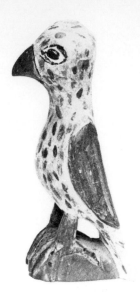

Small bird or "distlefink" carved in the manner of Wilhelm Schimmel by C. Snavely near Ephrata, Pennsylvania. Height: 4 inches. (*Collection of Mr. and Mrs. Harold Corbin*)

Schimmel "distlefink" painted green, red, and black in contemporary carved glass-front cabinet. *Circa* 1880. Height of bird: 4 inches. (*Collection of Harvey Kahn*)

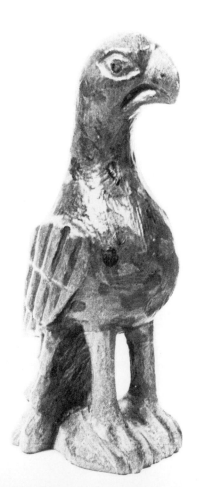

Pair of "distlefinks" of Pennsylvania origin. Possibly by Wilhelm Schimmel. Height: 6½ inches. (*Private Collection*)

154

According to an account by a local researcher, Schimmel would often visit the taverns in Carlisle and trade a carved eagle, one of his masterpieces, for as much whiskey as it would fetch. Soon all of the local bars displayed his eagles and whatever other work he was able to barter. These eagles were his largest subjects and when carved with outspread wings measured up to 3 feet from wing tip to wing tip. The feathering of the body was indicated by a diamond-shaped pattern, which is not seen in his roosters. The latter have a smooth body with only the tail feathers carved in detail. The beaks on Schimmel's eagles are far from accurate and are said to resemble a parrot's.

All of Schimmel's work, including the small birds, animals, and religious groups that he also made, were painted in brown, black, red, or yellow over a gesso base. He made no particular attempt to achieve accuracy in the coloring, using whatever paint was at hand.

Aaron Mountz was a contemporary of Schimmel, and his work was strongly influenced by him. Mountz worked with the same economy of carving, marked by crosshatched cutting, but with a higher degree of finish and precision. Mountz carved roughly the same range of subjects as did Schimmel, mostly eagles, barnyard fowl, squirrels, sheep, and dogs. If Schimmel's best work was his eagles, it is with dogs that Mountz is most closely identified. His poodles, especially, with their clipped coats, have great humor and style.

Schimmel and Mountz were both active towards the end of the nineteenth century and are considered to be the best of the Pennsylvania primitive carvers. Their rugged styles are distinctive, and even without documentation, it is possible to make fairly accurate attributions to their work.

Many other Pennsylvania carvers had a facility for making carvings of small whimsical cartoon-style birds known as "distlefinks." This term is a Pennsylvania-Dutch corruption of the pronunciation of a species of bird called the thistle finch. These small birds, as seen in the photographs of examples by Schimmel and other Pennsylvania carvers, are usually painted in uncharacteristic plumage and are carved in an upright attitude with the tail feathers forming part of the base.

Domestic birds, especially of the barnyard variety, were favorite subjects for the itinerant "tramp carvers" who sold their wares as they traveled. Because the shapes of the birds were simple and easily recognized, they were easy to sell for a few pennies or to trade for a meal or a drink. Few of these carvings are realistic, and only the shapes and a few incised details suggest a rooster, a hen, a robin, or a parrot. Many of the nineteenth-century carved birds found today bear no resemblance to any known breed and were purely fanciful.

Because the bird has always been so popular with the amateur carver, a great variety of primitive bird carvings is available to today's collector. Amateur artists usually took for a subject a known type of bird that especially appealed to them, and there is a preponderance of bluejays, robins, orioles, and other colorful birds. Naturally, some carvers and whittlers were better than others, but since so few of these artists can be identified today, each carving must be judged on its own merits. Realism in bird carvings, as opposed to decoys, is not especially important. Some of the most simple nineteenth- and early twentieth-century amateur bird

Small whimsical carved rooster (*Collection of Harold Corbin*)

155

carvings, with their umbrella rib legs, have a kind of charm that is missing in more skilled work.

Illustrated in this chapter is a group of birds made in the nineteenth and twentieth centuries by carvers whose identities are largely unknown. In some cases, the area of this country from which they came can be established from records as to where the carvings were first acquired by a dealer or collector. Many of these birds are quite crude and their charm lies perhaps only in an unusual shape or amusing attitude or expression. The chunky white bird mounted on a fluted pedestal bears the inscription "For My Mother." It may have been a youngster's first attempt at whittling, and the message is perhaps more important than the medium.

The unpainted rooster with flared tail feathers is by an unschooled carver who managed to achieve great movement and vigor with a minimum of cutting. The pair of polychromed fowl shows more sophistication and care in the delineation of the wings and the carving of the necks, combs, and wattles. These roosters were mounted on a wheeled board and were undoubtedly intended as a toy.

White bird on finial is in a primitive style and is inscribed on base, "To my mother." Length of bird: 5½ inches. (*Collection of Harold Corbin*)

Carved rooster with painted red comb. Height: 5½ inches. (*Collection of Harold Corbin*)

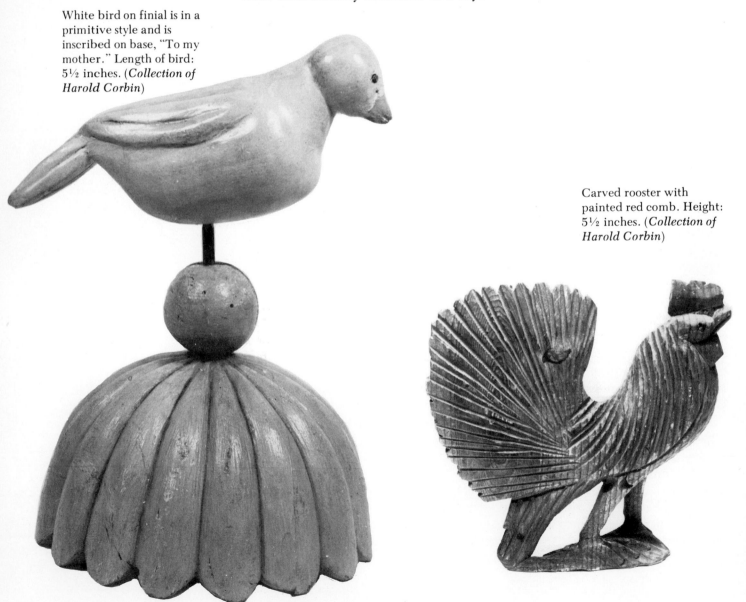

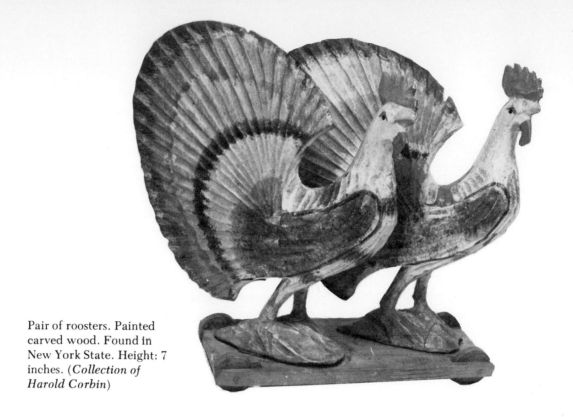

Pair of roosters. Painted carved wood. Found in New York State. Height: 7 inches. (*Collection of Harold Corbin*)

The sleek yellow bird shows no mastery of detailed carving, but the carver has achieved, perhaps unconsciously, a very satisfactory shape that is uncommonly graceful. This same simplicity and grace is evident in the piece called "Birds in a Tree." This was done in the third quarter of the nineteenth century by an Illinois shoemaker named Stephen Deady. Deady was obviously not a master of detail—note the lack of any extraneous carving on the birds or the turtles forming the base—but there is no question that he had a wonderful facility for design and for reducing a subject to its aesthetic essentials.

Contemporary bird-carvers are mostly concerned with turning out as accurate representations of the original species as careful study, masterful carving, and meticulous painting technique can achieve. There are some, though, who do let their fancy wander to produce more imaginative results. The owl pictured in this chapter is by Lou Schifferl of Green Bay, Wisconsin, who made a sort of cartoon character of the bird, but the shape, carving, expression, and originality make it a successful piece of folk art.

In the same spirit is the large figure of a goose with extended wings done by an anonymous carver in Nova Scotia around 1900. This bird must have been carved just for fun, possibly to be used as a lawn ornament, because the separate upright wings would make it too fragile for a decoy. The heaviness of the body is rescued by the long extension of the neck and the upthrust of the beak. The wings are shorter than they would be in nature, but were probably as large as the carver could safely mount on the bird.

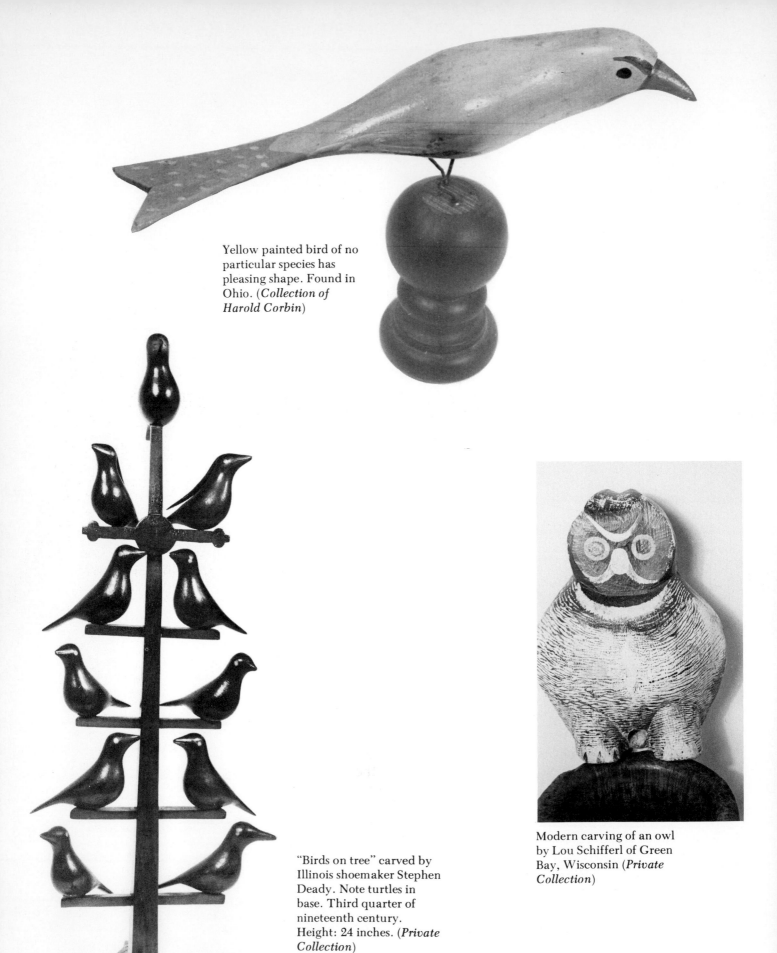

Yellow painted bird of no particular species has pleasing shape. Found in Ohio. (*Collection of Harold Corbin*)

"Birds on tree" carved by Illinois shoemaker Stephen Deady. Note turtles in base. Third quarter of nineteenth century. Height: 24 inches. (*Private Collection*)

Modern carving of an owl by Lou Schifferl of Green Bay, Wisconsin (*Private Collection*)

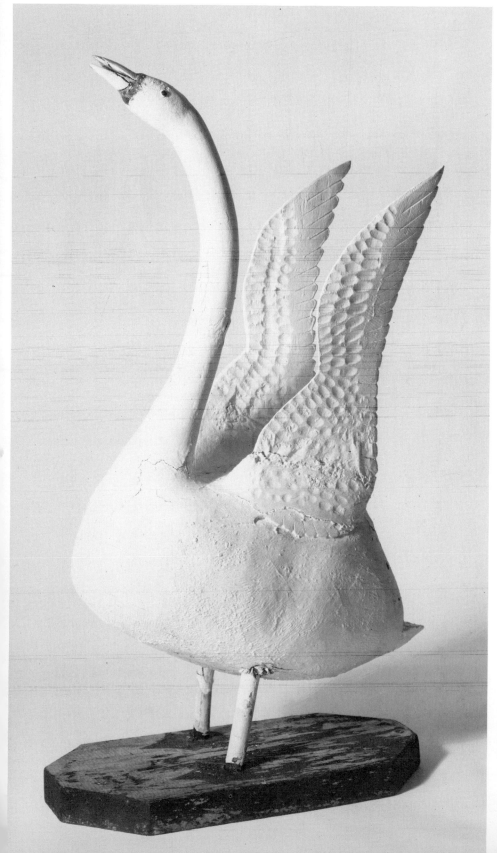

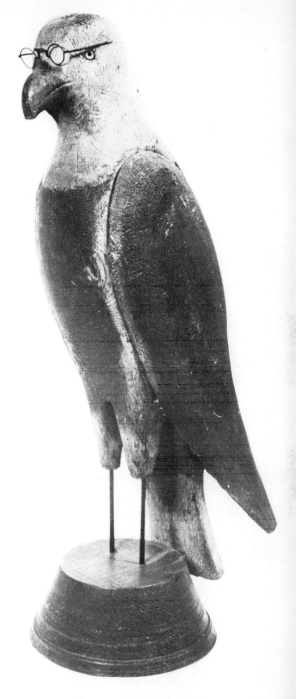

Wood carving of eagle was
used as crow decoy.
Eyeglasses are later
addition. Found in Iowa.
(*Private Collection*)

Goose, found in Nova
Scotia. *Circa* 1900.
Height: 39 inches. (*George
Schoellkopf Gallery*)

In his book *American Bird Decoys*, published in 1965, the late William F. Mackey, Jr., makes a distinction between the makers of working decoys and those carvers whose perfection places their work in a special category. Two artists he mentions in this latter context are Harold Haertel and Hector Whittington, both of Illinois. Haertel, now in his seventies, lives in East Dundee, Illinois, and is still actively engaged in making decoys that are designed to be exhibited rather than shot over. At this point, he probably has enough work, specially commissioned, to occupy the rest of his life. In the opinion of connoisseurs, his birds are unequaled in conformance to species and delicacy of plumage painting. The examples shown in this chapter give some idea of his range and versatility. From the smooth, fluid, unadorned shapes of the trumpeter swan and raven to the detailed delineation of the plumage of the pintail hen and blue-wing teal, his mastery is evident.

"Heck" Whittington's work is bolder and more oriented to effect than to verisimilitude. This quality can be seen in his hen mallard, with its less precise painting, but with great expressiveness in the carving and turn of the head. Mackey remarked particularly on Whittington's skill in modeling heads.

Three grebes by Harold Haertel. Bird on left is a western grebe, at the rear is a piedbill grebe, and in the right foreground is the earred grebe. (*Private Collection*)

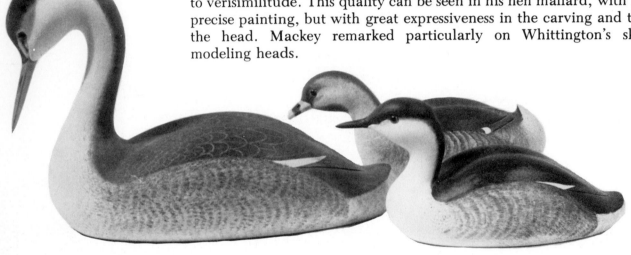

Pintail hen by Harold Haertel of East Dundee, Illinois, who is a preeminent contemporary bird-carver. (*Collection of Harold Corbin*)

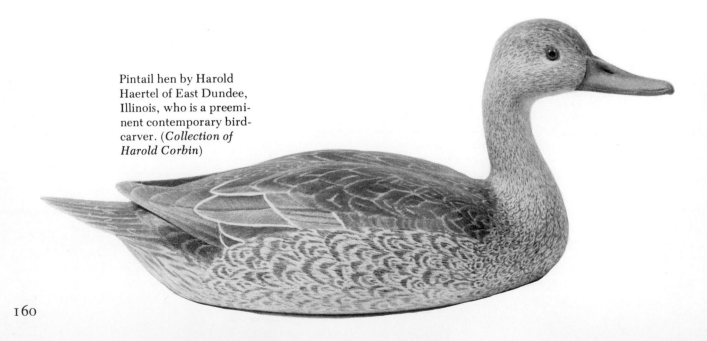

Inscription on the bottom of pintail hen by Haertel. Quotation is from a poem written by Mr. Corbin.

Pair of mourning doves originally used as confidence decoys. They were mounted on bicycle spokes to give them slight movement. These birds were carved by Harold Haertel. (*Private Collection*)

Common loon in summer plumage by Harold Haertel. Bird is indigenous to northern United States. (*Private Collection*)

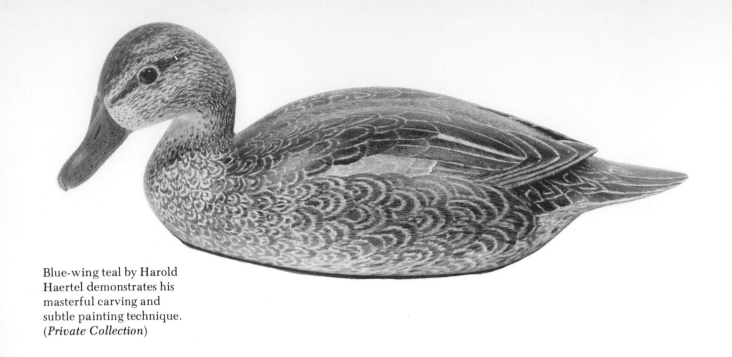

Blue-wing teal by Harold
Haertel demonstrates his
masterful carving and
subtle painting technique.
(*Private Collection*)

Life-size trumpeter swan
by Harold Haertel.
Length: 33 inches. (*Private
Collection*)

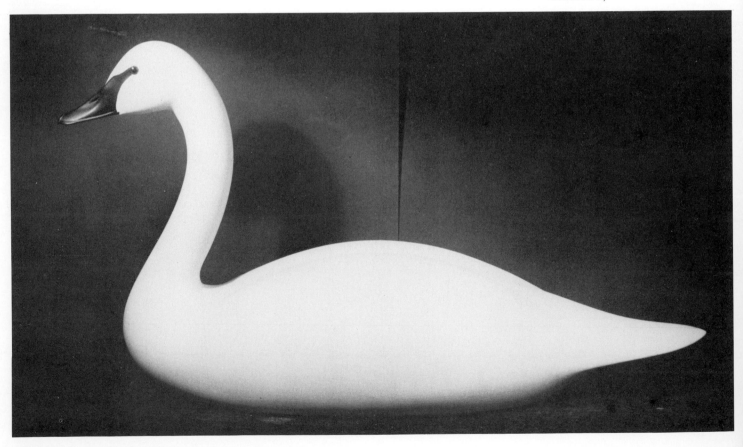

Crow by Harold Haertel is distinguished by smooth, flowing lines and natural turn of head. (*Private Collection*)

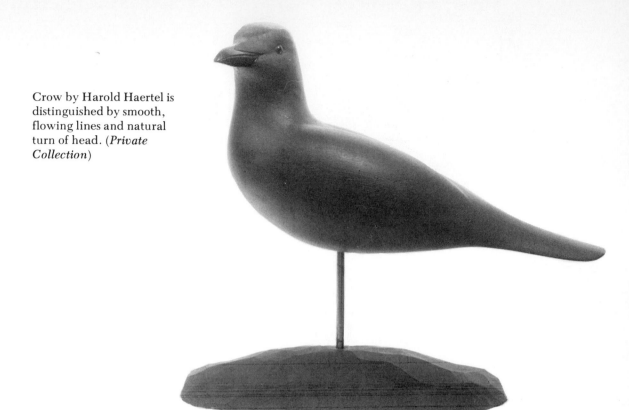

Hen mallard by Hector "Heck" Whittington of Oglesby, Illinois. Whittington has been making decoys since 1924 and is noted for the delicate modeling of his heads. (*Collection of Harold Corbin*)

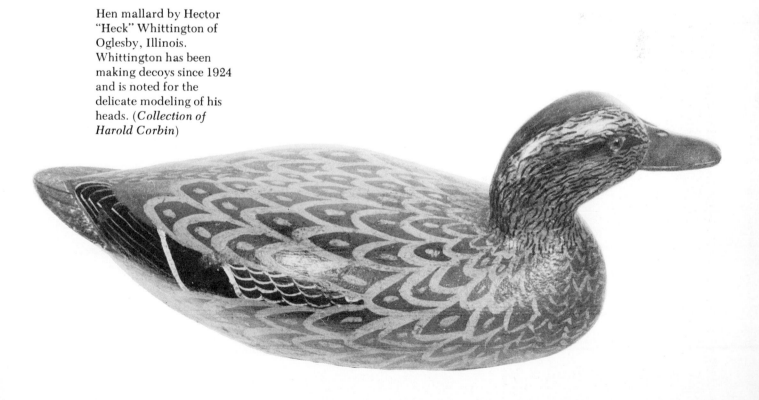

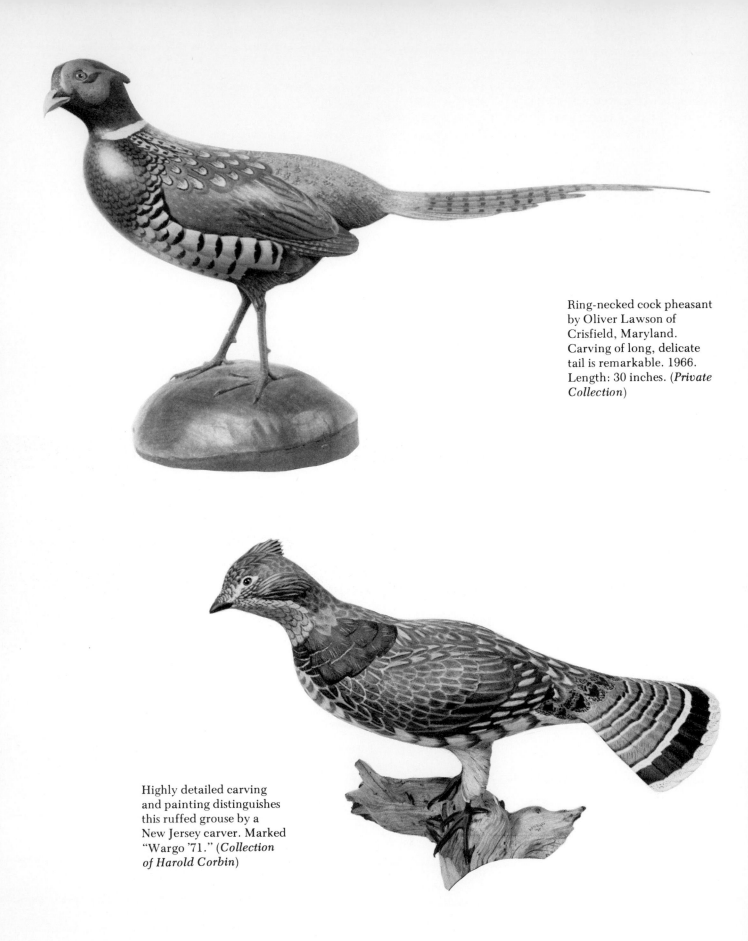

Ring-necked cock pheasant
by Oliver Lawson of
Crisfield, Maryland.
Carving of long, delicate
tail is remarkable. 1966.
Length: 30 inches. (*Private
Collection*)

Highly detailed carving
and painting distinguishes
this ruffed grouse by a
New Jersey carver. Marked
"Wargo '71." (*Collection
of Harold Corbin*)

The ring-necked cock pheasant shown with this group of birds by contemporary carvers is described by its knowlegeable owner as a *tour de force*. It was carved in 1966 by Oliver Lawson of Crisfield, Maryland. Chrisfield, located on the upper Chesapeake Bay, has a long heritage of decoy making that goes back into the nineteenth century. It is the home of the Ward brothers, Lem and Steve, whose work was discussed in the previous chapter. Lawson's pheasant is 30 inches from beak to tip of tail, and it is the tail, of course, that is most remarkable. Carving that long, slender appendage that far from the body requires enormous patience, daring, and skill.

Little is known of the carver of the ruffed grouse pictured here, except that the piece is signed simply "Wargo 71" on the base, and was found in New Jersey. With this bird, the artist took no license whatsoever. His primary concern was to create an exact replica of the live model, and in this he has succeeded right down to defining the pattern and texture of every feather.

As pointed out earlier in this chapter, there are literally thousands of enthusiastic hobbyists in this country presently specializing in bird carving. Typical of the more talented of this group is Michael Jaeger of Southbury, Connecticut. Mr. Jaeger, a retired toolmaker, carves and

For Michael Jaeger, a retired toolmaker of Southbury, Connecticut, carving is a recent avocation. Here Mr. Jaeger is exhibiting some of his lifelike models at a local crafts fair.

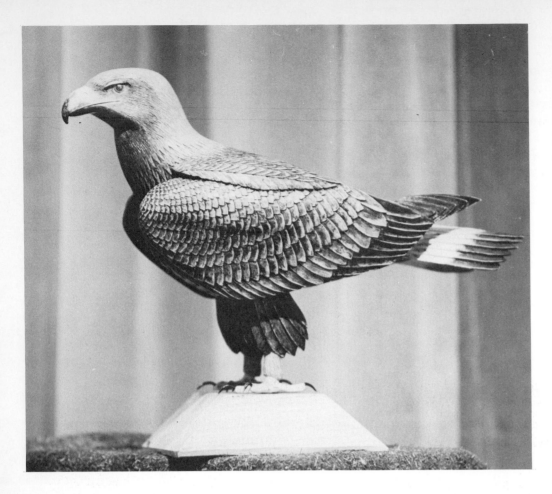

Golden eagle by Michael Jaeger. Contemporary carving shows excellent detail and lifelike painting.

Thrush by Michael Jaeger has natural tilt of head of bird in song.

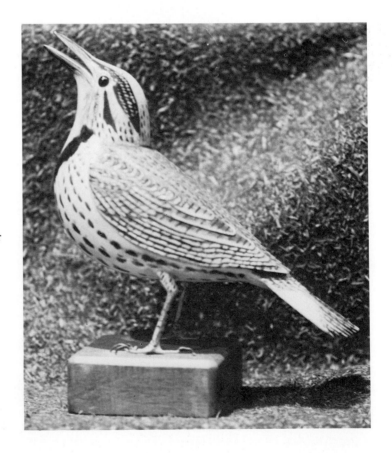

166

paints his birds only for his own pleasure, and none is offered for sale. All of his work exhibits great technical competence in the carving and accurate and subtle painting. The reproductions of birds he has had the opportunity to study closely are superior to those of birds that are seen less frequently in this area. The difference is obvious between the realistically carved pair of mourning doves and the thrush, and the stylized golden eagle, which would be difficult to observe at close range.

The trend among today's bird-carvers seems to be to try to achieve the utmost in realism and fidelity to detail. Many successfully realize their aim, but the results are often somewhat cold and impersonal. These lifelike carvings sometimes relate to more imaginative pieces as a photograph would compare to a painting of the same subject.

Two hawks on a branch. Made in Brooklyn, New York, by an unknown carver. Height: 12 inches. (*Private Collection*)

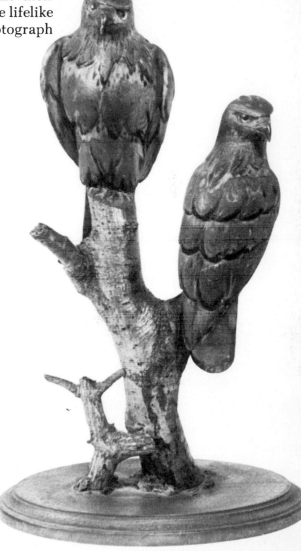

Distlefink-like bird on perch. Blue and red paint. Pennsylvania. Height: 14½ inches. (*Collection of Harold Corbin*)

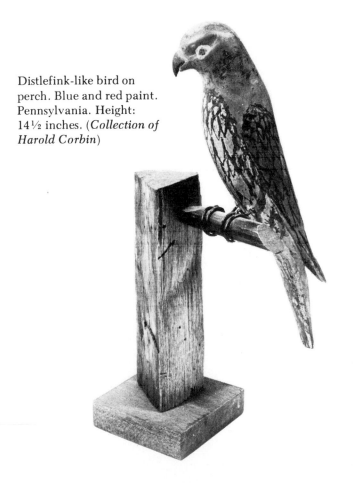

Pair of mourning doves by Michael Jaeger

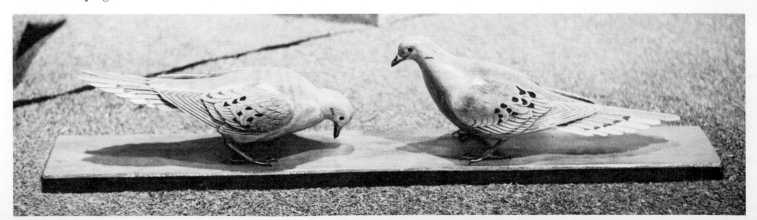

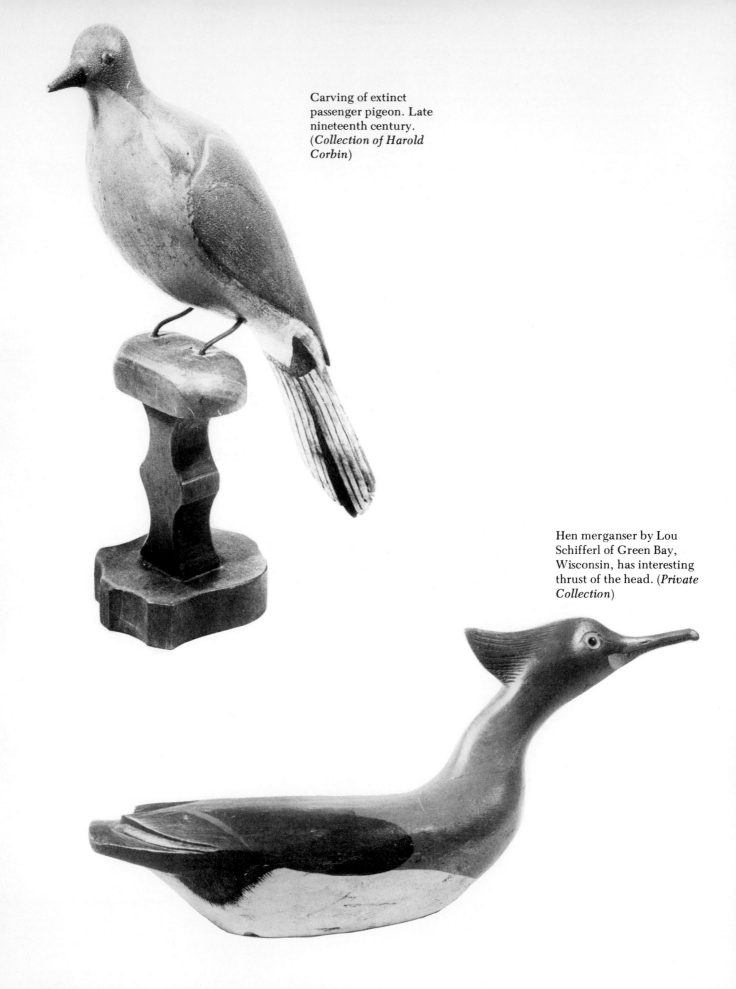

Carving of extinct
passenger pigeon. Late
nineteenth century.
(*Collection of Harold
Corbin*)

Hen merganser by Lou
Schifferl of Green Bay,
Wisconsin, has interesting
thrust of the head. (*Private
Collection*)

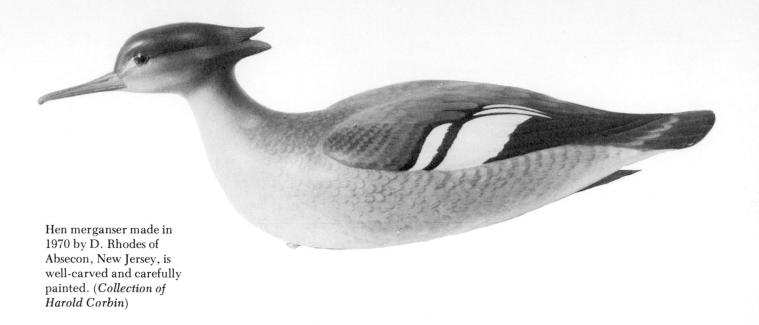

Hen merganser made in 1970 by D. Rhodes of Absecon, New Jersey, is well-carved and carefully painted. (*Collection of Harold Corbin*)

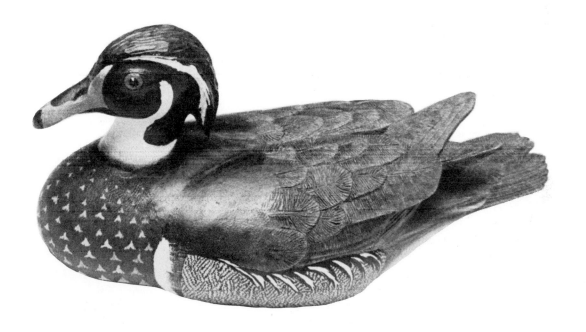

Wood duck drake by Charles Murphy, who has a studio in Concord, Massachusetts, where he conducts classes in decoy making.

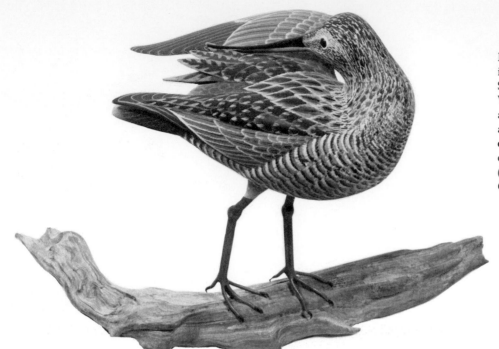

Hudsonian godwit, carved in 1968 by William L. Schultz of Milwaukee, Wisconsin. Legs and bill are metal. Note unusual attitude of head and extreme detailing of outspread plumage. (*Collection of Harold Corbin*)

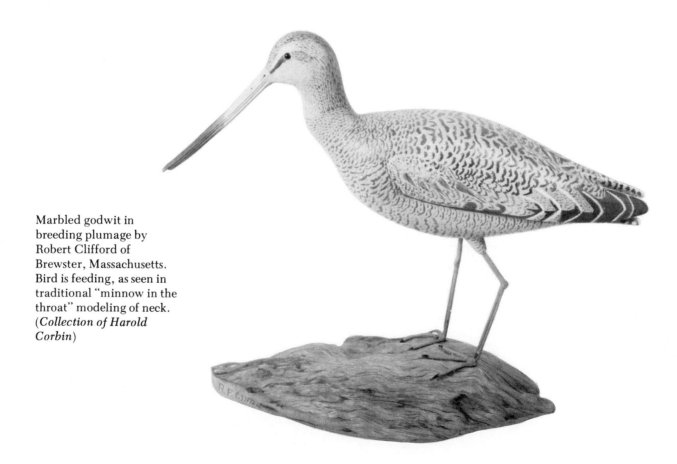

Marbled godwit in breeding plumage by Robert Clifford of Brewster, Massachusetts. Bird is feeding, as seen in traditional "minnow in the throat" modeling of neck. (*Collection of Harold Corbin*)

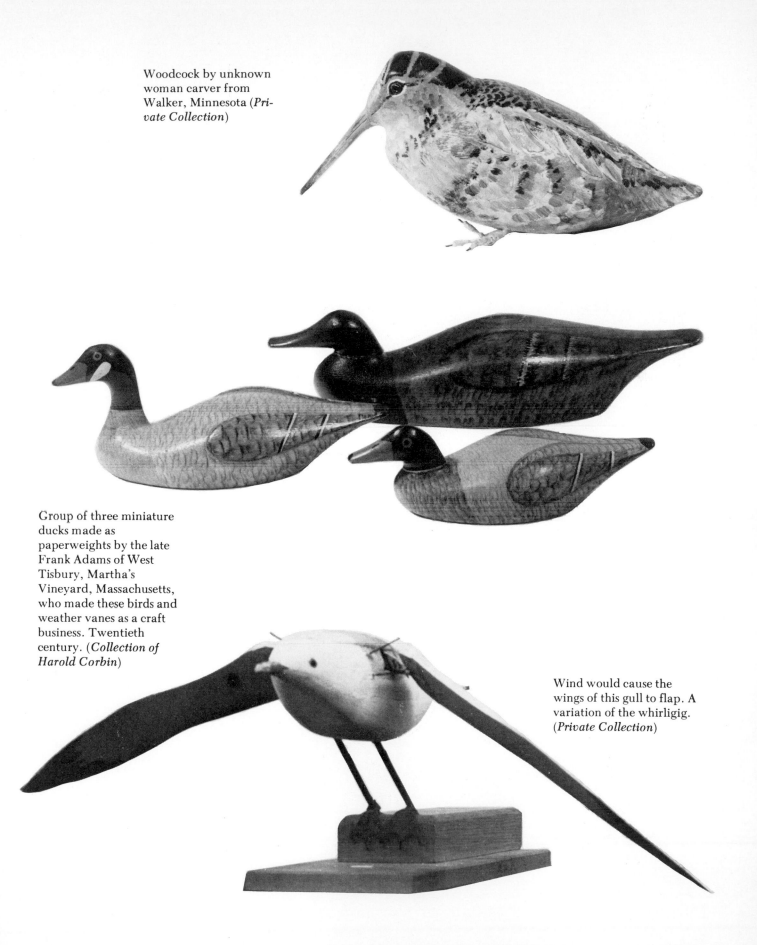

Woodcock by unknown woman carver from Walker, Minnesota (*Private Collection*)

Group of three miniature ducks made as paperweights by the late Frank Adams of West Tisbury, Martha's Vineyard, Massachusetts, who made these birds and weather vanes as a craft business. Twentieth century. (*Collection of Harold Corbin*)

Wind would cause the wings of this gull to flap. A variation of the whirligig. (*Private Collection*)

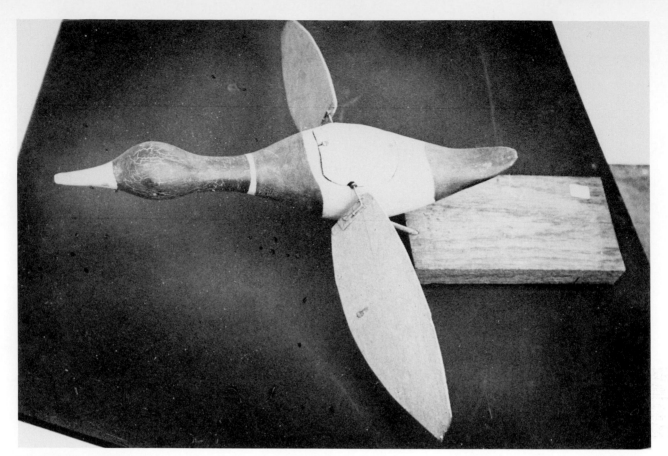

Duck with wings that
rotate in the breeze
(*Collection of Harold
Corbin*)

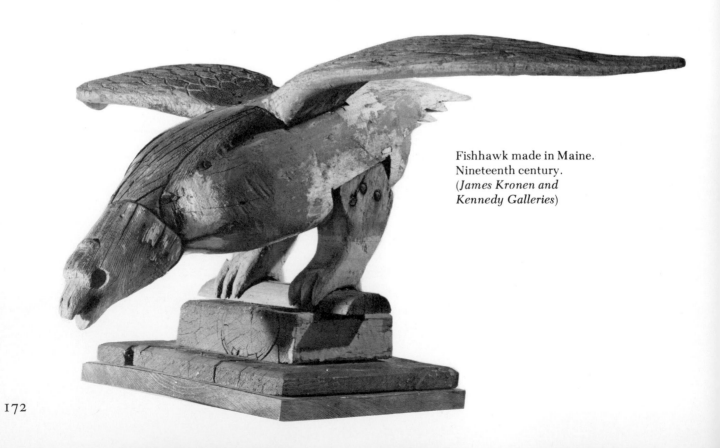

Fishhawk made in Maine.
Nineteenth century.
(*James Kronen and
Kennedy Galleries*)

16 Fish and Fish Decoys

The fish form has long appealed to the American wood-carver, both amateur and professional. Perhaps one reason is that it is not a complicated form to carve, and often a piece of uncut wood will suggest to the carver the shape of a fish. There are, however, more practical reasons for the prevalence of wood-carved fish, especially in the East Coast towns where they are often found. Many of the carved fish from the nineteenth century that have survived were used as trade signs for markets. The simple form of a cod or other type of fish commonly found in the Atlantic Ocean, if hung outside a fish market or tackle shop, announced to passersby the products being sold within. No writing was necessary. To gain further realism, many early carvers painted their wooden fish in colors as close to those of the original subjects as possible. Some of the old signs found today still have traces of the orginal paint on them.

Half-models of fish, carved and usually painted, have long been considered handsome decorations for the libraries and dens of sportsmen. Carvers who specialize in fish subjects have found a steady market for their products among fishing enthusiasts. There are still some modern woodcarvers who favor the fish as a subject and continue to carve, in the old tradition, realistically scaled and painted half-models of their favorite prey. One twentieth-century carver who is noted for such work is M. H. Gould of Cape Cod, Massachusetts. An example of his work, a painted trout, is shown here. The work of many other talented fish-carvers is not signed, and must be judged by the carving technique and realism in shape and decoration.

A type of carved fish that has been given little attention in the area of American folk art has recently come to the notice of collectors. The fishermen of the Lake Winnebago area in Wisconsin discovered their own rather original method of catching the fat sturgeon that once populated that lake in great numbers. They built huts on the lake in the harsh winter and cut holes in the ice, through which they let down their lines. Sometime during the nineteenth century, it was discovered that the sturgeon

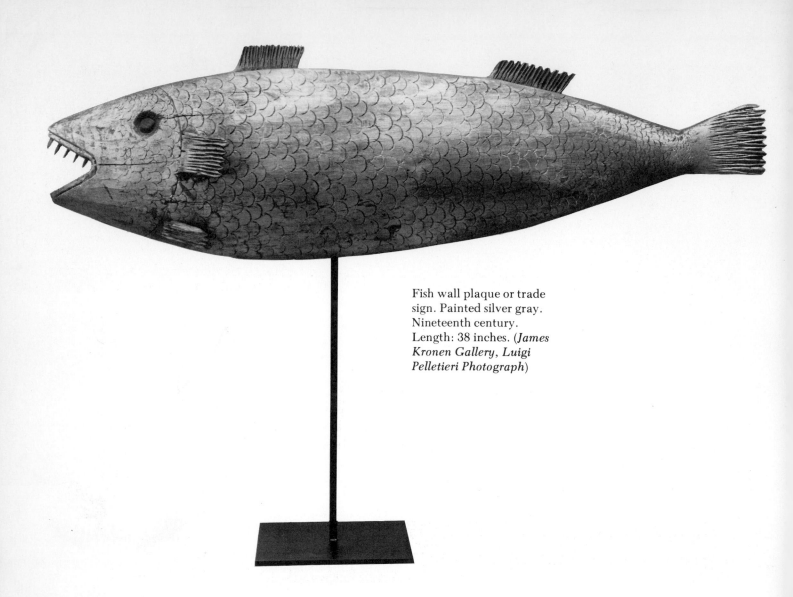

Fish wall plaque or trade
sign. Painted silver gray.
Nineteenth century.
Length: 38 inches. (*James
Kronen Gallery, Luigi
Pelletieri Photograph*)

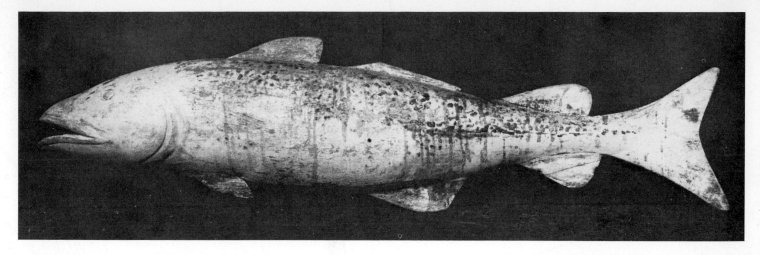

Codfish trade sign.
Massachusetts carving.
Length: 29¾ inches.
(*Collection of Harold Corbin*)

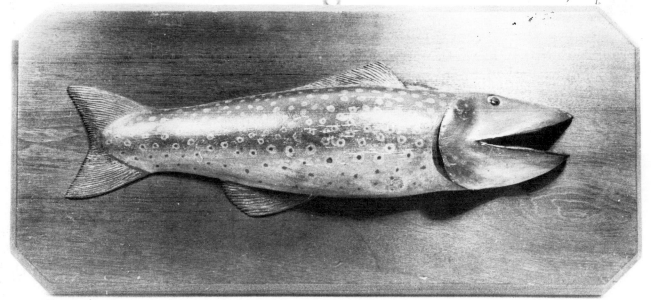

Half-model of fish, carved
and painted (*Private Collection*)

Swordfish. Carved and
painted wood. (*Private Collection*)

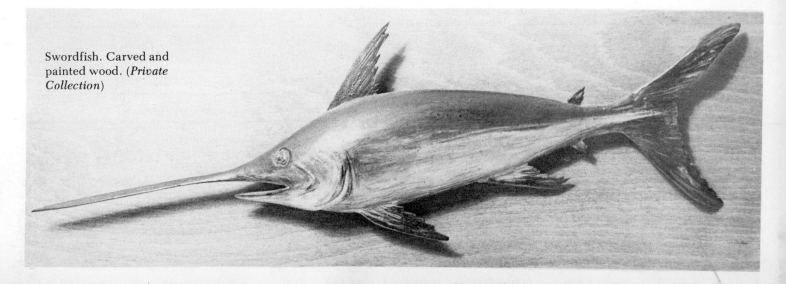

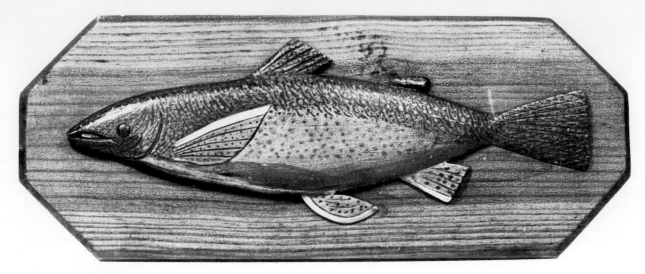

Half-model of trout.
Carved and painted wood.
(*Private Collection*)

Fish decoy. Carved wood,
metal tail and fins.
Thumbtack eye. Painted
yellow, black, and red.
Length: 24 inches. (*Private
Collection*)

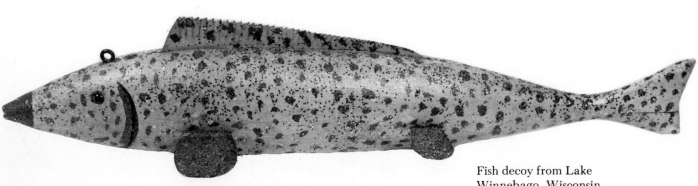

Fish decoy from Lake
Winnebago, Wisconsin.
Carved wood with metal
fins. Painted yellow with
red dots and decorated
with applied glitter.
Length: 17½ inches.
(*Collection of Harold
Corbin*)

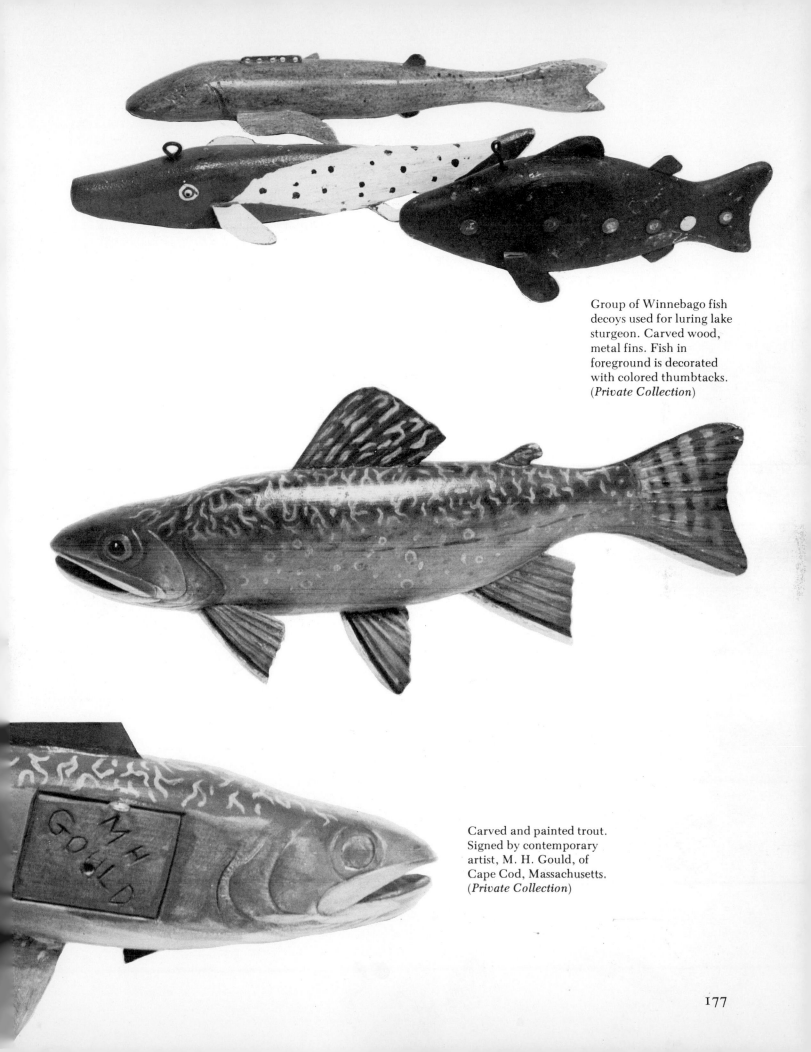

Group of Winnebago fish decoys used for luring lake sturgeon. Carved wood, metal fins. Fish in foreground is decorated with colored thumbtacks. (*Private Collection*)

Carved and painted trout. Signed by contemporary artist, M. H. Gould, of Cape Cod, Massachusetts. (*Private Collection*)

could be lured by brightly painted wooden fish. Many of these fish decoys were hand-carved and painted, and, so that they could easily be seen by the sturgeon, embellished with materials at hand that might attract the fish. Thus, we find Winnebago fish decoys covered with spangles or decorated with brightly enameled thumbtacks. Only the carver's imagination limited the fanciful coloring and shapes of these fish decoys, and to the unknowledgeable they look like toys rather than practical lures.

The sturgeon, however, learned to take these rather large lures seriously. That there is so much variety in the shapes, colors, and decorations of the fish decoys indicates the value of a good catch of lake sturgeon. A great deal of time, thought, and attention went into this rather unique method of catching them. The lures were used well into this century.

Whether made for practical purposes or not, the Winnebago fish decoys are amusing and interesting folk carvings that represent an important aspect of Americana. Most have no resemblance to any fish ever seen. Illustrated here, for example, is a decoy painted a bright yellow enamel with red dots and covered with applied glitter of the type used for Christmas decorations. The large smiling red mouth of the fish and its beady glass eyes appealed to the lake sturgeon.

Another fish decoy with a more serious expression is painted bright yellow and has black and red painted decoration. Its eyes are thumbtacks. Still another has colored tacks inserted along its body as decoration. Most of the fish decoys still have a screw eye inserted just above the head where the line was attached. While the bodies of these fanciful fish were carved of wood, the fins and tail were often made of sheet metal, both to give the decoy enough weight to keep it underwater and to allow the lures to have a somewhat realistic movement as the fisherman waited patiently in hopes of catching a lucrative sturgeon.

Eventually, these carefully made lures were of little help, since the fish they were designed to lure became scarcer and scarcer. The Winnebago decoys are an interesting form of American folk art that should be preserved, if only to remind us of a formerly profitable midwestern industry and the bounty that our lakes once held.

17 Whimsical Carvings

Few forms of American wood carving, with the exception of decoys, are indigenous to this country. Hand carving is an ancient art, and many objects that have appealed to American wood-carvers throughout the history of this country were first made in some form by the ancient Chinese. Some of these ideas have been adapted by carvers around the world who enjoy making elaborate and puzzling objects that have no function other than to occupy their maker and entertain the observer. Into this category go carved chains, balls (and other objects) in cages, and what, for want of another term, are called "whimsies."

The most simple form of wooden puzzle is the ball in a cage carved from one block of wood. The mastery of this form often leads to more complicated variations of carvings made on the same principle. Birds, human figures, and animals were (and are) frequently substituted for the simple free-turning sphere within an oblong cage. Advanced carvers of this type of work make cages that contain more than one revolving ball or a ball within a sphere within a cage.

Wooden chains, balls in cages, and the thousands of variations thereof require infinite patience on the part of the carver and a certain kind of philosophy. One modern carver of intricate balls in cages and chains explained his enjoyment: "None of the carvings I have made take me long to complete—but, in any case, why hurry? I can sit, relax, and slice and scoop clean slivers from the fragrant wood, then enjoy watching them curl almost lazily from my tools."

The end product, while fascinating, certainly has no practical purpose. It is their own enjoyment of the work that has led carvers to keep this facet of the art alive for centuries. The ancient Chinese used ivory to carve elaborate spheres within spheres, and these complicated miniature puzzles can now be found in museums throughout the world.

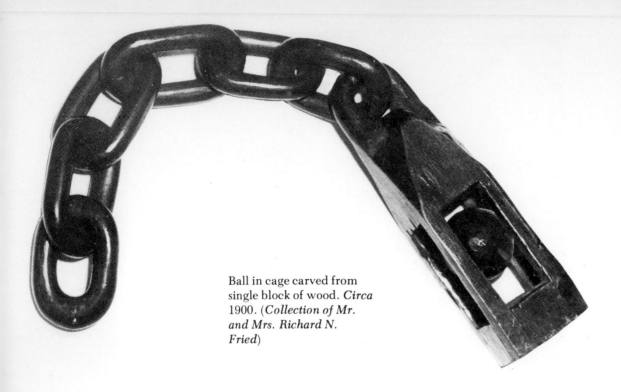

Ball in cage carved from
single block of wood. *Circa*
1900. (*Collection of Mr.
and Mrs. Richard N.
Fried*)

The answer to the inevitable question from the nonwhittler: "How is it
done?" is "Very carefully." Many makers of chains and other puzzle
carvings design their own intricate miniature tools for chipping out the
wood. Often they work with a magnifying glass to be certain that every
surface is smooth.

The secrets of carving chains, balls in cages, and other complicated and
puzzling objects can be found in almost any book on the art of whittling
and carving. Wherever modern carvers exhibit their work there are
usually some entries of this type. Every hand-carved chain or ball in cage is
different and reflects the skill and personality of the carver. Many varia-
tions of joints and figures and shapes of links can be found, some of them so
intricate and carefully designed that they can be compared with fine
jewelry design.

Chain carving has often been the pastime of men with unlimited hours
to fill. Prisoners of war used this time-consuming hobby to keep their
minds and hands busy. One particularly interesting chain illustrated here
is documented as having been made by a Civil War prisoner in 1864. The
complicated chain ends in two cages, one containing four wooden balls
and the other a center post, a ball, and two sliding vane-shaped blocks.
What makes this particular chain a *tour de force* is a secondary chain
emanating from a cage in the center of the primary chain which ends in
two more cages, both elaborately carved with balls in the centers. Carved,
of course, from one piece of wood, this project must certainly have
occupied its maker for a long time.

The fascination with this form of whittling comes from the fact that a
plain piece of wood can be turned into a flexible and handsome object,

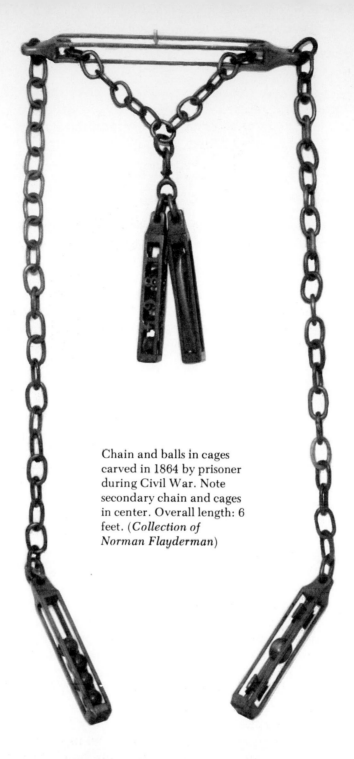

Chain and balls in cages
carved in 1864 by prisoner
during Civil War. Note
secondary chain and cages
in center. Overall length: 6
feet. (*Collection of
Norman Flayderman*)

often with the use of a single tool. The ability of the carver to see in a solid
piece of wood, before he makes a single cut, the complicated end product
is a large part of the final success of such carving.

Many modern carvers of chains use a soft wood, such as balsa or pine.
The advantages of this choice are obvious. The disadvantage is that an
entire project can be near completion when a slip of the knife causes one
link to come out wrong, or the weakness in the wood causes a link to
break. Many of the older chains were painstakingly carved from
hardwoods. The links are smoothed and polished so that they all appear to
be identical, and the multiple balls in one cage are so perfect that it is diffi-
cult to believe that they were not turned by machine.

An interesting variation on the chains made from identical links is that type in which every link is carved differently. More ambitious carvers made chains consisting only of miniature cages in a variety of shapes attached by single links. Within this category of wood carving there are endless varieties.

Complicated figures in cages, usually without chains attached, are called "whimsies," and a few of these that survive from the nineteenth century are of historical value as well as important folk art. One is a two-story cage made during the Civil War. The lower level contains the ball and the top level has four male figures, each facing in a different direction. Two of the figures are wearing Union caps, while the two opposite men have stovepipe hats. In the center of these figures is a free-moving ball. Another related type of carving, less intricate than the first in that it has no moving parts, was carved from a single piece of walnut and has a dog sitting on a stool within the cage.

In the same genre of "things impossible to make" are the boats-in-bottles and the many variations thereof. The same infinite patience required to whittle chains and balls in cages was undoubtedly necessary for the undertaking of some of the elaborate ships-in-bottles that have been preserved. The hobby was especially prevalent among seafaring men, who carved tiny ships and boats and inserted them through the necks of bottles. Many of these bottles contain panoramas of entire coastal towns, with the buildings in the background and boats in the foreground. The carving of the objects to be inserted was, of course, done first, and sails and masts attached and folded down in such a way that they could slide through the neck of the bottle. Once inserted, usually into a blue-painted putty ocean, the masts and sails could then be pulled into position by the use of a long hooked wire.

Many boats-in-bottles required little of the whittler's skill, but some show a great talent and understanding of a ship's contours. In a few, miniature carvings of sailors are seen on the decks of the ships.

An interesting variation of the ship-in-a-bottle is the Civil War relic illustrated here. Using the bottle in an upright position, the maker carved tiny figures of Union soldiers about to fire a cannon. Many other scenes within glass jugs or bottles have been made and there are still a few craftsmen who specialize in this kind of work. One amusing and appealing variation is an entire nineteenth-century saloon scene built within a bottle.

A fascinating and original type of whimsical sculpture is illustrated here. It was carved by a German immigrant who settled in Pennsylvania, John Scholl. Scholl was a house and barn builder who came to America in 1853 and died in 1916. His astonishing sculptures, mostly made in celebration of the Christmas season, are decorative in nature and include snowflake and star patterns. Some have parts made up of carved movable toys, such as a Ferris wheel, birds that move on a seesaw, and animals and human figures that become mobile when a hand crank is turned. His work is unmistakably Pennsylvania-German in origin, but the mobile parts predict the mobile sculptures of Alexander Calder.

Another whimsical piece that can be attributed to an artist about whom something is known is the clock case carved by the Ohio craftsman

Civil War whimsey.
Figures are four men, two
wearing stovepipe hats and
two wearing Union caps.
Ball in lower compartment
is painted gold. Height:
13½ inches. (*Private
Collection*)

Whimsey, carved from
single block of walnut
wood, has dog sitting on
stool in cage. (*Ross Levett*)

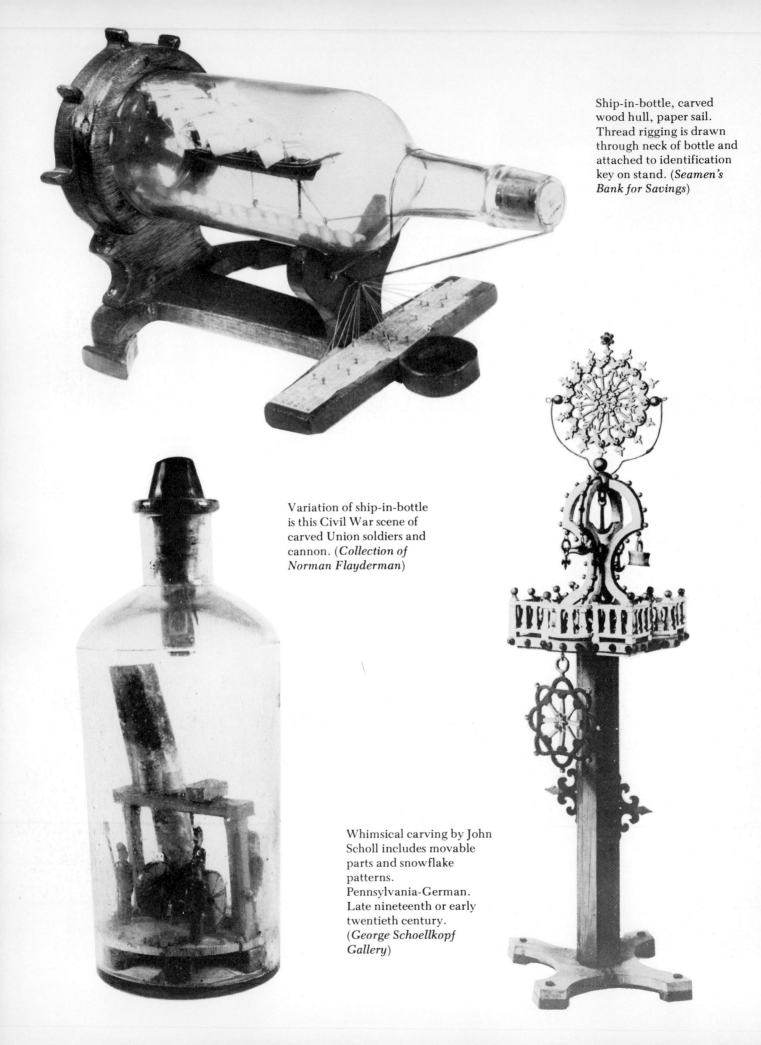

Ship-in-bottle, carved wood hull, paper sail. Thread rigging is drawn through neck of bottle and attached to identification key on stand. (*Seamen's Bank for Savings*)

Variation of ship-in-bottle is this Civil War scene of carved Union soldiers and cannon. (*Collection of Norman Flayderman*)

Whimsical carving by John Scholl includes movable parts and snowflake patterns. Pennsylvania-German. Late nineteenth or early twentieth century. (*George Schoellkopf Gallery*)

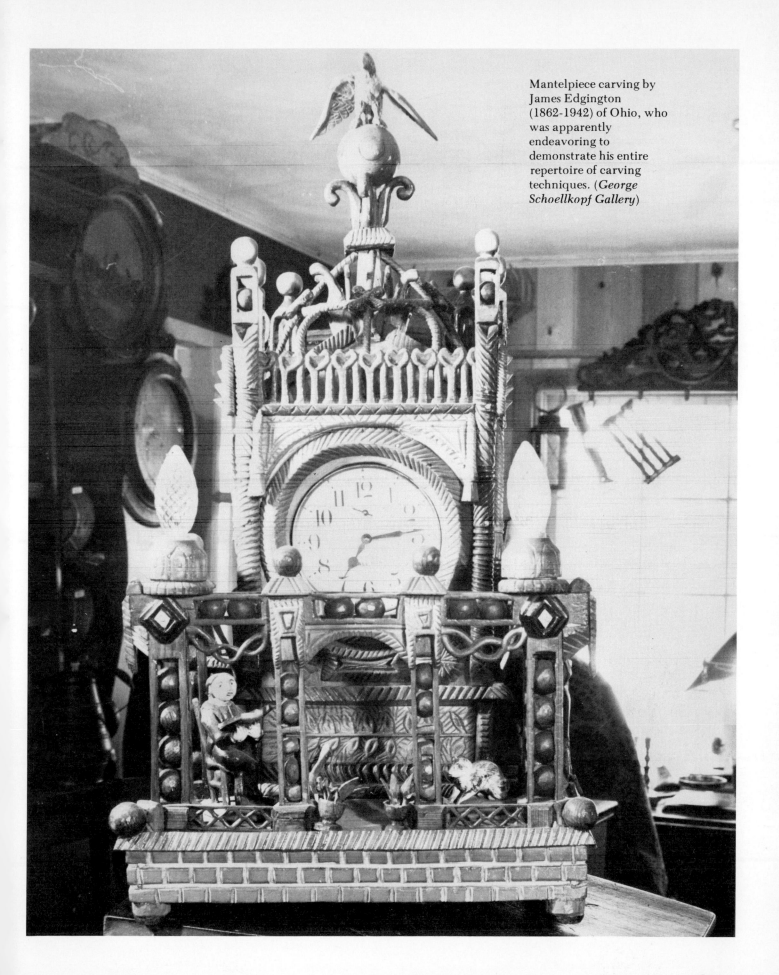

Mantelpiece carving by James Edgington (1862-1942) of Ohio, who was apparently endeavoring to demonstrate his entire repertoire of carving techniques. (*George Schoellkopf Gallery*)

James McCallister Edgington. The case includes a figure of a woman sitting in a rocking chair, a cat, glass finials, and numerous roughly carved balls in cages. This is certainly a complicated work and illustrates the kind of settings Edgington's figures originally were part of in his "Automatic World."

Puzzles and whimsies are the "doodles" of wood-carvers everywhere, probably the most expressive and most personal form of folk carving. Their primary purpose was to give the carver something to do with his hands. If the result delighted or amused those who saw the carvings, that was enough reward.

18 Fragments of Our Past

In the latter half of the nineteenth century, the competent wood-carver was frequently called upon to create a wide variety of architectural details for the interiors of houses and public buildings. He also found work carving pictorial medallions for the heavy and ornate furniture of the period. When many of the great Victorian houses were torn down in this century to make room for contemporary shopping centers and housing developments, only a few of the fine examples of carved architectural detail were salvaged by knowledgeable housewreckers. The carved wood fragments that have been saved are an infinitesimal portion of what originally existed. Very few of these preserved carvings have any known provenance, and it is difficult to find out from what buildings they were taken or even the general geographical area in which the houses were located. It is only within the past few years that these carvings were thought to be of any value at all, and, unfortunately, most of the nineteenth-century carved wood pillars, pediments, overmantels, and other ceiling and wall details have been lost forever.

Within the past few years, we have begun to realize what this destructiveness has cost us, and some effort has been exerted in American towns and cities to preserve the few fine examples of Greek, Italianate, and French-style houses that have escaped the wrecker's ball. It is now generally accepted by collectors of American wood carving that the few fragments we have left from the thousands of magnificent Victorian houses that were destroyed have artistic and historical merit. Some interior designers have devised modern applications for old pieces of carved wood. An example is the lamp made from a pair of matching carvings long since removed from a Victorian house.

Architecural carvings from nineteenth-century house have been made into a contemporary lamp. (*Collection of Mr. and Mrs. Richard N. Fried*)

The variety of styles of architecture in the latter half of the nineteenth century led to the commission of thousands of wood carvings for exterior and interior decoration. While some of this carved work was turned out in factories geared to make quantities of carvings, more demanding architects and builders hired local carvers to make wainscoting, columns, and other carvings that contributed to the elaborateness of nineteenth-century mansions. Most of the carvers were thought to be no more important to the entire structure than the ordinary carpenter or stonemason, so there are few records of who these artists were or where they worked. A fine example of the type of architectural detail done towards the end of the century is shown here. Carved of beechwood in very high relief, it is done

Architectural detail with
legend "Good Morning"
incised at bottom.
Matching male head with
"Good Night" is known to
have existed. This figure
was at bottom of staircase,
the other at top.
Beechwood. (*James
Kronen Gallery*)

in the flowing art nouveau style typical of the period. It was originally one of a pair of carvings, and this "Good Morning" carving of a young girl decorated the bottom of a staircase, while a carving of a boy, "Good Night," was placed at the top landing. The detail of a stork in a garden is from the same period, but its origins are also unknown.

In the latter half of the nineteenth century, such a diversity of subject matter and styles was used for architectural detail and furniture design that it is impossible to show more than a few examples here. It is anyone's guess as to where the classical urn with foliage and flowers was originally used, but there can be little argument that these small remnants of our art and architectural past are worth salvaging. Details in the half-round, such as the urn illustrated here, are now treasured as decorative wall plaques.

Architectural detail. Painted stork and cat-o'-nine-tails. Carved and painted wood. Turn of century. (*Harold Cole*)

Carved lion's head gargoyle used at Lion's Head Bar and Restaurant in Greenwich Village, New York City. *Circa* 1908. Originally carved for Prudential Insurance Building in Newark, New Jersey.

Architectural detail.
Classical urn with flowers.
(*Private Collection*)

Carved head. Furniture
detail, possibly from
headboard. Found in
midwest. (*Private Collec-
tion*)

The ponderous furniture of the nineteenth century is difficult to place in today's low-ceilinged, small rooms, and many of the pieces of huge case furniture could not even be brought through the doors of our modern houses. Earlier in this century, this heavy and ornate furniture was thought to have no artistic merit whatsoever, and many beautiful carved beds, chests, breakfronts, and other pieces of Victorian furniture were chopped up and used for firewood. The relatively few pieces of custom-built and -decorated furniture from that period that still do exist are now treasured, as the price of fine wood has become prohibitive and we have begun to realize that good craftsmanship is a thing of the past. The beautifully carved woman's head in an oval medallion that is illustrated here was removed long ago from the ornate bedstead it once adorned.

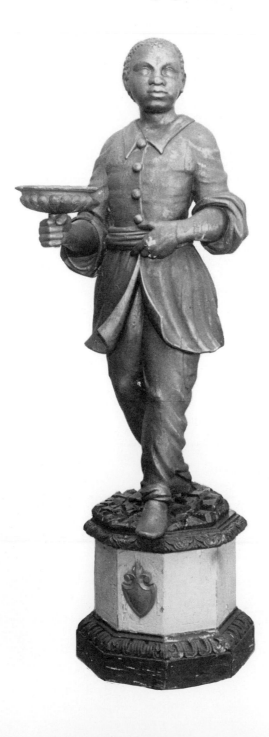

Foyer figure, carved wood and painted. Similar figures were used in cigar stores and held lamps and cigar lighters. (*Mahopac Country Museum*)

Head of carved deer figure. Glass eye and real attached antlers. Carved wood, brown paint. (*Collection of Ross Levett*)

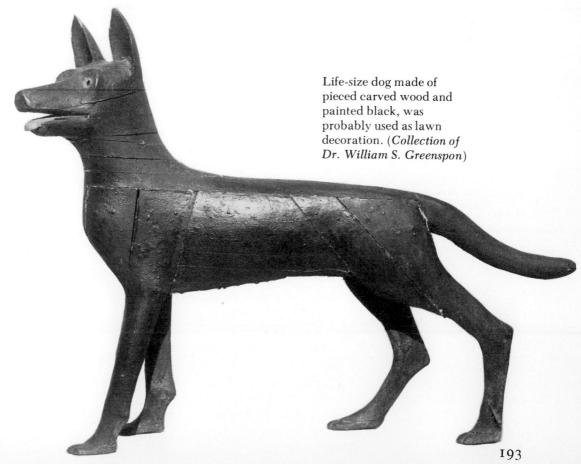

Life-size dog made of pieced carved wood and painted black, was probably used as lawn decoration. (*Collection of Dr. William S. Greenspon*)

193

The hand of the talented wood-carver touched many aspects of buildings and furnishings in the nineteenth century. The carving of the black boy shown here was used in a large and ornate foyer where, with his twin, he stood on one side of the door to hold a plant or vase or to accept calling cards. This figure and many like him were probably made by trade figure companies.

Amateur as well as professional carvers made objects that were stylish during the Victorian period of ornate decoration. If the wealthy ordered iron lawn fawns, some less affluent carvers made life-size animals, birds, and other objects to decorate their gardens. Included here is a life-size carving of a deer, given real antlers and glass eyes for realism. Another life-size animal figure that was probably made as lawn decoration is the black painted dog.

Wall plaque, "Man in the Moon." Painted silver. *Circa* 1910. (*Private Collection*)

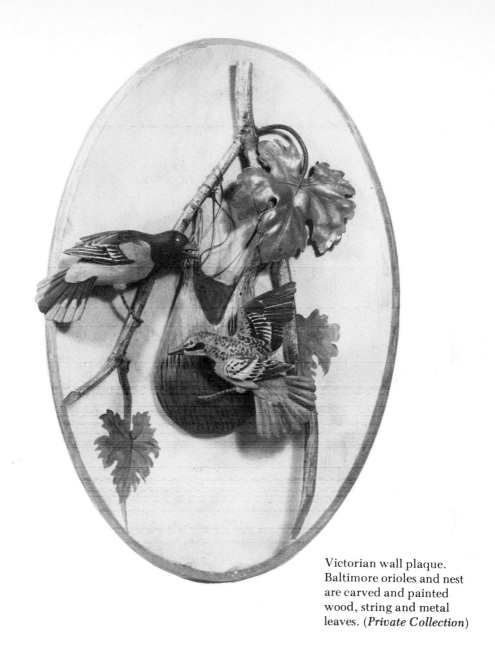

Victorian wall plaque. Baltimore orioles and nest are carved and painted wood, string and metal leaves. (*Private Collection*)

A carved wall decoration that is in the folk art idiom is the silver-painted man-in-the-moon. Another amateur carver designed and made a wall plaque showing a male and female oriole hovering near their carved nest. For added realism, this wood-carver used a real tree branch, string, and a painted metal leaf.

The word "Victorian" was distasteful to many museum curators, collectors, and dealers in the first half of this century. They considered only the neoclassic carvings from the eighteenth and the first quarter of the nineteenth centuries to have any real merit. Architects and interior designers advocated the uncluttered look, and the fragments of our more recent past were considered to be so much junk. Now we realize that any object that exemplifies the best workmanship of its time deserves reappraisal and preservation.

19 Contemporary American Wood Carving

Wood carving is very much alive and flourishing as a hobby, avocation, or business for thousands of people, both in this country and abroad. Contemporary American carvers are organized into local, state, and regional clubs, have a national organization, publish journals, exhibit at crafts shows, and even operate a new museum near Colorado Springs, Colorado. The museum is dedicated to the preservation and display of the work of over two thousand American wood-carvers, whittlers, and sculptors, and is supported by a nonprofit foundation.

The largest national organization is the National Wood Carvers Association headquartered in Cincinnati, Ohio, which has over 5,000 active members. The N.W.C.A. distributes to its members a bimonthly magazine entitled *Chip Chats* that contains news of local chapters, feature articles on the more interesting work of its members, information regarding sources for wood and tools, outlets for the sale of wood carvings, and patterns for carving projects.

The N.W.C.A. has sponsored a tour for its members to Europe, where they visited carving centers in England, Switzerland, Austria, and West Germany. This was in connection with an international convocation of carvers in Oberammagau, Germany, in 1972. Oberammagau has been, of course, a wellspring of distinguished carvers of toys and religious subjects since the end of the Middle Ages. Located there is the renowned wood carving school sponsored by the German government to perpetuate the art.

All of this activity underscores the intense interest and enthusiasm that carving still generates among its practitioners. At club meetings, members bring examples of their recent work for criticism and evaluation, and often

those present vote to choose the best pieces in various categories. Judging is also done at the crafts shows, and awards may be presented in the areas of figure, bird, and animal carving, relief, and wood sculpture. Prizes are sometimes further divided between advanced and novice carvers. This competition and opportunity for exhibition stimulates an exchange of ideas and promotes a higher standard of accomplishment among contemporary carvers.

There are also groups of wood-carvers who have formed organizations to advance specialized aspects of their art. Among these are the Circus Model Builders, who devote their efforts exclusively to carving circus figures, animals, and equipment to exact scale. The usual standards to which the circus buffs work are either ½ inch or ¾ inch to a foot. Many circus–carvers have over a period of years assembled complete miniature circuses for their own amusement; some supply other enthusiasts with carvings to augment their layouts. In addition, these carvers have stored and preseved a wealth of information regarding circus history.

Decoy-makers have clubs and other associations to encourage that aspect of wood carving. They hold an annual world championship decoy contest in Salisbury, Maryland, where such superlative awards as "best in the world" are presented. The most recent contest drew 915 entries from over 200 contestants, both professional and amateur. It should be obvious that this indigenous American folk art is still a very lively segment of American carving.

Many of the carvers who are working now either as hobbyists or who devote part or all of their time to making items for sale are quite adept in a technical sense. They are capable of producing finished pieces in a wide range of sizes, styles, and subjects. The principal criticism of the majority of this work is that for the most part there is a destinct lack of originality in themes and execution. In almost any exhibit of the work of contemporary carvers one will see innumerable birds, both utterly realisitic and pre-dictably stylized. There will be the "cute" figure carvings, most of them done in caricature. Around the Christmas season someone will always show a nativity scene, and at least one carving of an American Indian, either in relief or the full-round, will be found. Then, too, there are the people who exhibit pieces that show their patience and skill—chains with connected links, balls inside cages, and ships or other complicated structures inside bottles.

Budweiser brewery wagon pulled by eight Clydesdale draft horses. This work has been exhibited in a Circus Model Builder's show. Carved by Dexter L. Schaffner, Malden, Massachusetts. Overall length: 54 inches.

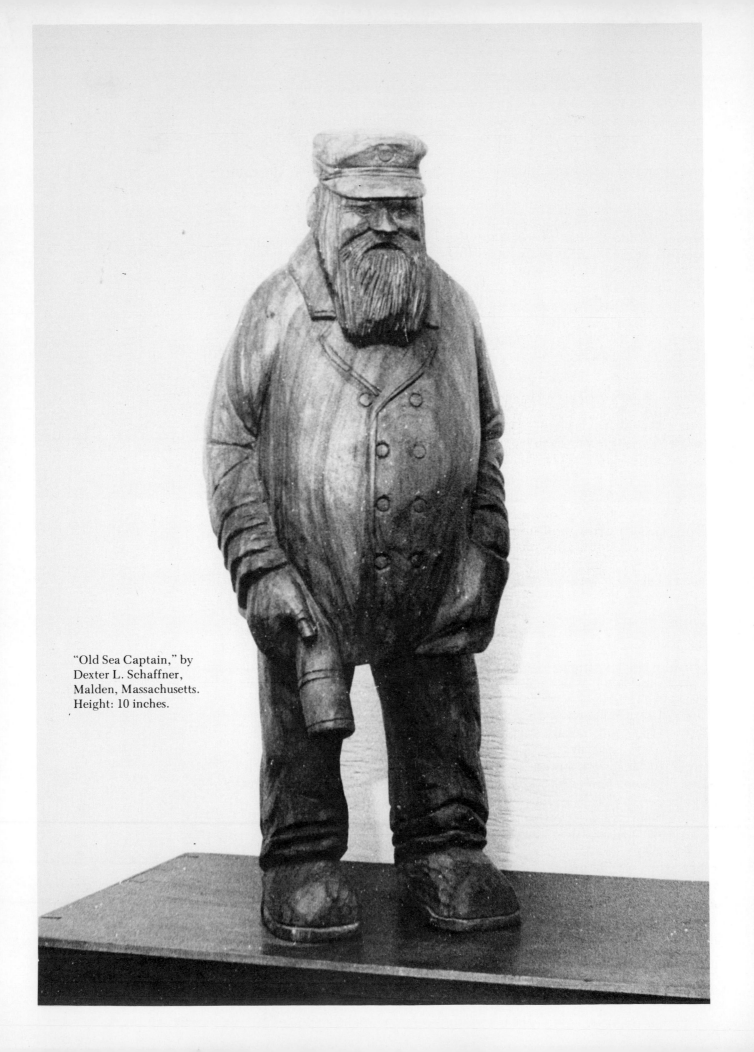

"Old Sea Captain," by
Dexter L. Schaffner,
Malden, Massachusetts.
Height: 10 inches.

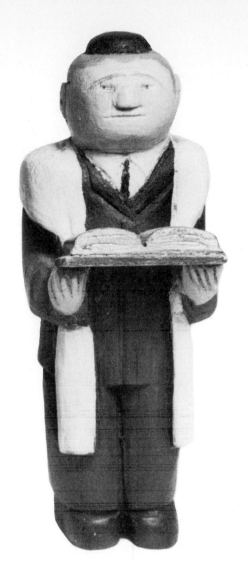
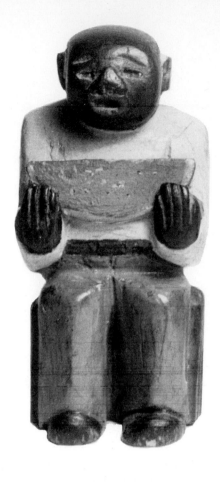

Two carvings in caricature style by anonymous contemporary carver. Figure of rabbi is 6 inches high and dated 1962. (*Collection of Harvey Kahn*)

What most contemporary carvers seem to lack is originality—of subject, style, and execution. A whittler working with only a pocketknife will sacrifice some degree of surface finish, but this is excusable if the completed object has aesthetic appeal and shows an imaginative concept. Since the small birds and animals done by Wilhelm Schimmel and Aaron Mountz have already received recognition and are cited in every treatise on American folk art, they are the standards against which primitive or naïve American wood carving is judged.

When a carver employs a wider assortment of chisels, gouges, files, and other tools, the detailing and finish he is able to achieve may bring his results closer to what may be considered as true sculpture rather than folk art. This tendency is evident in three works shown here: the "Cossack" head, the "Abbott" wall carving, and the root carving of the figure with upstretched arms.

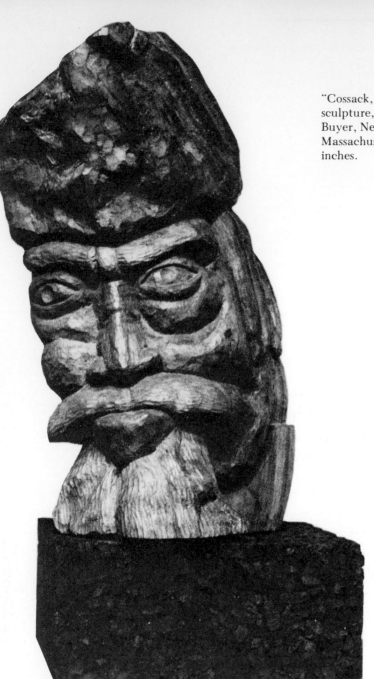

"Cossack," walnut wood sculpture, by Alfred S. Buyer, Needham, Massachusetts. Height: 22 inches.

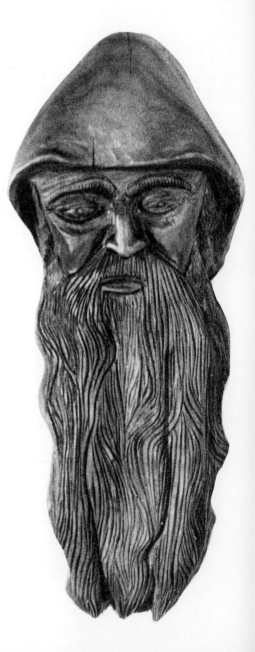

"Abbott," carved wood sculpture, by M. Paul Ward, Chelmsford, Massachusetts.

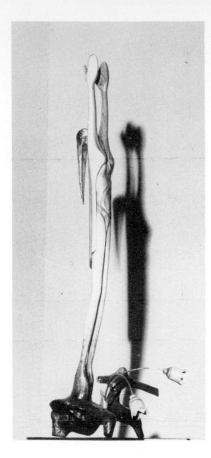

"Waiting for Rain," by
Pranas Baltuonis, LaSalle,
Quebec, Canada. Carved
from staghorn sumac root.
Height: 30 inches.

Adam and Eve being
driven from the Garden of
Eden. By Edgar Tolson,
contemporary carver from
Kentucky. Length: 17
inches. (*Collection of
Harvey Kahn*)

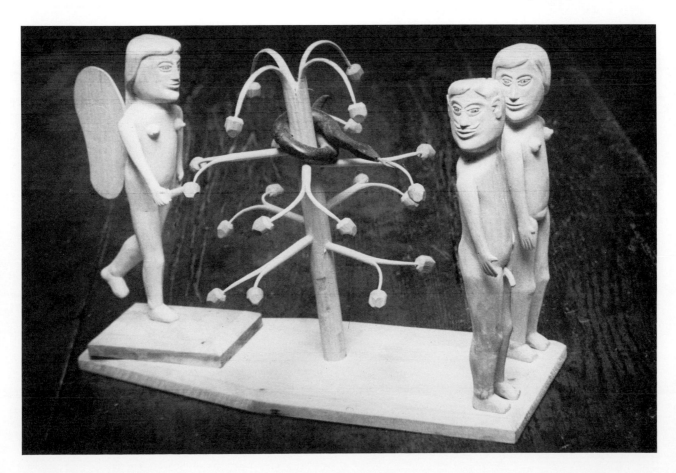

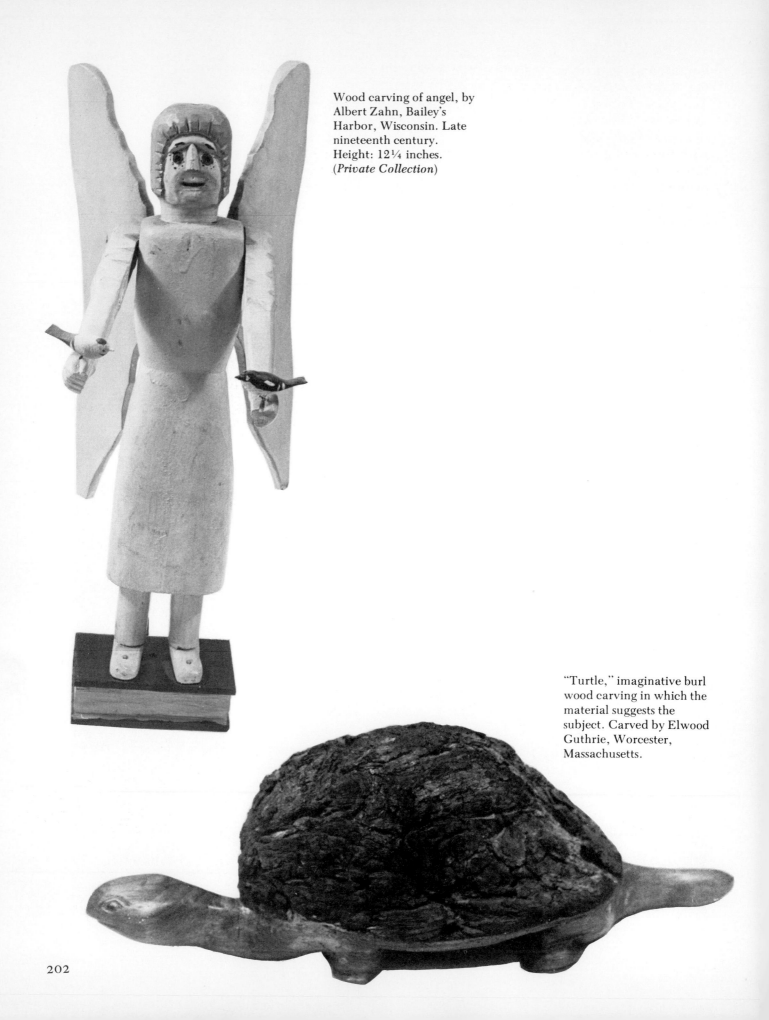

Wood carving of angel, by
Albert Zahn, Bailey's
Harbor, Wisconsin. Late
nineteenth century.
Height: 12¼ inches.
(*Private Collection*)

"Turtle," imaginative burl
wood carving in which the
material suggests the
subject. Carved by Elwood
Guthrie, Worcester,
Massachusetts.

A contemporary work that embodies craftsmanship, originality, humor, and vigor is the group depicting Adam and Eve being driven out of the Garden of Eden. This was created by Edgar Tolson of Camptown, Kentucky. Tolson is a street corner whittler and philosopher who carves scenes from the Old Testament, particularly the Garden of Eden. The figures are out of scale, with oversize heads, and stand as tall as the tree with the serpent and the forbidden fruit. Genitalia are quite explicit, and the reason why the figure representing the Lord has female breasts is unexplained. Tolson, an unspoiled folk-carver who is working today, has received attention from museums of American folk art, and his work is currently in demand by collectors. The Garden of Eden illustrated here is unquestionably a unique and valuable addition to our folk heritage.

Tolson's sexually direct images can be compared to the carving of an angel done by a prolific late-nineteenth-century carver, Albert Zahn. Zahn was a German farmer who settled in Bailey's Harbor in Dorr County, Wisconsin, which is on Lake Michigan. As a hobby, Zahn whittled figures and animals out of cedar fence posts. His representation of the angel is almost asexual and reflects a more rigid attitude than Tolson's toward depicting the human form in an undraped state. The work of both of these carvers is superb, and both pieces excellently represent the period in which their makers worked.

In the southwestern part of the United States, especially in New Mexico, there are wood-carvers who follow in the tradition of the eighteenth- and nineteenth-century carvers of religious subjects who were active in that area. The early carvers were known as *santeros*, after the

"Shoal of Fish," walnut. Carved by Charles K. Savage, Jr., Newburyport, Massachusetts. Length: 24 inches.

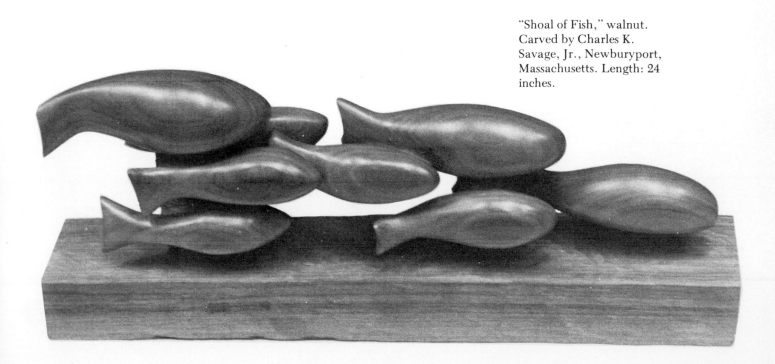

images of the saints which they carved and peddled from village to village. At that time no household was without its own altar or shrine, which housed a carved figure of a favorite saint. The style in which the *santos* were carved is a departure from the Spanish tradition introduced by the Franciscan friars. As native carvers took over from the monks, the style became simpler, more emotional, and the art developed apart from the classical models. The outstanding contemporary carvers in this idiom are Patrocinio Barela, who died in 1969, George Lopez, José Mondragon, and Apolonio Martinez.

It is encouraging that many of the serious folk-carvers working in America today incorporate regional aspects in their work. Those with special talent in their art will not remain anonymous, as have our early good carvers, whose work was not considered of enough importance to deserve special attention in its time. Outstanding wood carving now gains early recognition, and curators in charge of American folk art collections search the country for recent works by talented carvers.

"A Dead Whale or a Stoved-Boat," wall plaque carved in relief by James A. Harrop, Jr., of New Bedford, Massachusetts, is more in the American folk art idiom than most contemporary wood carving. Length: 48 inches.

Contemporary wall carving, "Journey Through Hades," is in pine and was carved by Edward Lukatch, Jamaica Plain, Massachusetts.

Bibliography

Books

BARBER, JOEL. *Wild Fowl Decoys*. New York: Derrydale Press, 1932.

BUTLER, JOSEPH T. *American Antiques 1800-1900*. New York: Odyssey Press, 1965.

CHRISTENSEN, ERWIN O. *Early American Woodcarving*. New York: World, 1952.

CHRISTENSEN, ERWIN O. *The Index of American Design*. New York: Macmillan, 1950.

EATON, ALLEN H. *Handicrafts of New England*. New York: Bonanza Books, 1959.

FLAYDERMAN, E. NORMAN. *Scrimshaw and Scrimshanders, Whales and Whalemen*. New Milford, Conn.: N. Flayderman & Co., Inc., 1972.

FREEMAN, RUTH, AND FREEMAN, LARRY. *Cavalcade of Toys*. New York: Century House, 1942.

FRIED, FREDERICK. *A Pictorial History of the Carousel*. New York: Bonanza Books, 1964.

FRIED, FREDERICK. *Artists in Wood*. New York: Clarkson N. Potter, Inc., 1970.

HORNUNG, CLARENCE P. *Treasury of American Design*. New York: Harry N. Abrams, Inc., 1972.

KLAMKIN, CHARLES. *Weather Vanes: The History, Manufacture, and Design of an American Folk Art*. New York: Hawthorn Books, Inc., 1973.

KLAMKIN, MARIAN. *Hands to Work: Shaker Folk Art and Industries*. New York: Dodd, Mead & Co., 1973.

LICHTEN, FRANCES. *Folk Art of Rural Pennsylvania*. New York: Charles Scribner's Sons, 1946.

LIPMAN, JEAN. *American Folk Art in Wood, Metal, and Stone*. New York: Pantheon, 1948.

LORD, FRANCIS A. *Civil War Collector's Encyclopedia*. Harrisburg, Pa.: The Stackpole Company, 1963.

MAASS, JOHN. *The Victorian Home in America*. New York: Hawthorn Books, Inc., 1972.

MACKEY, WILLIAM F. *American Bird Decoys*. New York: E. F. Dutton, 1965.

McClinton, Katherine Morrison. *American Country Antiques.* New York: Coward-McCann, Inc., 1967.

McClinton, Katharine Morrison. *Antiques of American Childhood.* New York: Clarkson N. Potter, Inc., 1970.

Pinckney, P. A. *American Figureheads and Their Carvers.* New York: Norton, 1940.

Robacker, E. F. *Pennsylvania Dutch Stuff.* Philadelphia: University of Pennsylvania Press, 1944.

Stackpole, Edouard A. *Figureheads and Ship Carvings at Mystic Seaport.* Mystic, Conn.: The Marine Historical Association, Inc., 1964.

Winchester, Alice, and the Staff of the Magazine Antiques. *The Antiques Book.* New York: Bonanza Books, 1950.

Welsh, Peter C. *American Folk Art from the Eleanor and Mabel Van Alstyne Collection: The Art and Spirit of a People.* Washington: Smithsonian Institution, 1965.

Auction and Gallery Catalogs and Journals

The American Heritage Society Auction of Americana (November 12 and 13, 1971). New York: Parke-Bernet Galleries.

The American Heritage Society Auction of Americana (November 15, 16, and 17, 1973). New York: Sotheby Parke-Bernet, Inc.

The Edith Gregor Halpert Folk Art Collection, Property of Terry Dintenfass (November 14 and 15, 1973). New York: Sotheby Parke-Bernet, Inc.

American Eighteenth and Nineteenth Century Folk Painting, Sculpture and Pottery (Special Exhibition and Sale October 25 to November 10, 1973). New York: George E. Schoellkopf.

Selected Examples of American Folk Painting, Sculpture and Pottery (Exhibition and Sale January 19 to February 2, 1974). New York: George E. Schoellkopf.

The Kennedy Quarterly, Vol. XII, No. 1. New York: Kennedy Galleries, Inc., Jan., 1973.

Index

HL1E